D1238241

KALIGHAT PAINTINGS

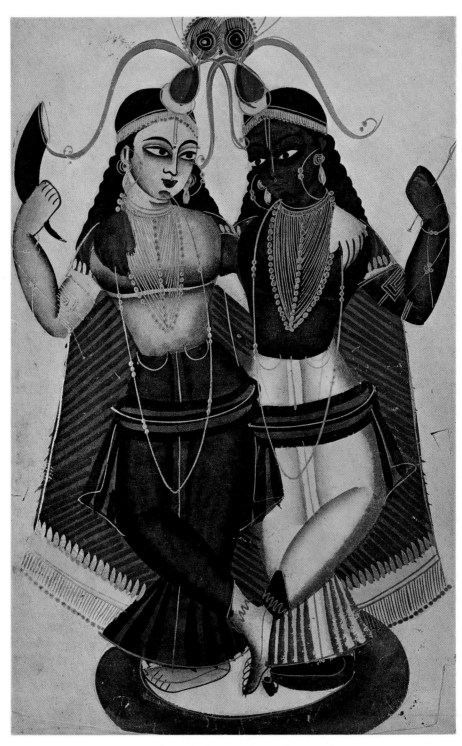

A Frontispiece. Balarama standing with Krishna. Kalighat, *c*.1855–1860.
I.M.2(62)–1917. Cat.no.5,ii.

VICTORIA & ALBERT MUSEUM

Kalighat Paintings

A CATALOGUE AND INTRODUCTION BY

W. G. Archer

LONDON
HER MAJESTY'S STATIONERY OFFICE
1971

Printed in England for Her Majesty's Stationery Office
by Butler & Tanner Ltd, Frome and London

Preface

In preparing this new and enlarged study of Indian paintings from Kalighat, Bengal, I have included passages from my early monograph, *Bazaar Paintings of Calcutta* (London, 1953), and have also incorporated some paragraphs from my later *Kalighat Drawings* (Bombay, 1962). The contents are otherwise new and, with many fresh illustrations, the book should now provide a fuller introduction to the subject than was possible in 1952. Besides revising identifications, dates and attributions, I have included an annotated bibliography, a list of public collections, a short guide to iconography (in the form of a glossary of principal proper names) as well as a detailed catalogue raisonné of the Museum's collection, the largest and most comprehensive in existence. It is hoped that with the aid of the catalogue, students of Indian painting, Bengali culture and the Hindu religion will now be able to avail themselves effectively of a body of material which, by any standards, is unique.

For help in research during the last thirty-five years, I am deeply indebted to many friends and colleagues. In India, Professor Humayun Kabir accompanied me on my first visit to Kalighat in 1932 and helped me with enquiries and Mukul Dey, then Principal of the Government School of Art, Calcutta, showed me his pioneer collection of Kalighat pictures and permitted me to acquire a part of it. Later, in 1954, Dr Suniti Kumar Chatterji, then Vice-Chancellor, Calcutta University, was good enough to correct me on points of detail and to draw my attention to the Tarakeshwar murder case, of which I then knew nothing. I must also acknowledge my indebtedness to Professor Tridib Nath Roy for facts concerning Calcutta society in the nineteenth century, and to my close friends, Deben Bhattacharya and the late B.B. and Amala Mukherjee of Patna, for information on Bengali proverbs and customs. To the Rt. Hon. Malcolm MacDonald, PC, I owe a special debt of gratitude. Press accounts of the Tarakeshwar murder case had for long proved elusive and it was through his personal interest and intervention as UK High Commissioner in India that I was at last able to obtain copies of contemporary reports in the Calcutta newspaper, *The Englishman*.

For help in England, I am deeply grateful to Mildred Archer for constant advice, to Mr John Irwin and Mr T.M. MacRobert for valued cooperation, to Mr Robert Skelton for identifying certain mythological subjects and drafting early catalogue entries, to Mr Douglas McDougall for discussing iconography, to Mr D.P. Choudhury for reading Bengali inscriptions and explaining their significance, and to Mr R.W. Ingle, Dr A.L. Rice, Mr A.F. Stimson and Mr A.C. Wheeler of the British Museum (Natural History) for identifying illustrations of snakes, fishes and fresh-water prawns. I must also express my thanks to Miss Ann Opie of the Indian Section, Victoria and Albert Museum, for preliminary work on the catalogue, to Mr C.H. Cannings and his staff, also of the Museum, for prompt and skilled photography and to Miss M.B. Dixon of the Department of Education and Science for organising the efficient typing of the manuscript. I am particularly indebted to Miss Betty Tyers, who, although a new-comer to the Indian Section in 1967, quickly mastered the subject and gave me indispensable assistance.

October 1968 W.G. ARCHER

Contents

Illustrations

76 Jasoda, with the infant Krishna, milking a cow. Kalighat, *c.*1900. I.P.N.2574. Cat.no.34.

77 Courtesan trampling on a lover. By Kali Charan Ghosh, Kalighat, *c.*1900. I.S.39–1952. Cat.no.36,v.

78 Courtesan with roses. By Nibaran Chandra Ghosh, Kalighat, *c.*1900. I.S.31–1952. Cat.no.37,iii.

79 Courtesan smoking a hookah. By Kali Charan Ghosh, Kalighat, *c.*1900. I.S.38–1952. Cat.no.36,iv.

80 Domestic violence: a husband striking his wife. By Nibaran Chandra Ghosh, Kalighat, *c.*1900. I.S.36–1952. Cat.no.37,viii.

81 Courtesan playing a violin. Colour-lithograph based on Kalighat models. Printed at the Kansaripara Art Studio, Kristo Das Pal's Lane, Calcutta. Calcutta, *c.*1930. I.S.50–1968. Cat.no.41,iii.

82 Hand with fresh-water prawns. Kalighat, *c.*1880. Monier-Williams Collection, Indian Institute, Bodleian Library, Oxford. See note to cat.no.5.

83 Fresh-water prawn with cat-fishes. Copy of a Kalighat painting by a modern Calcutta painter. Calcutta, *c.*1940. I.S.2–1954. Cat.no.42.

84 Two figures, 1923. By Fernand Léger. Oil. *Cahiers d'Art*, vol.viii (1933). Page 1.

85 Le siphon, 1924. By Fernand Léger. Oil. *Cahiers d'Art*, vol.viii (1933). Pages 17–18.

86 Hand with fresh-water prawns. Tinted woodcut based on Kalighat models. Calcutta, *c.*1890. I.S.469–1950. Cat.no.40,ii.

87 A pair of Nepal Kaleege pheasants (*Gennaeus leucomelanos*. Watercolour by an Indian artist, probably employed by the Barrackpore Menagerie, near Calcutta, *c.*1804–1805. Wellesley Collection (N.H.D.29 f.73), India Office Library, Foreign and Commonwealth Office, London. Page 46.

88 Scenes from a scroll painting illustrating the *Ramayana*: (i) Sugriva imploring Rama and Lakshmana to aid him; to the right, Rama and Lakshmana cremating the bird, Jatayu. (ii) Rama demonstrating his strength to Sugriva by piercing seven palm trees with an arrow; to the right, Bali fighting his brother, Sugriva. (iii) Bali dying supported by his wife; Sugriva being reconciled, Rama and Lakshmana looking on. Gouache on paper and cloth. By a rural *patua* artist, Murshidabad District, West Bengal, *c.*1800. I.S.105–1955. Page 8.

89 Metamorphosis. Caricature of the westernised Bengali. Water-colour. By Gogonendranath Tagore, dated 9 August 1917. Collection G.K. Kanoria, Patna. Page 26.

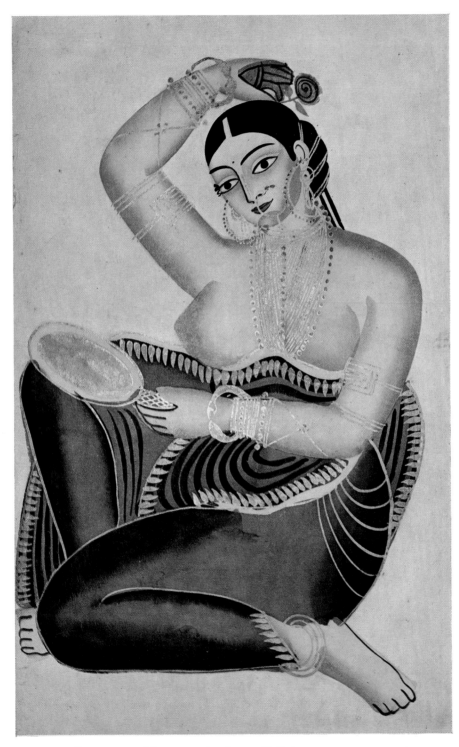

B Courtesan with rose and mirror. Kalighat, *c.*1875. N.M.W.6.
Cat.no.13,v.

Introduction

On 8 August 1917, Rudyard Kipling presented the Victoria and Albert Museum with a series of water-colour paintings of Hindu gods and goddesses which had been collected by his father, J. Lockwood Kipling, while Principal of the Lahore School of Art. These pictures were not the first of their kind to reach the Museum, but, owing perhaps to their connection with Kipling, the gift drew attention to what had hitherto been a neglected type of Indian art. The pictures were painted by *patuas* or village artists at Kalighat, Calcutta, and had been produced for mass sale to the pilgrims who thronged the Kalighat temple. They supplied a different kind of public from the local aristocracy, and for this reason appeared to be a more popular form of Indian expression. But it was not only in their condition of production that the pictures were novel; their style also marked a radical departure from prevailing conceptions. With their bounding lines and bold rhythms, they were obviously close to the ancient murals of Ajanta and Bagh, while the same qualities of line and rhythm, linked with powerful colour, displayed a surprising affinity with modern art. The work of Fernand Léger[1] was a particularly striking analogy, for here were the same bold simplifications, the same robust and tubular forms. The Kipling pictures, in fact, were not only a new kind of Indian art but one which had seemingly antedated some of the more audacious inventions of the modern epoch.

At about the same time, critics in India also became aware of Kalighat painting. Prominent among them was Ajit Ghose, who in an article contributed to the Indian art journal, *Rupam*, in October 1926, made the first serious appraisal of the style.

'There is an exquisite freshness and spontaneity of conception and execution in these old brush drawings [he wrote]. They are not drawn with the meticulous perfection which gives such distinction to Mughal portraiture. They have not the studied elegance and striving after effect of the charmingly sensitive later drawings of the Kangra school with which they are contemporary. But there is a boldness and vigour in the brush line which may be compared to Chinese calligraphy. The drawing

is made with one long sweep of the brush in which not the faintest suspicion of even a momentary indecision, not the slightest tremor can be detected. Often the line takes in the whole figure in such a way that it defies you to say where the artist's brush first touched the paper or where it finished its work. Indeed the line work can hardly be improved upon. Though drawn firmly and unerringly, not only is there no lack of flexibility in their draughtsmanship but there is indeed an exquisite sensibility.' The affinities of Kalighat pictures with those of certain modern artists were also not lost upon Ghose and he claimed that some of their productions 'anticipated by a century or more cubism and impressionism'.[2]

Such painting, at once so Indian and yet so modern, compels us to face some unexpected facts for, despite its marked dissimilarity from British art of the eighteenth and nineteenth centuries, the style was actually a by-product of the British connection and can only be understood against that background. The first evidence for its existence occurs in a volume published in 1832. This book, *Twenty-four Plates Illustrative of Hindoo and European Manners in Bengal*, by Mrs S.C. Belnos, was a series of pictures illustrating 'native scenes' and in her general preface, it was explained how being 'a native of the country' the author had attempted to depict some 'peculiarities of its customs and ceremonies'.

'Every plate [she wrote] is executed from sketches after nature which I made chiefly during my pedestrian excursions in the interior of the country, on the banks of the Ganges where the restraints which confine respectable Europeans to the palkee are laid aside and they can enjoy in uninterrupted freedom the contemplation of the various scenes presented by the country and its inhabitants to their view.'

Among these pictures is one entitled *Interior of a Native Hut*, where a woman is shown cooking by an earthen hearth (*Figure 91*). Mrs Belnos explains that the hut 'is supposed to belong to a Hindoo whose earnings just enable him to possess a neat little hut with a thatched roof supported by bamboos and mud walls. The furniture [she adds] consists of low beds, small stools, a chest or two, a Hookah of coconut shell on a brass stand, a stone or earthen image of their great deity Jughernauth' and finally 'a few ill-executed paintings on paper done by the natives representing some of their gods and goddesses, such as Krishna, Radah, Siva, Doorga.'[3] It is this last remark which is of special significance for, in the plate itself, one of these paintings illustrating Shiva is clearly depicted. Although Mrs Belnos does not seem to have correctly copied the figure, her sketch is unmistakably based on a Kalighat picture. We can assume, therefore, that

by, at any rate, 1830, Kalighat pictures were in active production, and for reasons which will presently be clear we can conclude that the school itself had probably started some twenty or thirty years earlier.

The circumstances which fostered this development were the growth of Calcutta as a large industrial city and the presence in it of a powerful British community. Throughout the eighteenth century, the British settlement on the Hooghly River had been rapidly expanding. Mansions in eighteenth-century style had been erected and although the first streets were two miles distant from Kalighat itself, the steady expansion of the colony gradually brought the temple into intimate contact with the city.[4] The prime purpose of Calcutta had been to trade, but industrial enterprises were also started and among the commodities which came to be manufactured was an article of special importance for artists—paper of a quality which was both cheaper and thinner than the indigenous hand-made paper.[5] Without this steady supply, Kalighat painting could hardly have come into existence. With it, the painters were able to capture a vast and popular market.

But besides this economic stimulus, Calcutta was responsible for formative influences of much greater significance. By the end of the eighteenth century, it had become the most important clearing house in India for British pictures. Many of these were oils, but in addition engravings and aquatints were readily selling. Amateur artists existed among the European residents and there was probably a greater production of work in the European manner than anywhere else in India.[6] The chief British medium was water-colour—as against the tempera employed by indigenous artists—and in subject matter there was another major departure from Indian traditions. Instead of illustrating religious or romantic subjects or portraying the Indian nobility, British painting concentrated on landscapes and picturesque scenes of everyday life, the latter ranging from 'native characters and festivals' to local plants and animals. To supplement their activities, some of the British engaged Indian artists and by the late eighteenth and early nineteenth century, Mughal painters from Patna and Murshidabad had already drifted to Calcutta. Here they absorbed Western techniques and began to make pictures in a half-Indian, half-British manner.[7] Sets of pictures were produced illustrating costumes, occupations, festivals and methods of transport, and these were hawked round the city. Indian artists were also engaged by the British to paint birds, beasts and flowers.[8] As early as 1770 to 1790, Sir Elijah and Lady Impey, Mrs Wheler (the wife of a Member of the Supreme Council of Bengal)

and Nathaniel Middleton were all recruiting Indian artists to record local fauna and flora in a British manner—Pennant going so far as to refer to Middleton's 'great treasure of Asiatic drawings of quadrupeds, birds, fishes and vegetables'. Marquess Wellesley,[9] Governor-General from 1798 to 1805, employed Indian artists to paint studies of plants, animals, fishes and insects—twenty-seven massive folios of which are in the India Office Library—and artists were also retained by the East India Company itself. A Botanic Garden had been established at Sibpur near Calcutta and from 1793, first under Roxburgh (1793–1813) and then under Wallich (1817–1846), Indian painters made a systematic record of Indian plants. In 1804, Wellesley founded a menagerie at Barrackpore and here birds and animals were carefully portrayed by an Indian artist working under Dr Francis Buchanan. All these studies were carried out under British direction. The medium was water-colour and the technique was the same as that employed by British artists in Europe for similar purposes.

The existence of all this work by or for the British gave a new definition to art in Eastern India. It was not merely that the most influential public was British or that a few indigenous artists had succumbed to an alien medium. The British style carried with it the vast prestige of a new and flourishing community. It was the counterpart in painting of Anglo-Indian architecture and like the latter it received the same measure of acceptance. Moreover, although the pictures were originally designed for purely British enjoyment, the high British death-rate and the constant movement of British personnel resulted in the frequent sale of 'gentlemen's effects' and their consequent diffusion through the neighbouring population. Many of these articles were doubtless bought by other Europeans, but at least a proportion also passed to Indian ownership. It is not surprising, therefore, that from the end of the eighteenth century British water-colours and prints were found in the bazaars and Thomas Daniell goes so far as to say, in 1788, that 'the commonest bazaar is full of prints—and Hodges' *Indian Views* are selling off by cart loads'.[10]

So flourishing an art inevitably had repercussions on indigenous practice and when Kalighat paintings first appear, in the early nineteenth century, some of their most salient characteristics can only be explained as the result of British influence. Their most significant innovation—the use of water-colour[11]—is clearly a carry-over from the British technique, for in this respect the break with the former traditions of Indian artists is complete. The method of treating forms derives from a similar source, for every contour is shaded in a way which stands in utter contrast to in-

digenous work. In scale also, each picture is a counterpart of the plant and animal studies made for Europeans. Ordinary measurements are seventeen inches by eleven inches and these are not only considerably larger than those of Indian pictures but are approximately the same as those of the plant and animal studies in the Wellesley folios. Moreover, as in all these studies of flora and fauna, the subject is normally depicted on a blank sheet and there is rarely any attempt to fill the space with flat washes of colour. But it is even more in their themes and subjects that the decisive influence of British models is apparent. As was only to be expected in pictures designed for sale to pilgrims, the majority depicted religious or mythological themes—Shiva and Parvati, Shiva as ascetic or musician, Vishnu and Lakshmi, Radha and Krishna, Rama, Sita, Lakshmana and Hanuman, Brahma and Saraswati as well as many popular episodes from the *Bhagavata Purana*, the *Ramayana* and the *Mahabharata*.[12] Prominent in this medley of gods and goddesses was Kali herself, her tongue dripping with blood, while other forms of Devi, maternal yet terrifying, were also shown in fearsome poses.[13] Such themes reflected orthodox Bengali interests. Yet, alongside their robust portrayal, and indeed in sharp contrast to them, appear other subjects. These were new to popular Bengali art and are explicable only in terms of British water-colours, aquatints and engravings. The Englishman on an elephant shooting a tiger (*Figure 1*) can be paralleled in Williamson and Howett's *Oriental Field Sports* (published 1807) and in Captain Mundy's *Pen and Pencil Sketches* (published 1832). Plate X of Sir Charles D'Oyly's *The European in India*, published 1813, shows a gentleman with a hookah seated against a wall on which appears a print of two jockeys horse-racing. This print is the exact prototype for the Kalighat picture (*Figure 2*) where three jockeys are shown urging their horses into a furious gallop. The subject of courtesans and dancing-girls, common enough in Mughal miniature painting, was non-existent in rural Bengali painting, but it appears in the earliest known series of Kalighat pictures. Here too British models were plentiful. On European residents of Calcutta, 'nautch girls' had exerted a strong fascination[14] and in a number of books—D'Oyly and Williamson's *The Costume and Customs of Modern India* (1813), D'Oyly's *Tom Raw, the Griffin* (1828) and Mrs Belnos's *Twenty-four Plates* (1832)—courtesans are seductively presented. Even natural history subjects—pigeons, crows, water-snakes, fresh-water prawns, musk-rats, jackals, *rui* fish, snakeheads and cat-fish (subjects of a type common in natural history drawings for the British)—make a sudden strange irruption. Their purpose is to illustrate proverbs or folk

5

tales—scraps of popular wisdom likely to amuse or please a pilgrim clientèle—but the method of presentation, large, bold and dominating the whole page, is wholly un-Indian. Finally, 'native characters', such as the *bhisti* or 'water-carrier' (*Figure 6*), for whose depiction Mughal painters from Patna and Murshidabad had found a ready market among the British in Calcutta, are also included. There is no evidence that any of these subjects had been previously treated by the *patuas* of Bengal or had been in any way a normal part of their native traditions. No religious considerations account for their inclusion and while any picture purchased at the Kali temple may have sufficed to remind a pilgrim of his visit, more is needed to account for so unusual a range of unrelated subjects. The only credible explanation is that they entered Kalighat painting as a result of British example. All these circumstances point to only one conclusion— that Kalighat painting originated in the early years of the nineteenth century and that it was a product of the special conditions then obtaining in Calcutta.

Yet if the school presupposes this Anglo-Indian source, its final character is so un-British that other influences must also have affected its development. And in this connection the fact that none of the early Kalighat painters are known to have practised for the British is of some significance. The artists who executed plant and animal studies were either up-country Kayasths from Patna or Murshidabad, or Muhammadan descendants of former Mughal artists.[15] Kalighat painters, on the other hand, were Bengali Hindus of the *patua* community. We know from oral tradition that two of the most prominent, in the second half of the nineteenth century, were the brothers Nibaran Chandra Ghosh and Kali Charan Ghosh, both of whom migrated to Kalighat from the adjacent district of the Twenty-four Parganas and died in 1930 aged over eighty. Other important Kalighat artists were Nilmani Das, Balaram Das and Gopal Das, as well as Balakrishna Pal, Balai Bairagi and Paran.[16] None of these is known to have been employed by the British and it is obvious, therefore, that profound as was the influence of British art on the inception of the school, this influence must be attributed more to some casual acquaintance with Anglo-Indian pictures than to any direct training in the British technique. One further possibility cannot be excluded: that certain artists may have watched Europeans sketching by the temple and noticed that they employed a distinctive medium. But such observation can only have been from a distance and is hardly likely to have resulted in any definite form of instruction. It is not surprising, therefore, that in

adopting the British medium, the Kalighat painters availed themselves only of its more superficial characteristics, while other circumstances led them to make new and vital alterations.

The most important circumstances which determined their adjustments were the actual conditions under which the painters worked. The original temple of Kali had been built in the seventeenth century on a desolate strip of marshland near the Hooghly. Despite its lonely situation, the temple had rapidly become a famous place of pilgrimage. The principal festival was held on the second day of the Durga puja, in the early autumn, but by the middle of the eighteenth century it was attracting pilgrims throughout the year. In 1809 a new building had been erected and a great thoroughfare known as 'the Broad Road' ran out to it from Calcutta. Along this route, pilgrims saw hordes of beheaded goats, a tribute to Kali's dreaded powers. As the temple's fame increased, a small settlement had grown up in the neighbourhood. Stalls and booths had been erected and a brisk trade had developed in pilgrims' souvenirs such as wooden dolls and clay figures. It was this trade which came to include water-colour paintings in the early nineteenth century. The amount of money available for the purchases was normally small, for the pilgrims were rarely people of lavish means. A trade in pictures was possible, therefore, only on the most modest of foundations. A picture at one rupee would obviously seem too costly to one whose monthly earnings were little more than five. Whatever form the style might take, then, it was neces-sary that the finished product should be saleable at a small and insigni-ficant figure. The actual charges, as we know from later evidence, ranged from a pice to one anna, the equivalents in English money of a farthing and a penny.[17] These prices were quite incompatible with minute and laboured delicacy and in fact the only possible style was one which enabled pictures to be produced with brisk rapidity. As a corollary, in-vention itself had also to be confined to the creation of suitable prototypes and once these were devised the process of picture-making had necessarily to consist merely in their rapid duplication. These circumstances could not of themselves have created the Kalighat style, but there can be little doubt that the use of broad and sweeping curves and the employment of ruthless simplifications were all encouraged by this stark and basic necessity.

Such economic factors must undoubtedly have helped to condition the style, but to explain the precise form which the painting took we must bear in mind one further influence—the earlier traditions of the *patua* community.[18] Apart from the painting of wooden dolls and clay figures,

it had long been customary for some of its members to act as artist-minstrels, entertaining the villagers with Hindu ballads and painted scrolls. The painter would travel from village to village singing long stories, and slowly unwinding his pictures. These scroll paintings were done in tempera on thick sheets of paper mounted on cloth and illustrated stories from the *Ramayana* and the *Krishna Lila*. The painting of them was in no sense rapid. Their masterly compositions were due to slow and patient effort. Panels swarmed with figures and the final effect can only be attributed to careful calculation. We do not know how long was taken to complete a particular scroll, but it is probably safe to think in terms of weeks. These scroll paintings owed nothing to the miniature technique or to Mughal influence, and since they were executed in conditions of peaceful leisure, the style had none of the curving exuberance of the Kalighat pictures. Yet important affinities are, none the less, present. Each form is given a sharp firm outline and although the treatment is entirely flat, there is a continual regard for rhythm. Emotional attitudes are expressed through violent distortions and there is a constant predilection for deep intense greens, glowing reds, eloquent browns and rich blues. Faces are shown in profile and the whole picture is used as if it were a tense and crowded diagram. Shading is markedly absent. The whole character of *patua* painting, in fact, was un-representational, aiming at providing a dazzling summary of situations rather than a delicate evocation of some natural event. The total quantity of these scrolls was probably never very great but local styles can be associated with six districts of Bengal—Midnapore, Hooghly, Burdwan, Bankura, Murshidabad and Birbhum. Between these scrolls and Kalighat paintings are certain marked differences, but the earlier tradition is undoubtedly the source of the powerful colours, the stressed contours and primitive distortions which, in spite of its many Anglo-Indian elements, made the school of Kalighat so basically un-British.

Against this general background we must now consider, in greater detail, the history of the style. In the earliest series which has so far come to light, a series which can be safely dated to about the year 1830, the effects of all these different factors can be clearly seen. In 1830, the painters were evidently still in process of mastering the alien medium and adjusting it to their earlier traditions. The result is that, while the later style is already present in broad essentials, it is over-tempered by respect for Anglo-Indian models. The colouring is strong and vital, yet compared with later productions has a certain diluted air, as if the influence of

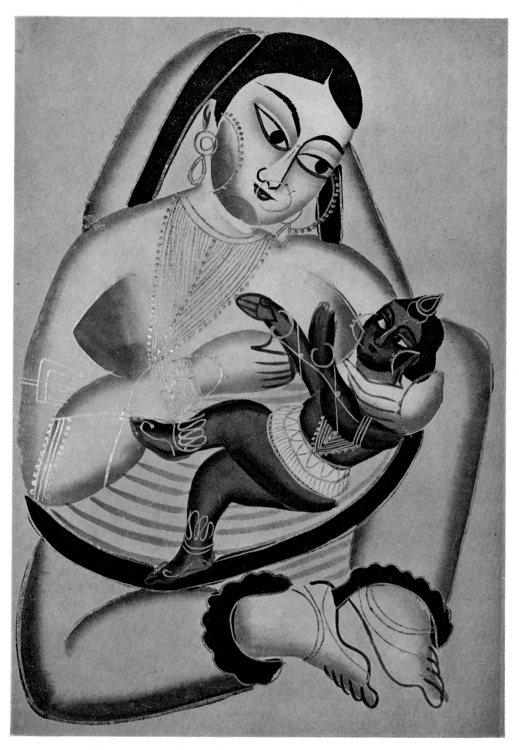

c Jasoda nursing Krishna. Kalighat, *c.*1890. I.M.119–1914. Cat.no.31,xiv.

English water-colours with their tepid sombre hues were still too strong to be ignored. Compositions are boldly conceived but the sensitive, almost timid care with which they are executed, suggests that natural history paintings with their meticulous accuracy were an inhibiting influence. In yet another way the over-close presence of Anglo-Indian models can be recognized. The British device of shading is incorporated in the paintings, but its *rationale* is only partly understood. Instead of being fully rounded, the forms in early Kalighat pictures give the impression of being only shallow plaques—shadow falling on both sides of the object at once. As a result, far from suggesting three-dimensional qualities, shading exists only to stress the outlines and enhance the general rhythms. Finally, perhaps on account of their still uncertain character, pictures of about the years 1840 to 1860 are often painted over lithographed outlines. Lithographic presses had appeared in Calcutta in the eighteen-twenties, and in Patna, D'Oyly had set up his Bihar Lithography in 1828 and trained a Patna artist, Jairam Das, to assist him.[19]

As the school develops after 1850, these peculiarities of detail vanish. British influences weaken and while each picture continues to be painted with neat precision, the general organization grows perceptibly sharper. Shading is no longer treated as an awkward novelty, a slightly cumbrous means of enhancing rhythm. Its aesthetic possibilities are fully realized, and its primary purpose—the creation of a sense of volume—is better understood. As a result, it is no longer confined to the stressing of contours but skilful gradations of tone are used to suggest the fully rounded character of the human form.

Paintings of this kind dominate the school until about the year 1870. By then, the pilgrim market had been fully captured, production had been vastly expanded and the style had achieved new levels of rhythmical expression. A crisis, however, was fast approaching and we can gauge its character from an account by T.N. Mukharji, an official of the Indian Museum, Calcutta, written in 1888:

'Until recently a superior kind of water-colour paintings were executed in Bengal by a class of people called the *patuas*, whose trade also was to paint idols for worship. These paintings were done with minute care and considerable taste was evinced in the combination and arrangement of colours. The industry is on the decline owing to cheaper coloured lithograph representations of Gods and Goddesses turned out by the ex-students of the Calcutta School of Art having appeared in the market. A painting in the old style can still be had, by order, at a price of Rs 10 and

upwards. The *patuas* now paint rude "daubs" which are sold by thousands in stalls near the shrine of Kalighat in the neighbourhood of Calcutta as also in other places of pilgrimage and public fairs. The subjects are usually mythological, but of late they have taken to making pictures representing a few comical features of Indian life. Such pictures are generally sold at a price ranging from a pice to an anna. The following is a typical list: Kali, Radha Krishna, Jagadhatri, the Mother of the World, Goddess of Learning, Woman fetching water, Milking.'[20]

Mukharji's account is obviously not a full analysis of the situation and in one important respect—the evaluation of the style—his sentences have a somewhat Victorian ring. They are, none the less, significant, for besides being the only early account of the Kalighat school which has so far come to light, they accurately suggest the developments which did, in fact, occur. The earlier, more finished productions seem gradually to have lapsed and while the basic designs are still continued, actual execution is characterized by a considerably ruder energy. Silver paint which was formerly used to define contours is resorted to more recklessly. There is no longer the early sense of chiselled precision, and brush lines are in general much bolder and more impulsive. There is, in fact, an even greater tendency towards simplification and while, in some cases, this undoubtedly led to a certain crude coarseness, it also resulted in the release of compensating qualities. More forcibly than in the early phases we now obtain an expression of the Indian ideal of human form. Throughout Sanskrit, Hindi and Bengali literature, a certain sumptuous magnificence had been predicated of the female body[21] and it is precisely this conception which now inspires the artists. The great sweeping curves which evoke the human shape may well have started as a kind of pictorial economy—a simplification forced upon them by the need to produce the pictures more rapidly and in even greater quantities. But the result is more vital and significant—the uninhibited expression of a national ideal.

More significant of the crisis, however, is a change of emphasis in subject-matter. Scenes of current Calcutta life as well as illustrations of proverbs and folk-tales had all along been part of the *patuas'* repertoire but a satirical or moralising purpose had not, at first, been obvious. From 1870 onwards, a note of criticism appears and it is hardly possible to doubt that, faced with contemporary developments such as the oleograph, the camera and the printed news-sheet—developments which threatened their means of livelihood—the *patuas* gave subconscious vent to their fears and resentment. This resentment took the form not of an attack on the machine

as such, but rather of an intense aversion from the kind of society created by the modern age.

During the years 1870 to 1900, Calcutta witnessed a social phenomenon —the 'new Babu' or westernized 'man about town'.[22] His career resembled the rake's in William Hogarth's *The Rake's Progress*. Demoralized by contact with the less savoury aspects of Western life in Calcutta, he disliked orthodox behaviour, neglected his family and squandered his substance. A common institution was the 'garden house' where he could revel freely with dancing-girls.[23] He had succumbed to what Picasso has called 'the charm of the prostitute' and his daily conduct and nightly routine illustrated her sinister ascendancy. It was this theme—the power of woman—which came increasingly to be stressed in Kalighat pictures. In one type (*Figure 43*) the 'new Babu' was shown, foppishly attired—the exact embodiment of the weak male. In another (*Figures 22, 54, 78, 79*) his supreme interest was revealed—a vast rotund woman, waving a rose, holding a mirror, dressing her hair, toying with a hookah or lazily asleep, her very amplitude suggesting, as in pictures by Rowlandson, the ruthless character of feminine power. In yet a third type (*Figures 56, 60*) the abject character of male capitulation was forcibly expressed. The 'new Babu' was shown, carousing with a prostitute, timidly embracing her or meekly begging her favours.[24] Indeed so strong is female influence that in one picture (*Figure 77*) the male admirer lies prone on the floor while the courtesan, like Kali herself, tramples on his form. We are reminded, in fact, of a mother-in-law's joking admonitions to the bridegroom at weddings in Bengal: 'I have purchased you with cowries. I have tied you with a rope. I have put a spindle in your hand. Now bleat like a sheep.' But it is not the sheep husband but the sheep lover who sustains this vapid role (*Figure 18*). Such pictures may well have been influenced by dim associations with the goddess Kali and may even, in some oblique way, have glorified the 'female principle'. Yet a further purpose is also present. Linked to fascination, there is disgust and ridicule, and we can hardly doubt that in these caustic exposures of dissolute living, there is also an indictment of Calcutta—the machine-ridden city which, like a mountainous courtesan, was grimly smothering the painters themselves.

A similar conviction that 'the age is evil' is expressed in pictures in which violence itself achieves a kind of apotheosis. One consequence of decaying morals was domestic friction and the painters return, again and again, to incidents in which husbands or wives are shown blatantly resorting to force.[25] In certain pictures an irate housewife birches an

over-persistent Vaishnava mendicant. Mendicants and holy-men often belied their pious appearances and, despite a show of asceticism, exploited their supposedly magical or super-normal powers in order to enjoy whatever comely woman came their way. A woman who called a mendicant's bluff or smartly rounded on an unwelcome visitor, belabouring him with a birch or broom, was certain, therefore, of popular approval. In other pictures, the theme is less edifying. A co-wife thrashes her rival or two wives struggle for the same husband. A husband pulls his wife's long hair, as she kneels before him, and then prepares to strike her with a lifted hand or with a shoe (*Figures 74, 80*). In others still, the role is reversed and the husband cringes at the woman's feet, ready to receive whatever punishment she proposes to inflict (*Figure 56*). The fact that scenes of this type should so suddenly appear in Kalighat painting can hardly be accidental. The cult of Kali, lovingly maternal yet cruel and violent, may partially explain this new obsession. But there is room for further interpretation. In their helplessness against aggression, the victims are not unlike the painters, stunned by economic forces, while the attackers, whether male or female, suggest Society, formerly kindly but now indulging in a savage *volte-face*.

The most striking development in subject-matter, however, is the inclusion in painting of a contemporary scandal (*Figures 26–41*). The Tarakeshwar Murder, as it came to be known, took place in 1873 and had all the ingredients of Victorian melodrama. It was the Bengali equivalent of *Maria Marten or The Murder in the Red Barn*, and, like that British thriller, it occasioned a flood of popular literature.[26] The murder had every reason to excite the Kalighat-going public but to the artists, it may well have been especially relevant since here, once more, was violence in its starkest form.

The facts of the scandal, as contemporary newspaper reports and a High Court judgment make clear,[27] were briefly as follows. Three principals were involved. The first, Nabin Chandra Banerjee, was a young Brahmin who worked in Calcutta in the office of the Superintendent of Government Printing. The second was his wife, Elokeshi, a buxom girl of about sixteen, who lived in her father's house at Kumrul, a village in Hooghly district close to Calcutta. The third was Madhav Chandra Giri, the Mahant or chief priest of the Shiva temple at Tarakeshwar, some short distance away. In 1872, perhaps during a visit to the temple, Elokeshi caught the Mahant's eye, was seduced by him and for about a year visited his quarters. Her father, Nil Kamal Mookerjee, her younger sister,

Muktakeshi, and her mother were all privy to the intrigue—her sister along with a female servant, Telebo, even making a practice of escorting Elokeshi up to the Mahant's house. The family's motives were never made clear though it is likely that Telebo had acted as procuress and the Mahant, as a man of wealth, had easily suborned her father. Elokeshi seems to have acquiesced in her role but, at the same time, to have amiably complied with her husband's conjugal wishes when occasion arose. Nabin, for his part, was devoted to his wife and had no suspicion of what was happening until Sunday, 25 May 1873, when he arrived from Calcutta on one of his visits. Elokeshi was in her father's house, but, almost immediately, he sensed an atmosphere of tension and realized that something was amiss. According to one version, he was asked not to mix with the village people as his father-in-law had made enemies of them. According to a second, a feast at the house of his wife's grandmother was boycotted by his fellow Brahmins. According to a third, he was refused the hookah by his Brahmin castemen. As a result, news of the intrigue was quickly broken to him and there ensued a great scene between himself and his father-in-law, to be followed by a second scene with Elokeshi. Both denied the allegation and Nabin, though not entirely convinced, seems to have loved Elokeshi too much to take extreme steps. He therefore adopted a middle course, removed her to her grandmother's house—though whether on the Sunday or the Monday is uncertain—and was sufficiently pacified by her loving entreaties that he slept with her. He was very much upset, however, by the whole incident and on the morning of Tuesday, 27 May, decided to remove Elokeshi from the village and take her to Calcutta. He began to make arrangements for palanquin bearers—for carrying Elokeshi with him—and then took her to her father's house to pack up her luggage. The two reached the house and from then onwards events moved to a grisly climax. Until this time, the Mahant, Madhav Giri, had kept quietly in the background. But he had been more captivated by Elokeshi than was realized and on hearing of her imminent departure, he rashly determined to obstruct it. It is uncertain if he posted servants to waylay the litter or whether his plan amounted to positive abduction. Whatever the case, Elokeshi's father was primed to sabotage the husband's plans. He instructed Telebo, the female servant, but was overheard by Nabin while doing so. And it was this chance discovery which precipitated the murder. There is no evidence that Elokeshi herself knew what was intended but any doubts that Nabin may have had about her faithfulness were at once revived. He may have felt doubly deceived or, on the other

hand, bitterly resentful. He lost all self-control and in a fit of 'anger, jealousy and grief', seized a fish knife and dealt her three ghastly blows. In the struggle, Elokeshi was killed, her neck being almost severed and her left hand and wrist deeply gashed. Nabin then ran from the house, crying out that he had killed his wife and only wanted to be hanged. Later, he repeated his confession to a magistrate and was put on trial for murder. The matter, however, did not end there for while in jail he charged the Mahant with the criminal offence of adultery. He also named a certain Kinaram and Nil Kamal (Elokeshi's father) as abettors. The Mahant began by absconding but later surrendered and there ensued two trials—one of Nabin for murder, the other of the Mahant for adultery. Both trials aroused intense excitement, both were reported in Calcutta newspapers, both were the subject-matter of High Court judgments. In the case of Nabin, the jury returned a verdict of not guilty, holding that at the time of the murder he was not of sound mind. 'After the verdict was given', *The Englishman* reported, 'the crowd which was assembled, more than 800 in number, commenced clapping and cheering' and it was only 'after a quarter of an hour that the police managed to keep them quiet.' The Judge, however, rejected the verdict and while admitting that Nabin might have been in a 'violent state of excitement when he heard of his wife's intrigue with the Mahant', held that there could 'hardly be any unsoundness of mind on his part immediately before he killed her'. The High Court Judges were of the the same opinion and on the Sessions Judge's reference, Nabin was convicted of murder and sentenced to transportation for life. Some years later, he was released under an amnesty granted when the Prince of Wales (later King Edward VII) visited India in 1878. So far as the Mahant of Tarakeshwar was concerned, the case aroused similar interest. Two judicial enquiries proved necessary before it reached the Sessions Court. No jury was involved—though, of two assessors, one found the Mahant guilty and the other not. The Sessions Judge held that, although no one had witnessed any adultery, all the circumstances proved it and he therefore convicted the Mahant and sentenced him to rigorous imprisonment (hard labour) for three years and a fine of two thousand rupees. On appeal to the High Court, the conviction and sentences were upheld.

This *cause célèbre* inspired a whole sequence of Kalighat pictures, the artists distorting and magnifying its phases in the light of sentiment and fancy. Illustrations of events leading up to the crime show Elokeshi visiting the temple, sitting in the Mahant's house, embracing Nabin and

begging his forgiveness, while in later phases of the drama Nabin is actually killing his wife or holding her body in his arms. A final group depicts the Mahant standing trial in court, serving his sentence in jail, working an oil press and doing penance after release.[28]

Such pictures may have been prompted by several circumstances. The incident involved the exposure of a famous priest; it discredited a rival shrine; the sentences vindicated morals. Indeed, just as the Nanavati trial of 1959 stirred Bombay, the Tarakeshwar scandal rallied orthodox sentiment. It is other reasons, however, which probably caused it to figure in Kalighat painting. Although Elokeshi herself was murdered, both her husband and lover went to jail and thus her career illustrated once more the power of women to destroy and ruin men. The name 'Elokeshi'—'one whose hair is untied'—was often applied to Kali herself and thus suggested her fatal power. But perhaps even more the very manner of her death had sinister associations. Nabin Chandra Banerjee did not stab his wife or beat her—he tried to cut off her head. Beheading was the standard practice at the Kalighat temple for sacrificing goats and by employing this form of execution, the husband was unconsciously selecting the same type of violence sanctified by Kali herself.

The last phase of Kalighat painting occurs in the years 1885–1930. Bold simplifications continued to be the rule and in a desperate attempt to cheapen production, line-drawings (*Figures 34, 35*) and tinted wood-cuts (*Figure 86*) were also produced. But the times themselves were against any prolonged survival. In other occupations than art, the Indian industrial revolution had destroyed the hand-worker. The lithograph and the printed picture were now so general that hand-painting seemed out of date. In 1920 almost all the descendants of the original artists had ceased to paint and by 1930 the school had ended.

Yet although the *patuas* no longer painted, their example remained and there are two directions in which their influence can be clearly seen. In the early twentieth century, Gogonendranath Tagore collaborated with his brother, Abanindranath, in creating a modern movement in Indian painting. In 1923, he 'discovered' Cubism and in a series of water-colour pictures, he endeavoured to apply Cubist principles to Indian subjects.[29] Somewhat earlier, he had shared the indignation felt by Calcutta patriots at the sharp decline in Indian morals caused by the uncritical adoption of Western dress, habits, and forms of behaviour. He had resorted, therefore, to a satirical form of expression, the caricature. Employing a style of flippant realism, he devised and illustrated ludicrous situations in which

he exposed the hollow pretensions of 'the new Babu' or westernized 'man-about-town' (*Figures 89, 90*). Despite differences of inspiration, motive and manner, these caricatures exactly parallel Kalighat paintings of Calcutta life and it seems impossible to deny some relationship of cause and effect between them.[30]

The second influence is perhaps more important and concerns not subject matter but style. Under E.B. Havell's guidance (1896–1905), artists at the Government School of Art, Calcutta, had returned to Mughal and Ajanta painting as the only means of achieving an Indian form of expression.[31] Their efforts had resulted in a strangely hybrid type of art, for which the best analogy is the pre-Raphaelite school in England. The reason for this outcome lay in the fact that current knowledge of traditional Indian painting was limited and many vital styles were inevitably ignored. Moreover, knowledge of the art of other countries was still so meagre that canons of artistic taste were undeveloped. As more and more Indians visited Europe and books on art reached India, these early ideas began to alter, and while the complete discovery of the Indian tradition had still to be achieved, Mughal painting was increasingly regarded as only an episode. The bias in favour of representation vanished and vigorous styles from Rajasthan, the Punjab Hills and rural Bengal were recognized as valid expressions of the national spirit. Against this background, Kalighat painting acquired a fresh significance. Its quality of simplification was recognized as an outstanding merit since by this means figures were imbued with new dignity and grandeur. The rhythmical verve of the pictures, their exhilarating colour and strong contours seemed part of that 'search for intensity' which in France had already captured modern painting. For one outstanding artist trained at the Government School of Art, Calcutta—Jamini Roy—its discovery precipitated a style of painting which, while remaining linear and monumental, was to prove even more subtly expressive of Indian sensibility.[32] Later still, in about the year 1940, its rapid and summary brushwork led a younger artist, Gopal Ghose, to develop a style of impulsive expressionism.[33] Such influences may, for the moment, appear to have been exhausted, but unless there is a sudden revolution in aesthetic taste, Kalighat painting is likely to be valued for many years to come as one of the most original and authentic contributions made by Bengal to Indian painting and culture.

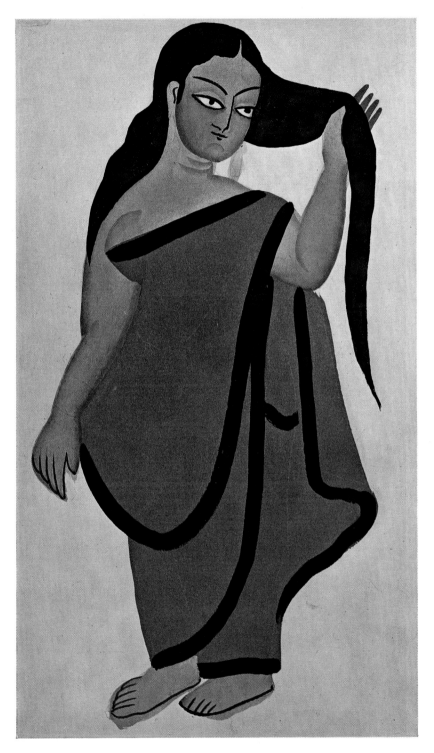

D Courtesan dressing her hair. By Kali Charan Ghosh, Kalighat, *c.*1900.
I.S.37–1952. Cat.no.36,iii.

Notes

[1] For examples of paintings by Fernand Léger, see *Figures 84, 85*. For other examples and for a discussion of his place in modern art, see Herbert Read, *Art Now* (London, 1933) and *A Concise History of Modern Painting* (London, 1959), R.H. Wilenski, *Modern French Painters* (London, 1940), Douglas Cooper, *Fernand Léger* (Geneva, 1949) as well as *Cahiers d'Art* (Paris), Vols.VIII (1933), XX–XXI (1945-1946) and XXIV (1949).

[2] Ajit Ghose, 'Old Bengal Paintings', *Rupam*, Nos.27&28, (July to October, 1926), 98-104. The whole of Ajit Ghose's article should be consulted.

On the possible validity of Ghose's claim that Kalighat pictures 'anticipated by a century or more cubism', see the following reasoned comment by Mildred Archer (*Indian Miniatures and Folk Paintings* (London, 1967), 9–10). 'Such a claim can hardly be accepted in quite such sweeping terms but in the case of one master of the modern movement in France, Fernand Léger (born 1881), there are some similarities which are too close to be lightly ignored. Not only does Léger's work with its vigorous bounding line and tubular simplification closely resemble Kalighat painting but his picture of a hand entering the picture from the top right-hand corner and holding a soda-water syphon (painted in 1924 and reproduced *Cahiers d'Art*, Vol.VIII, p.118; present *Figure 85*) exactly parallels a Kalighat painting of the year 1880. In this painting, a hand enters the picture in precisely the same way but instead of the syphon holds a bunch of prawns. The production of two such closely similar pictures can hardly be accidental. Most Kalighat pictures in British collections reached this country through the agency of missionaries who were anxious to illustrate to the British public the kind of "heathen" gods they were combating. It is more than likely, therefore, that French missionaries from Chandernagore, a French enclave only twenty-five miles from Kalighat, may have brought examples of Kalighat painting to France. In the first decade of the twentieth century, the great pioneers of modern art in Paris—Picasso, Matisse and Derain—vied with each other in raiding the Paris shops in search of exotic art which might confirm or stimulate their revolutionary tendencies.

Picasso, in particular, availed himself of Iberian sculpture and of African masks from the French Congo and the Ivory Coast for his picture, *Les Demoiselles d'Avignon*, and indeed his whole production in the crucial years, 1906–1908, his "Negro" period, is closely geared to African sculpture. It is no belittlement of Léger to suggest that an equally vital fertilization may have occurred at a similarly crucial stage in his development and that instead of Iberia and Africa, India and Kalighat were the source.'

[3] Mrs S.C. Belnos, *Twenty-four Plates Illustrative of Hindoo and European Manners in Bengal* (London, 1832). Preface and Notes to Plate 14.

Although Plate 14 (present *Figure 91*) shows a seated figure apparently holding a bow in its right hand, thereby suggesting Rama, the whole pose as well as the swollen tip of the 'bow' closely resemble a study of Shiva holding a horn and attended by a cobra (see cover plate, Archer (1962) and present *Figure 19*). It is conceivable that in her original sketch, Mrs Belnos did, in fact, copy the cobra correctly but in the course of lithography in England, the snake's identity was mistaken and its form changed to that of a 'bow'. The coiled cobra on Shiva's head in present *Figure 19* may similarly explain the oddly piled-up head-dress in her Plate 14.

[4] For a study of British mansions in Calcutta in eighteenth century style, see Roderick Cameron, *Shadows from India* (London, 1958) and Sten Nilsson, *European Architecture in India, 1750–1850* (foreword Sir John Summerson; London, 1968).

[5] It is possible, as Ajit Mookerjee has suggested, that further supplies of cheap and thin paper may have been obtained from Canton in China with which the East India Company had trade.

[6] For an indication of the range of British art in India, see Sir William Foster, 'British Artists in India, 1760–1820', *Walpole Society*, Vol.XIX (1930–1931); Graham Reynolds, 'British Artists in India', *The Art of India and Pakistan* (ed. L. Ashton, London, 1950), 183–91; and Mildred Archer, 'British Painters of the Indian Scene', *Journal Royal Society of Arts*, Vol.CXV, no.5135, (October 1967), 863–79, *Indian Architecture and the British* (London, 1968), and *British Drawings in the India Office Library* (London, 1969). For a comprehensive catalogue of British aquatints, engravings and lithographs by British artists in India, see J.R. Abbey, *Travel in Aquatint and Lithography, 1770–1860* (London, 1956, 1957), I, II.

[7] For a history of this type of Indian painting—generally termed 'Company'—see Mildred and W.G. Archer, *Indian Painting for the British, 1770–1880* (Oxford, 1955).

[8] A detailed account of natural history paintings by Indian artists working for British patrons in Calcutta is given in Mildred Archer, *Natural History Drawings in the India Office Library* (London, 1962).

[9] Marquess Wellesley (1760–1842), brother of the future Duke of Wellington.

[10] Thomas Daniell, letter to Ozias Humphry, dated 7 November 1788 (quoted M. Hardie and Muriel Clayton, 'Thomas Daniell, William Daniell', *Walker's Quarterly*, (London, 1932), Nos. 35 & 36, 26).

[11] The consistently basic medium in Kalighat painting is water-colour but, in certain instances, body colour is also used. There is no recourse to tempera.

[12] A vivid exposition of religion in Bengal is provided in the following paragraphs by Edward Thompson and A.M. Spencer (*Bengali Religious Lyrics: Shakta* (London, 1923), 9–14):

'Vishnu, in his avatars as Rama and Krishna, and Shiva divide the allegiance of the vast majority of Hindus. This allegiance is further divided by the existence of *Shaktas*, worshippers of the female energy, *shaktī*, of these deities. Their worship is an expression of the age-long Hindu recognition of a dual principle in nature, *purusha* (male) and *prākritī* (female). For practical purposes, Shaktism may be regarded as the worship of Durga or Kali, Shiva's consort. Parvati, daughter of Himalaya; Uma, the gracious and (as Sati) the self-immolating wife; Kali the terrible; Durga "the unapproachable", less terrible than Kali—these are all manifestations of the one goddess, Shiva's consort.

Shiva—called by many names, Mahadeva, "The Great God", or, Bhairava, "The Terrible One"—is the destroyer. He is the great Ascetic, with matted locks, seated in age-long meditation, or haunting burning-grounds, wandering fiercely, accompanied by ghosts and goblins. At first sight, it might seem that no more repellent deity could be imagined; but there is so much of sublimity in the conception of him that many of the most religious Hindus have been attracted by his figure. It is easy to understand and to share this attraction. The dreadful need not be immoral and it can be, often is, sternly bracing, as well as wildly poetical. All men must in the end come to the burning ground; and the God who is a destructive

fire, shrivelling to ashes all that is transitory and fleshly, who is divine negligence personified, meditating amid the ruin of worlds or wandering among the cinders which are all that is left of men's hopes and passionate love—all except memory, growing ever fainter as the years pass—this God in the mind's bleaker moods may bring such sad exultation and courage as men have felt on a lost battlefield or amid eternal snows.

But much of Shiva's worship has gone to his consort, Kali or Durga. Possibly because it was felt necessary to remove the God beyond the operation of *karma* or activity, logically involving change and consequences, the tendency grew up to centralize and intensify his energies in his *shakti* or female counterpart. Vishnu, too, has his *shakti*, as have all the gods; but it is round the names of Kali and Durga that the great bulk of *shakta* worship has gathered.

Shakta-poetry is written today; but if we would see the adoration of the terrible goddess in all its sincerity and passion, we must go back to the eighteenth century, to the period when the Bengali mind became so unhappy and so darkened, when men died and despaired so easily, and when the number of satis increased to such a grim extent, in the last half century before the rite was abolished. The cult of Kali received another great revival in the days of the swadeshi struggle, within the present century, when the thought of the educated classes began to be consolidated in the demand for the control of their own destinies. There was a strong attempt to identify it with nation-worship; Kali was held to be Bengal personified. This aspect of the cult is perhaps not very far below the surface even now. But there has come such an access of mental happiness and of self-respect to the people, that it is certain that they will not again feel as despondent as the poet of Chandi did "with no hope but from the intervention and eruption of sudden irresponsible power".'

[13] On the role and significance of Kali for Hindus in general, Dr G. Morris Carstairs (*The Twice Born* (London, 1961), 156–62) has a number of perceptive remarks: 'Ideally, woman is regarded as a wholly devoted, self-forgetful mother, or as a dutifully subservient wife, who is ready to worship her husband as her lord. In fact, however, women are regarded with an alternation of desire and revulsion. Sexual love is considered the keenest pleasure known to the senses: but it is felt to be destructive to a man's physical and spiritual well-being. Women are powerful, demanding, seductive—and ultimately destructive. On the plane of creative phantasy, everyone worships the Mataji, the Goddess, who is a protective

mother to those who prostrate themselves before her in abject supplication, but who is depicted also as a sort of demon, with gnashing teeth who stands on top of her male adversary, cuts off his head and drinks his blood. This demon-goddess has the same appearance as a witch—and that brings her nearer home, because *any* woman whose demands one has refused is liable to be feared as a witch who may exact terrible reprisals.'

Carstairs then emphasizes, on the one hand, the sense of false security induced in an Indian child by over-prolonged breast-feeding and by inadequate experience of petty frustrations and, on the other, the apparent inconstancy and unpredictability of his mother's caresses, the feeling of rejection caused by over-late weaning and the shock to his confidence engendered by the abrupt ban which is placed on his mother 'when she resumes her menstrual functions and becomes periodically "unclean"'. This impurity is not believed to endanger small children 'but as the child grows older, he has to learn to avoid his mother at such times as one who is mysteriously dangerous, like the blood-stained demon-goddess Durga (whose name means "Unapproachable")'. He adds that 'the underlying mistrust which seems to cloud so many adult personal relationships may well be derived from the phantasy of a fickle mother who mysteriously withholds her caresses and attentions from time to time'. He concludes: 'In contrast with the Western child whose familiarity with intermittent experiences of frustration and delayed satisfaction has enabled him to indulge his aggressive phantasies in moderation, only to be reassured by his mother's renewed affectionate attentions, this desertion on the part of his mother seems a final one. In his phantasy she becomes someone terrible, revengeful, bloodthirsty and *demanding* in the same limitless way as the formerly imperious child. As the Goddess, she is seen as a horrific figure, decapitating men and drinking their blood. In order to appease her fury she must be placated with offerings, but what is more important, she must be appealed to in an attitude of complete submission. She becomes kind and rewarding, a mother again and no longer a demon, only when one has surrendered one's manhood and become a helpless infant once again. Significantly, as will be shown below, the offering proper to the Mataji consists of the symbolic castration of a male animal, whose blood she drinks. This may be the source of the feeling that sexual intercourse represents a victory for the woman, who must be served when she demands it, and a castrating of the man, because with every issue of semen he loses virtue and manly strength at the same time.'

Dr Carstairs' whole account is one of the most rewarding analyses of Indian religion and mentality so far published.

[14] For the British reaction to Indian courtesans and dancing girls, see Mildred Archer, 'The Social History of the Nautch Girl', *The Saturday Book* (1962), Vol.XXII, 242–54.

[15] The names of artists employed on plant, animal and bird studies have in certain cases been preserved. In the case of the Impey collection of plant drawings (formerly Linnaean Society Library), executed between 1774 and 1783, a number of sheets bear the names of the artists Ram Das and Bhawani Das, both being recorded as 'natives of Patna'. There is also the name of a Muhammadan, Sheikh Zayn-al-Din. The collection of two thousand five hundred plant studies, the Roxburgh Icones, made between 1793 and 1813 and still preserved in the herbarium of the Royal Botanic Garden, Calcutta, also contains the names of artists—the most common being those of such typical Bihari Kayasths as Vishnu Prasad and Mahangu Lal.

[16] The names of the Kalighat artists, Nilmani Das, Balaram Das and Gopal Das, with illustrations of their work, are recorded in Ajit Ghose, *op. cit.* The remaining three are noted in Prodyot Ghosh (1967).

[17] For the prices at which Kalighat paintings were sold, see T.N. Mukharji, *Art Manufactures of India* (Calcutta, 1888), 20, where the current prices are given at between one pice and one anna. These rates are confirmed by inscriptions on the pictures (on loose sheets) in the Monier-Williams Collection (Indian Institute, Bodleian Library, Oxford), each of which possesses a separate label noting its price in English as one anna.

[18] For an example of the rural *patua* tradition, see *Figure 88*. Further scroll-paintings from the Murshidabad and Midnapore districts of West Bengal, collected by J.C. French, are also in the Indian Section. For further references, see Bibliography.

[19] The work of Sir Charles D'Oyly and his Indian assistants at Patna is discussed in Mildred and W.G. Archer, *Indian Painting for the British, 1770–1880* (Oxford, 1955), 30–5.

[20] T.N. Mukharji, *op. cit.* 20.

[21] For discussions of the Indian ideal of feminine form, see W.G. Archer, *Ceylon: Paintings from Temple, Shrine and Rock* (Unesco World Art Series, New York Graphic Society, New York, 1957).

[22] For Indian reactions to this phenomenon, see Archer (1959), 19.

[23] I am deeply indebted to Professor Tridib Nath Roy and to my friends, the late B.B. and Amala Mukherjee of Patna for much information concerning social customs in Calcutta in the nineteenth century contained in this and following paragraphs.

[21] For a Western instance of male subservience, compare the following passage from Rousseau's *Confessions*: 'To fall on my knees before a masterful mistress, to obey her commands, to have to beg her forgiveness, have been for me the most delicate of pleasures; and the more my vivid imagination heated my blood the more like a spellbound lover I looked. As can be imagined, this way of making love does not lead to rapid progress, and is not very dangerous to the virtue of the desired object. Consequently I have possessed few women, but I have not failed to get a great deal of satisfaction in my own way, that is to say imaginatively.'

[25] Illustrated Archer (1962), plates 7, 9 and 10.

[26] The following Bengali plays and pamphlets, dealing with the Tarakeshwar murder case, were published in Calcutta between 1873 and 1876 (*India Office Library, Catalogue of Bengali, Oriya and Assamese Books* (1905), II, part IV):

1873 Anon. *Mahanter ei ki kāj* (The Seduction of Elokeshi by the Mahant of Tarakeshwar).

 Anon. *Mahanter jeman karma temani phala* (The Trial and Imprisonment of the Mahant).

1874 Anon. *Mahanter jesā ki tesā* (The Case of the Mahant of Tarakeshwar).

 Anon. *Mahanter sesha kānnā* (The Imprisonment and Remorse of the Mahant).

 Chattopadhyaya, Harimohana. *Mahanta pakshe bhūtonandī* (A Drama on the Case of the Mahant).

 Das, Chandra Kumar. *Mahanter ki sājā* (The Trial of the Mahant).

 Ghosh, Jogendra Nath. *Mahanter ei kāj* (The Murder of Elokeshi by her husband for her seduction by the Mahant of Tarakeshwar).

 Ghosh, Jogendra Nath. *Mahanter ei ki dasā* (The Trial of the Mahant).

 Mukhopadhyaya, Bhola Nath. *Mahanter chakrabhramana* (The Mahant working at the oil-mill in jail).

1874 Mukhopadhyaya, Tinkari. *Mahanter ki durdasā* (The Trial and
 Imprisonment of the Mahant).
 Vandyopadhyaya, Suren Chandra. *Mahanter daphāraphā* (The
 Mahant in prison).
1875 Das, Mahesh Chandra. *Mahanta Elokeshī* (The Trial of Madhav
 Chandra Giri, Mahant of Tarakeshwar, for the Seduction
 of Elokeshi, the wife of Nabin).
1876 Ray, Nanda Lal. *Mahanta Elokeshī*.

[27] For contemporary accounts of the Tarakeshwar scandal and the ensuing
trials, see reports in *The Englishman* (Calcutta), 28 June, 18 September and
7 November 1873. The trial of the Mahant is reported in D. Sutherland,
The Weekly Reporter: Appellate High Court (Calcutta), Criminal Rulings, Vol.
XXI, 1892 (Queen versus Madhub Chunder Giri Mohunt, 15 December
1873). It is unfortunate that the records of the two Sessions cases (including
Nabin's confession) are no longer available, the Session records having
been destroyed after the legally prescribed period of twenty-five years.
Since no point of law was involved in the case of Nabin, the High Court's
appellate judgment was not reported. I am deeply indebted to Dr Suniti
Kumar Chatterji for first drawing my attention to the case and for
identifying for me certain pictures (Archer (1953), figures 7, 18 and 34–6).
Of these pictures, figures 7 and 8 should now be dated *c.*1875 and figures
34–6, *c.*1880.

[28] Paintings of the following episodes in the Tarakeshwar Murder case
have so far been traced:
1 The Mahant rides out on an elephant.
 (*a*) Victoria and Albert Museum, I.S.109–1965. Cat.no.17,ix. *Figure
 26.*
2 Elokeshi meets the Mahant at the Tarakeshwar shrine.
 (*a*) Victoria and Albert Museum, I.M.2(86)–1917. Cat.no.14. *Figure
 27.*
 Published: Archer (1953), figure 18.
 (*b*) B.K. Birla collection, Calcutta.
 Published: Archer (1962), plate 16.
3 Telebo deposits Elokeshi with the Mahant.
 (*a*) State Museum, Prague. *Figure 28.*
4 The Mahant fans Elokeshi.
 Victoria and Albert Museum, I.S.110–1965. Cat.no.17,x. *Figure
 29.*

5 The Mahant plies the reluctant Elokeshi with liquor.
 (a) Victoria and Albert Museum, I.S.111–1965. Cat.no.17,xi. *Figure 30.*
 (b) State Museum, Prague.
6 Elokeshi, installed with the Mahant, offers him *pān*.
 (a) Victoria and Albert Museum, I.M.137–1914. Cat.no.31,xxxii. *Figure 31.*
 (b) Collection Edwin Binney 3rd, Brookline, Mass. *Figure 32.*
7 Nabin is told by friends of Elokeshi's adultery.
 (a) Victoria and Albert Museum, N.M.W.8. Cat.no.13,x. *Figure 33.*
8 Elokeshi protests her innocence; Nabin forgives and embraces her.
 (a) Victoria and Albert Museum, I.S.24–1952. Cat.no.18,iii. *Figure 34.*
 Published: Archer (1953), figure 36.
 (b) B.K. Birla collection, Calcutta.
 Published: Archer (1962), plate 17.
9 The fatal blow.
 (a) Victoria and Albert Museum, I.M.140–1914. Cat.no.31,xxxiv. *Figure 36.*
 Published: Archer (1953), figure 34.
 (b) Victoria and Albert Museum, I.S.25–1952. Cat.no.16. *Figure 35.*
 Published: Archer (1953), figure 35.
 (c) National Museum of Wales.
 Inscribed: *Nabin murders his wife Elokeshi for her unfaithfulness.*
 (d) Indian Institute, Bodleian Library, Oxford.
10 After the murder.
 (a) Victoria and Albert Museum, I.S.240–1916. Cat.no.15,iii. *Figure 37.*
 (b) Indian Institute, Bodleian Library, Oxford.
 Inscribed: *Elokeshi. Price anna 1.*
11 The trial of the Mahant.
 (a) O.W. Samson collection, London.
 Published: Archer (1953) figure 7. See present *Figure 38.*
12 The Mahant arrives in jail.
 (a) Victoria and Albert Museum, I.S.112–1965. Cat.no.17.xii. *Figure 39.*
13 The Mahant works as a prison gardener.
 (a) Victoria and Albert Museum, I.S.113–1965. Cat.no.17,xiii. *Figure 40.*

14 The Mahant turns an oil-press.
 (a) Victoria and Albert Museum, I.M.138–1914. Cat.no.31. *Figure 41*.
 (b) Collection Edwin Binney 3rd, Brookline, Mass.
15 The Mahant does penance.
 Examples of this were known in Calcutta in 1954. (Information: Dr Suniti Kumar Chatterji).

[29] An account of Gogonendranath Tagore's Cubist phase is given in Archer (1959), 43, 138.

[30] Caricatures by Gogonendranath Tagore are discussed by Mulk Raj Anand in 'Gogonendranath Tagore: the realm of the absurd', *Roopa Lekha* (1969). For examples showing affinities in spirit with Kalighat paintings, see *Figures 89, 90*. *Figure 89*, entitled 'Metamorphosis', depicts a westernized Bengali, smoking a cigar, installed in a railway compartment reserved for Europeans. He is undressing for the night and is in the act of taking off his trousers when the railway guard surprises him. A bogus European is then exposed by the *dhotī* which appears under his trousers and by the amulet under his shirt. *Figure 90* inscribed in Bengali *pratikshā* (waiting) is even closer to Kalighat satires (see Cat.nos.12, 15,ii, 17,v, 29,vi–ix, 36,v, 39,ii and *Figures 21, 60–3* and *77*). In the upper part, inscribed in Bengali *ghare* (in the house), a Bengali wife, ready to fan her husband, squats by a tray of food, patiently awaiting his return. In the lower part, inscribed in Bengali *bāhire* (outside), the 'Babu Sahib', with rolled umbrella, smart town-shoes and pleated *dhotī*, gazes ardently up at a courtesan who stands, cigarette in hand, at a balcony. The devastating nature of her attractions is reflected in the two *sannyāsīs* (robed ascetics) who, despite their renunciation of the world, cannot keep their eyes off her, and in the attitude of a third passer-by whose eyes are almost popping out of his head in excitement. A final touch of absurdity is provided by two run-away horses who also find it impossible to avert their horror-stricken gaze. The two parts of the picture are linked by a coil of black smoke, rising from an old-type earthen hearth, and suggesting the ruin which will come on the house if the modern rake fails to mend his ways.

[31] For a discussion of E.B. Havell's influence as Principal, Government School of Art, Calcutta, the revivalist movement in Bengali painting in the early twentieth century and the appreciation in India of modern art, see Archer (1959), 28–48.

[32] For discussions of Jamini Roy and his place in modern Indian art, see Shahid Suhrawardy, 'The Art of Jamini Roy', *Prefaces* (Calcutta, 1938);

Sudhindranath Datta, 'Jamini Roy', *Longmans Miscellany* (Calcutta, 1943); John Irwin and Bishnu Dey, *Jamini Roy* (Indian Society of Oriental Art, Calcutta, 1944); E. Mary Milford, 'A Modern Primitive', *Horizon* (London, 1944), Vol.x; Shahid Suhrawardy, 'Jamini Roy', *Marg* (Bombay, 1948), Vol.ii, no.1; Ajit Moorkerjee, *Modern Art in India* (Calcutta, 1956) and W.G. Archer, *India and Modern Art* (London, 1959).

[33] For a note on Gopal Ghose, with reproductions of his work, see *Marg* (Bombay, 1952), Vol.v, no.1.

Bibliography

1832 BELNOS, Mrs S.C. *Twenty-four Plates Illustrative of Hindoo and European Manners in Bengal* (London, 1832).
 The first book to illustrate a Kalighat painting *in situ* (plate 14) and to give a short account of 'native drawings on paper' in the Calcutta area. Quoted Introduction (p.2). For plate 14, see present *Figure 91*.

1871 Anon. *London International Exhibition 1871: catalogue of the collections forwarded from India* (London, 1871).
 Includes the following entry:
 'Section C: Paintings and drawings in water-colours.
 32 (2054). Collection of eighty common pictures. Executed by natives in the Calcutta bazaars, and used by the poorer classes for the adornment of the mud walls of their houses. Bengal Committee. (These are interesting as showing the large demand which appears to exist for pictures among the poorest natives.)'
 NOTE: Following this exhibition, seventeen Kalighat paintings bearing Exhibition numbers ranging from '1' to '76', were deposited in the India Office Library, London (Add.Or.891–907). For a discussion of this group, see note to cat.no.5.

1886 MUKHARJI, T.N. 'The Art Industries of Bengal', *Journal of Indian Art*, January, 1886.
 Contains the following short reference:
 '*Paintings of Classical Subjects*—There are two classes of mythological paintings characterized by superior and inferior work. The ancient style of paintings of the former class was curious and Indian in execution. The art still exists at Jaypur. The inferior class of pictures is done by the painter caste, the *patuas*, and is sold by thousands at places of pilgrimage, like Kalighat and Tarakeswar and at local fairs, at prices ranging from one pice to one anna each.'

1888 MUKHARJI, T.N. *Art-Manufactures of India* (Calcutta, 1888), 20.
 A longer account, quoted in the text (pp.9–10).

1926 GHOSE, Ajit. 'Old Bengal Paintings', *Rupam* (July–October 1926), nos.27 & 28, 98–104.
 Reproduces line-drawings: *The Sleeper* (by Nilmani Das), *Kaliya Damana* (perhaps by Balaram Das, though the attribution is not entirely clear) and

Jasoda milking a Cow with the child Krishna (by Gopal Das)—three Kalighat artists of the late nineteenth century. Contains a vivid appreciation of the aesthetic qualities of Kalighat art.

1926 HAVELL, E.B. 'Fundamentals of Indian Art', *Rupam* (July–October 1926), nos.27 & 28, 74–7.
Refers to Ghose (1926) and stresses the affinity, in 'the strong rhythmic flow of line', between Kalighat painting and the murals of Bagh and Ajanta.

1930 SMITH, Vincent A. *A History of Fine Art in India and Ceylon* (2nd edition, revised by K. de B. Codrington. Oxford, 1930), 226.
Contains the following reference:
'Apart from the work of the court painters, much work exists which is the product of bazaar schools. Of these the Calcutta brush drawings in colour of the *patua* caste are especially notable for their vigorous line.'
Reproduces (Plate 162b) the line-drawing of *Kaliya Damana* illustrated by Ghose (1926).

1932 DEY, Mukul. 'Drawings and Paintings of Kalighat', *Advance* (Calcutta, 1932).
A newspaper article reproducing the following six Kalighat line drawings, five Kalighat paintings and one German oleograph based on a Kalighat model:
LINE DRAWINGS: *Bala Gopal* (the baby Krishna), *Milking scene: Yasoda and the child Krishna, Radha and Krishna, Vaishnava Guru in trouble* (A Vaishnava stroking a woman's chin while an irate outsider, perhaps her husband, raises a birch as if to thrash him), *The Sirens* (a pair of female acrobats, suspended from the shoulders of a male performer who bestrides the heads of two rearing horses), *Shamakanta fighting with a tiger* (see cat.no.1,xxvii).
PAINTINGS: *Durga Puja* (Durga on her lion killing the buffalo demon, Mahishasura), *Woman and Wine* (a Bengali 'man-about-town', with 'Albert' hair-style, seated, glass in hand, carousing with a plump Calcutta courtesan), *Mohunt in prison* (a priest working an oil press while a jailer with gun and bayonet strikes him with a cane; subject unexplained by Dey but identified (Archer, 1962) as part of a series of pictures illustrating the Tarakeshwar Murder case of 1873), *You can't propitiate tigers by prayers* (A Vaishnava (?) praying to two seated tigers in whose paws he has placed a ball of food; illustration of a Bengali proverb), *Fair Game* (a seated cat with a parrot in its mouth; illustration of a proverb).
OLEOGRAPH: *A coloured lithograph from Germany after a Kalighat painting* (a courtesan at her toilet).
Gives the following account of the artist colony at Kalighat as the writer knew it in about the year 1910 and of its subsequent extinction by 1930:
'Strolling through the streets of South Calcutta a few years ago I chanced

to get into the precincts of the old temple of Mother Kali. The lanes and bye-lanes leading to the temple courtyard were full of small shops dealing with everything interesting to the pilgrims, specially women-folk and children. There were sweetmeat shops in plenty, toys, utensils, bangles and what was most important to my eyes, pictures in colours as well as in lines, hung up in almost all shops. These drawings had a peculiarity of their own which attracted the attention and interest of any man who had any taste for art and drawings. The drawings were bold and attractive and at the same time their technique was so different and simple, that they looked something absolutely distinctive from their class found anywhere else.

These pictures have now entirely vanished. The artist craftsmen are nearly all dead, and their children have taken up other business. In place of these hand-drawn and hand-painted pictures selling at two or four pice each, garish and evil-smelling lithographs and oleographs—quite appalling in their hideousness —have come. The old art is gone for ever—the pictures are now finding their last asylum in museums and art collections as things of beauty which we cannot let die.

It is difficult to state definitely how this original and bold school of art originated and developed at Kalighat; who were the leaders and who followed them. As in the case of other departments of our national life, our ancestors were indifferent in putting down any chronological or historical data of their activities. In this region of art also they were either indifferent or careless. As a result, we cannot trace any history of the development of this wonderful culture of our own. It can be surmised, however, that as pilgrims would rush to this shrine of Kalighat from all parts of India, as peoples of different tastes and likings would stay at this small place for a certain period of time, their wants would naturally be met and supplied by local people. Thus a sort of market grew up at Kalighat for all things necessary for different types of people, of different provinces of our country; moreover these pilgrims would expect to take back something from this shrine which would have associated with it a peculiar halo and interest so that it may be kept up as a memento of the great event of their life. Ordinary things for day-to-day use can be had everywhere and however bright or cheap they might be, they would not add any special meaning. These drawings from the Kalighat *patuas*, however, would naturally possess a peculiar interest and if they would be hung up in any place amongst ten other pictures, they would outshine the others not only for their different characterization but for their wonderful colour-effects and contours as well. As pilgrims know no caste or difference in wealth, naturally these pictures would be taken, liked and hung up by peoples of all classes and communities from the big Rajas and zemindars down to the most ordinary villagers or even little children. These pictures would decorate the *thakurghars* or family chapels of the rich and the middle-class people, they would brighten up—some of them—the

drawings-rooms of people of all sorts; they would add a touch of colour and joy in the humble hut of a tiller of the soil; and the village grocer or the "panwalla" round the corner of a city street would find no better and no cheaper decoration than these pictures. Thus the pictures had a wonderful mass appeal and mass appreciation. The *patuas* would naturally sell a good lot of these pictures every year and I remember to have seen in my younger days at least 30 or 40 shops in those bye-lanes to deal exclusively in these pictures and I remember the *patuas* drawing the pictures in their "shop-studios". These "shop-studios" in those days were more or less "news bureaus" of the country, where not only the pictures of mythological subjects were drawn, but caricatures and satirical sketches would be drawn dealing with the topics of the day, the happenings in the law courts as well as in the bazaars. From a study of the drawings it will be found that these *patuas* were expert in handling the brush and colour and they were keen observers of life, with a grim sense of humour. For example, wealthy zemindars spending their money on wine and women, foppish babus spending their day and night at nasty places, a Mohunt suffering imprisonment for abducting girls, or a priest or Vaishnav "Guru" (who is invariably depicted as well-fed and well-groomed, pot-bellied and top-knotted—the veritable picture of a pious rogue) living with unchaste women—these would not escape the searching eyes of these artists and they would draw the caricatures in such a way as would repel ordinary people from such activities. Even popular sayings and proverbs get good illustrations from them.

But these *patuas* are not found in their old places now. When the other day I chanced to go over to the shrine again I searched in vain for all the old spots where those *patuas* in their "Shop-Studios" would draw pictures and sell them before standing crowds of buyers. The buyers are gone and so are the artists. Big buildings, three storeys high, have taken the places of old huts of which no trace can be found now. Not a shred of the old huts or the *patuas* are to be found now. The foreign imitators of these *patuas* have killed this trade out of its soil. Taking advantage of the popularity of those pictures the sly German traders sent thousands of lithographed copies printed on glazed papers with garish bright colours and flooded the whole country with these cheap imitations of Kalighat pictures. Following these German presses, a litho press of Western India then took the field and as a "Swadeshi" concern did the same thing and hastened the death of this wonderful school of indigenous Art in Bengal. The cheap price, the glazed paper and some kind of imitation of Kalighat pictures took away the crowd from those original artists who created them: the smelly character of these gaudy paints did not deter them.

But can this very original and vigorous school of painting, which formed a sort of window for the souls of Bengal, not be revived now? This is a question which every artist and every Bengali who loves his province and its culture should ask. The real merit of the art and the unquestioned superiority of its

quality created a great demand for these pictures throughout the country. I believe the demand still exists and it is being met in a niggardly way by those outrageous imitations of foreign make. It was more a spirit of making money by any means, even by degrading the art instincts of a people, that was more responsible than any actual decay of good taste among our people. The oleograph pictures were thrust upon the masses—*dallāls* and petty shopkeepers looked to the immediate commission and neglected the artist craftsmen. If we can now revive the old school of art, and produce similar pictures now, I believe they will have a very great demand throughout the country. As a matter of fact, the Kalighat School of Bengal Art has been a glory of Bengal's culture and it is our national duty to revive that culture and glory. If false imitators can take advantage of the popularity there is no reason why we should not revive the original movement and drive out the imitators now, when the merit of the original artists is being universally acknowledged and appreciated. Even now a few stray *patuas* of the old school can be found and if we encourage them and patronise them they can maintain their old calling, and revive the Art in the near future. If we can also arrange to train our young men in these lines they can easily find a way of living by drawing with the help of pen and brush simple drawings of popular interest and get good money out of them as in the days of old. This is an aspect of the question which our artists should not neglect—they should not turn up their noses at the idea of being a mere *patua*. As a matter of fact Bengal's traditional instinct lies with the methods of drawing inculcated in the Kalighat School of Art and I think these methods can be taught to our students much more easily than the complex western processes. We hope our countrymen, who are eager to regenerate the people and also those who are interested in the development of art and culture of the country, should pay a careful attention to this very important item of Bengal's culture which is really the pride of our country, and help in revivifying its old glory and popularity.'

1932 DUTT, G.S. 'The Art of Bengal', *The Modern Review* (Calcutta, May, 1932), Discusses scroll-paintings by *patuas* in rural Bengal.

1932 DUTT, G.S. 'The Tigers' God in Bengal Art', *The Modern Review* (Calcutta, November, 1932).
Discusses rural *patua* painting in Eastern Bengal, Birbhum and the Santal Parganas.

1933 DUTT, G.S. 'The Indigenous Painters of Bengal', *Journal of the Indian Society of Oriental Art* (1933), Vol.I, no.I.
A plea for a return by modern Bengali artists to indigenous traditions. Notes that 'a certain amount of interest' has already been aroused by 'the fine

line-drawings of the Kalighat school'. Goes on to discuss rural *patua* painting in West Bengal.

1939 MOOKERJEE, Ajitcoomar. *Folk Art of Bengal* (Calcutta, 1939).
Discusses rural *patua* painting in Bengal, reproducing six examples.

1942 MOOKERJEE, Ajitcoomar. 'Kalighat Folk Painters', *Horizon* (London, 1941), Vol.v, 417–18.
Reproduces three paintings—*Lady Sleeping* (*c.*1900), *Mendicant with Crow* (*c.*1900), *The Sheep Husband* (*c.*1900).

1943 DATTA, Sudhindranath. 'Jamini Roy', *Longman's Miscellany* (Calcutta, 1943), no.1, 131.
Discusses the affinity of Jamini Roy with popular Bengali painting in Bengal, suggesting, however, that 'he could not accept the Kalighat *pat* and the Bishnupur *pata*, the two easily available samples of Bengali art, as instances of racial purity. The former seemed to him to bear the clear stamp of Europe, its stylised naturalism deriving patently from that source, while the latter, though of obvious local origin, had about it an air of tottering courts where pleasure more than order was the impulse behind design. However, of the two the Bishnupur tradition was more authentic; and this, with its frothy luxuriance strained off, gave him during the next few years the impetus to compose some of his most successful friezes, now mythological in subject, now factual in intention, partial to *gopinīs* but not exclusive of everyman.'

1944 MILFORD, E. Mary. 'A Modern Primitive'. *Horizon* (London, 1944), Vol.x, 338–42.
A study of the modern Bengali artist, Jamini Roy, discussing the influence on his work of Kalighat pictures, and reproducing two works by the artist—*Temple Offering* and *Cat with Crayfish*. For the latter, compare *Figures 55, 82, 83* and *86*.

1945 GHOSH, D.P. 'An illustrated *Ramayana* Manuscript of Tulsidas and *Pats* from Bengal', *Journal of the Indian Society of Oriental Art* (1945), Vol.XIII, 130–8.
Discusses and reproduces four panels from scroll-paintings from Bankura, Burdwan, Birbhum and Midnapore, Bengal; and one panel from a scroll-painting on a Krishna theme, Santal Parganas, Bihar.

1946 STOOKE, H.J. 'Kalighat Paintings in Oxford', *Indian Art and Letters* (1946), Vol. XX, no.2, 71–3.
Lists the Monier-Williams collection of 109 Kalighat paintings, Indian Institute, Bodleian Library, Oxford and reproduces the following four examples:
Plate 1 (a) *Kite with fish* (a fishing-eagle holding a fish in its talons and pecking at its head; reproduced upside down), compare cat.no.17,viii; (b) *Man striking*

woman with shoe (a companion picture to a *Woman thrashing a man with a broom*), compare cat.no.31,xxxv.

Plate II (a) *Mahadeva and Parvati* (Shiva and Parvati seated on the bull, Nandi), (b) *Garuda, Krishna and Balarama.*

NOTE: The Monier-Williams collection includes, amongst other subjects, versions of *The Sheep Husband, Hand holding three prawns, Cat with prawns in its mouth, Rui fish with prawns, Pet cat being embraced by its owner* (a wrestler fighting with a tiger), *Tigers, Dancing girls, Bhisti* and two pictures each inscribed *Elokeshi* (the young Bengali wife, seduced by the Mahant of the Shiva temple at Tarakeshwar and later murdered by her husband; see Introduction, pp.12–15). For reproductions of further pictures in the Monier-Williams collection, see Archer (1953), figures 20–25, and present *Figure 82.*

For a discussion of the collection, see present catalogue (note to Series no.5).

1946 IRWIN, J. 'The Folk-Art of Bengal', *The Studio* (London, November 1946), Vol.CXXXII, no.644, 129–36.
Discusses rural *patua* painting in Bengal. Reproduces the line-drawing of *The Sleeper* illustrated by Ghose (1926).

1950 GRAY, Basil. 'Painting', *The Art of India and Pakistan* (ed. L. Ashton, London, 1950), 197.
Lists the three Kalighat paintings exhibited at the Royal Academy Exhibition of the Art of India and Pakistan at Burlington House, London, in 1947–1948—two (nos.1317 and 1318) from the Victoria and Albert Museum, the third (no.1319) *Cat eating fish*, 'late 19th century', from the Asutosh Museum, Calcutta.

1952 MOOKERJEE, Ajit. *Art of India* (Calcutta, 1952).
Reproduces the Kalighat brush-drawing, *The Sleeper* (*c.*1880), illustrated Ghose (1926) and Irwin (1946); a Kalighat painting, *Courtesan sleeping* (*c.*1900), illustrated Mookerjee (1942) and, a painting in tempera by the modern Bengali artist, Jamini Roy, *Head of Man.*
Captions *Courtesan sleeping* as *A neglected Wife* and comments 'A neglected wife falls asleep after waiting for her westernized husband, who is out boozing. In the hands of the Kalighat *patuas* who revolted from the idealistic view of life, art became a powerful instrument of satire and a form of revenge for social injustice.' Dates it to the early twentieth century.

1952 ARCHER, W.G. 'Kalighat Painting', *Marg* (Bombay, 1952), V, no.4, 22–7.
Discusses the historical development of Kalighat painting and reproduces the following ten pictures:
Figure 1 *Woman and wine.* Line-drawing, *c.*1890. See cat.no.18,i.

Figure 2 *Woman and master*. Collection W.G. Archer, London. Water-colour, by Nibaran Chandra Ghosh, *c.*1890.

Figure 3 *Parvati and Ganesha*. Monier-Williams collection, Indian Institute Library, Oxford. Water-colour, *c.*1860.

Figure 4 *Snake swallowing a fish*. Monier-Williams collection, Indian Institute, Bodleian Library, Oxford. Water-colour, *c.*1860.

Figure 5 *Wrestler with tiger*. Monier-Williams collection, Indian Institute, Bodleian Library, Oxford. Water-colour, *c.*1880.

Figure 6 (colour). *Vishnu as Varaha*. Collection W.G. Archer, London. Water-colour, *c.*1860.

Figure 7 *Karttikeya on a peacock*. Monier-Williams collection, Indian Institute, Bodleian Library, Oxford. Water-colour, *c.*1860.

Figure 8 *Woman with roses*. Water-colour, *c.*1900. See cat.no.37,iii.

Figure 9 *Woman with rose nursing a peacock*. Monier-Williams collection, Indian Institute, Bodleian Library, Oxford. Water-colour, *c.*1880.

Figure 10 *Hanuman with Rama and Sita in his heart*. Monier-Williams collection, Indian Institute, Bodleian Library, Oxford. Water-colour, *c.*1860.

1953 ARCHER, W.G. *Bazaar Paintings of Calcutta* (London, 1953).
A first historical reconstruction of Kalighat Painting, stressing the twin influences of British water-colour painting in Calcutta and the *patua* paintings of rural Bengal.
Illustrates fifty pictures, including thirty-three Kalighat paintings from the Victoria and Albert Museum's collection (see catalogue below), one—*The Murder Trial: An Englishman dispensing justice*—from the O.W. Samson collection, London, here dated *c.*1875, eight Kalighat paintings from the Monier-Williams collection, Indian Institute, Bodleian Library, Oxford, *c.*1860 and *c.*1880, and eight pictures suggestive of parallels, influences and sources. Includes a chronological bibliography up to the year 1952 and a short summary of the Museum's collection.

1954 KRAMRISCH, Stella. *Art of India* (London, 1954), 214.
Reproduces a Kalighat line-drawing, *Courtesan with Rose*, *c.*1875 or later.

1955 HOGBEN, C. *Bazaar Paintings of Calcutta* (London, 1955).
Catalogue of a Circulating Exhibition, Victoria and Albert Museum, based on Archer (1953) and the Indian Section's collection and reproducing on the cover in colour, *Vamana, the dwarf incarnation of Vishnu* (see cat.no.25,lxx). Includes notes on Hindu iconography.

1956 MOOKERJEE, Ajit. *Modern Art in India* (Calcutta, 1956).
Reproduces six works by the modern Bengali artist, Jamini Roy, one of them,

Two cats with prawn, similar in subject to the Kalighat picture *Cat with prawn* (Archer (1953), figure 21).

Stresses the effect upon Jamini Roy's style of contact with the work of rural painters (*patuas*).

Has the following informative comment:

'An interesting side-light on Jamini Roy's development was his early connection with the Bengali theatre which was then struggling for rehabilitation in the social and artistic life of the province. It was not the plays as such but the vibrant dramatic life around the theatre that attracted him most. In that world, it must be mentioned, a large part was played by women from the red-light districts of Calcutta. Not only did they keep alive the tradition of music and dance but their pioneering profession encouraged the growth of many talents over decades.' (17–18).

Colour plate 50. *Courtesan with rose*. Ex-Archer collection, Victoria and Albert Museum (see cat.no.37,iii).

Colour plate 52. *Death's Kingdom*. Panel from a scroll-painting by a *patua*. Bankura, Bengal, twentieth century. Asutosh Museum, Calcutta.

1956 ARCHER, W.G. *Indian Painting* (London, 1956), 16.
Includes a brief reference to Kalighat painting and stresses its importance as a new and vitally creative product of British–Indian connections.

1959 ARCHER, W.G. *India and Modern Art* (London, 1959), 102–4, 113–5.
Discusses the influence of Kalighat painting on the modern Bengali artist, Jamini Roy.
Reproduces two Kalighat paintings:
Figure 31. *Sleeping girl* (study of a courtesan asleep). W.G. Archer collection, London. By Nibaran Chandra Ghosh, Kalighat, *c*.1900.
Figure 43. *Cat with prawn* (a study satirical of 'the false ascetic'). Monier-Williams collection, Indian Institute, Bodleian Library, Oxford. *c*.1880 (Archer (1953), figure 21 paralleled by figure 45, *Two cats with prawn*, by Jamini Roy, *c*.1950.

1961 RAWSON, P. *Indian Painting* (London, Paris, 1961), 153–54.
Summarises Archer (1953), describing the Kalighat technique as 'giving rims of darker colour to sweeping areas of colour, whilst still wet' and 'later, defining contours, features, ornaments, fingers and toes in body-colour'. Reproduces in colour *A syncretic image of Brahma and Shiva* (Monier-Williams collection, Indian Institute, Bodleian Library, Oxford), Kalighat, *c*.1880.

1961 Anon. *Folk Paintings of India* (International Cultural Centre, New Delhi, 1961).
Illustrates in colour (p.11) two Kalighat paintings—*A nobleman* (Lakshmana?) and the two disciples of Chaitanya, Gaur and Nitai.

1962 ARCHER, W.G. *Kalighat Drawings* (Marg Publications, Bombay, 1962).
Incorporates much new material since the publication of Archer (1953), in-
cluding an account of the Tarakeshwar murder case of 1873, the role of the
courtesan in Calcutta, the theme of female dominance in rural Bengal, and the
use of natural history subjects for illustrating proverbs.
Reproduces and discusses the following line drawings (*c.*1880–1890) in the
Basant Kumar Birla collection (formerly Ajit Ghose collection), Calcutta.
Figure A *Courtesan combing her hair.*
Plate 1 *Shiva as musician.*
Plate 2 *Krishna and Bakasura.*
Plate 3 *The repentant Krishna.*
Plate 4 *Kamadeva arouses Shiva.*
Plate 5 *Sukh and Sarika* (a pair of mythological love-birds).
Plate 6 *A Yogi with water-pot and waiting woman* (perhaps an illustration of the
proverb 'A yogi takes his water-pot to a shrine but instead of watering the idol
waters his desires.')
Plate 7 *Woman thrashing a Vaishnava.*
Plate 8 *A doting husband caressing his wife's legs.*
Plate 9 *Wife birching a co-wife.*
Plate 10 *Co-wives assaulting a foppish husband.*
Plate 11 *Courtesan preparing a lamp.*
Plate 12 *Courtesan with sitar.*
Plate 13 *Courtesan with suppliant client.*
Plate 14 *Woman with pitcher.*
Plate 15 *Woman drying her hair.*
Plate 16 *Elokeshi visits the Tarakeshwar shrine.*
Plate 17 *Elokeshi embraces her husband, Nabin.*
Plate 18 *Elokeshi begs forgiveness from Nabin.*
Plate 19 *Nabin murders Elokeshi.*
Plate 20 *Girl circus rider with parachute.*
Plate 21 *Visvakarma's elephant* (illustration of a Bengali proverb).
NOTE: Plates 18 and 19 should now be regarded as illustrating the general
theme of domestic friction rather than the Tarakeshwar murder case.

1966 MAGGS Bros. *Oriental Miniatures and Illumination: Bulletin* (1966), Vol.III,
no.10, part 2, 106.
Plate 100 *Shiva and Annapurna.* Kalighat, *c.*1880.

1967 GHOSH, Prodyot. *Kalighat Pats: Annals and Appraisal* (Calcutta, 1967).
Repeats much of Archer (1953) but adds new information concerning Kali
Kshetra ('The Domain of Kali'), an area of 586 bighas of land donated to the
Kali temple by a local landlord when the former building was replaced by a
fresh structure in 1809; the ban on worshipping any deity other than Kali within

this special area and the fact that the local painters (*patuas*) confined their activities to painting on paper.

Notes that the painters Nibaran Chandra Ghosh and Kali Charan Ghosh (see present cat.nos.16, 18, 19, 36 and 37) belonged to the Sadgope Hindu caste and had migrated to Kalighat from Garia in the Twenty-four Parganas district of Bengal in the nineteenth century. Both had stalls on Nakuleshwartala 'by the side of the present temple'. Other nineteenth century Kalighat painters included the three noted by Ghose (1926), and three others—Balakrishna Pal (who lived 'just opposite the river to the temple at Chetla'), Balai Bairagi (a Vaishnava by religion) and Paran (later an emigrant to Burma). Several stalls flourished on 'what is today Amrita Banerjee Lane'. Besides Kalighat itself, Kalighat paintings were sold at six other fairs in Bengal.

Groups Kalighat pictures into the following five groups:
(1) puranic tales (2) Nature and steel-life (*sic*) including studies of a lobster, two fishes, a green parrot, red parrot, rohit fish and lobster, snake eating a fish, hand with a bunch of prawns, *The Tiger and Auntie Cat* (3) historical events (4) everyday life and (5) caricature. Claims that 'through the medium of *pats*, the *patuas* acted in the role of journalists and thus they offered a direct help in the spread of mass education. Nowadays, there are cartoonists but in that remote by-gone age of religion, the *patuas* used to draw cartoons on social themes at a time when the art of printing was still muling and puking (*sic*) in nurse's arms.'

On the aesthetic merits of Kalighat paintings, observes 'Some have placed this art on the same pedestal as those of Ajanta and the Bagh school but this is rather like calling Kalidasa a meteorologist because he wrote Megh Doota ("The Cloud Messenger").'

Mis-attributes the following extraordinary remarks to the present writer: 'These Pat drawings are not croquil or felt-pen sketches. They are brush drawings. There are exquisite freshness and spontaneity, both of conception and execution, in these drawings.'

Reproduces (plates 2 and 4) two pictures—*Karttikeya* and *Kamala Kamini* by Kanai Lal Ghosh, nephew (?) of Nibaran Ghandra Ghosh.

Plate 1 A 'Duel' between two cats.
Plate 5 *Courtesan preparing a lamp* (Archer (1962) plate 11).
Plate 3 *Elokeshi visits Tarakeshwar shrine* (Archer (1953) figure 18).
Plate 6 *Courtesan with rose.*

1967 BHATTACHARYA, Deben. *Love Songs of Chandidas* (London, 1967).
Discusses and translates the poetry of the Bengali Vaishnava poet, Chandidas, and places in a rural Bengali setting the following Kalighat paintings from the Victoria and Albert Museum:
Plate 4 *Narasimha rending Hiranyakasipu* (cat.no.5,viii).
Plate 5 *Vamana quelling Bali* (cat.no.4,vi).

Plate 12 *Jasoda nursing Krishna* (cat.no.31,xiv).
Plate 24 *Radha at Krishna's feet* (cat.no.4,x).

1967 IONS, Veronica. *Indian Mythology* (London, 1967), 77.
Reproduces (p.77) the Museum's Kalighat painting, *Savitri begs Yama to restore her dead husband* (cat.no.23,liv).

1967 ARCHER, Mildred. *Indian Miniatures and Folk Paintings* (Arts Council of Great Britain, London, 1967).
Summarizes Archer (1953, 1962) and discusses the circumstances in which the modern French painter, Fernand Léger, may have been directly influenced by Kalighat painting in the early twentieth century.
Reproduces the following Kalighat paintings from the Archer collection, London:
Figure 67 *Boar incarnation of Vishnu, c.*1860.
Figure 68 *Tortoise incarnation of Vishnu, c.*1860.
Figure 69 *Hand with prawns, c.*1880.
Figure 70 *Jasoda with Krishna*, by Kali Charan Ghosh, *c.*1900.
Figure 71 *Courtesan smoking*, by Kali Charan Ghosh, *c.*1900.
Figure 72 *Courtesan with rose*, by Kali Charan Ghosh, *c.*1900.

1967 RASUL, Faizur. *Bengal to Birmingham* (London, 1967), 13.
Includes the following note on social life in Calcutta in the early twentieth century:
'Far from drinking, we lived severely austere lives. Anything gaudy or even fashionable was frowned upon. Even our hair-cut had a way of its own. We had to have cropped hair, all of the same length, and it had not to be oiled or parted. The man with a hair-cut with short back and sides, and wearing it parted, was regarded as morally lax. This type of hair-cut was called the 'Albert' cut. Possibly the name was derived from Prince Albert. But then, what was good enough for the Prince Consort was not good enough for our puritan families. Yet, in the contagious atmosphere of the market, I was picking up a bit of these new hair-dos and ways of dressing-up, for which I was rebuked by my brothers.'
For Kalighat pictures of dandies with 'Albert' style hair-cuts, see Archer (1962), plates 13, 17–19 and present *Figures 31, 56–61, 63, 77*.

1968 KRAMRISCH, Stella. *Unknown India; ritual art in tribe and village* (Museum of Art, Philadelphia, 1968).
Summarizes Archer (1953, 1962), lists twenty-five Kalighat paintings and reproduces the following:
Plate 34. *Courtesan with rose and parrot*. Line-drawing, *c.*1875 or later.
No.388. *Saraswati, c.*1870.

Public Collections

NOTE: The following public institutions contain collections of Kalighat paintings:

Asutosh Museum of Indian Art, University of Calcutta.

Bharat Kala Bhavan, Banaras.

Birla Institute of Art and Culture, Calcutta.

Bodleian Library (ex-Indian Institute), Oxford.

British Museum, London.

Gulbenkian Museum of Eastern Art, Durham.

Gurusaday Dutt Museum, Calcutta.

India Office Library, London.

Musée d'Ethnographie, Geneva.

Musée Guimet, Paris.

National Museum of India, New Delhi.

National Museum of Wales, Cardiff.

Pushkin Museum, Moscow.

Rabindra Bharati, Dwarkanath Tagore Street, Calcutta.

Royal Scottish Museum, Edinburgh.

Santiniketan Kala Bhavan, Birbhum.

State Museum, Prague.

Tripura Raj Estate Museum, Tripura.

University of Michigan, Ann Arbor.

Victoria and Albert Museum, London.

Wadsworth Athenaeum, Hartford, Connecticut.

Catalogue of Kalighat Paintings in the Victoria & Albert Museum

Period I: 1800–1850

I, i–xxxiv I.S.192 to 225–1950. A series of thirty-four pictures illustrating:

(a) twenty-six religious or mythological subjects (i–xxvi)
(b) four scenes from current Calcutta life (xxvii–xxx)
(c) three scenes from Anglo-Indian life (xxxi–xxxiii)
(d) a Bengali proverb or folk-tale (xxxiv).

Water-colour with silver details.
Average size: 17 × 11 ins.
Kalighat, c.1830.
Acquired from a Roman Catholic Missionary College, England, 1950.
NOTE: The date of reccipt by the College is unrecorded, but a group of pictures from Tanjore, also illustrating Hindu gods and goddesses, was offered for sale along with the series. The Tanjore examples bore a note in English stating that they reached the College in 1855. It is likely, however, that the Kalighat pictures were painted at least twenty-five years earlier. The jockeys (*Figure 2*) wear the large peaked cap which was fashionable in 1820 but had already gone out of use ten years later. The Englishman on the elephant (*Figure 1*) also wears the top-hat and cut-a-ways which were current between 1820 and 1830. Details of the paintings also point to the fact that the series cannot be much later than about 1825—the pale and tepid colours, the chiselled precision of the execution, and the naïvely mannered use of shading (to emphasize contours rather than volume) all suggest the influence of Anglo-Indian water-colours of the 1780–1820 period but in a still undigested form. The series is further characterized by a plentiful use of silver pigment to indicate ornaments and tassels.

i	Saraswati.	I.S.192–1950
ii	Krishna and Balarama.	I.S.193–1950
iii	Parvati nursing Ganesha.	I.S.194–1950
iv	Narasimha.	I.S.196–1950
v	Balbhadra, Subhadra and Jagannatha.	I.S.197–1950
vi	Hanuman fighting with Ravana.	I.S.198–1950
vii	Hanuman with Rama and Sita in his heart.	I.S.199–1950

Inscribed: *Hanuman the Man Monkey concealing Rama and Sita in his heart.*
Published: Archer (1953), figure 5.

viii	Jatayu with Ravana and Sita.	I.S.200–1950
ix	Shiva Panchanana.	I.S.201–1950
	Inscribed: *Shiva, the five faced.*	
x	Saraswati.	I.S.202–1950
xi	Shiva accepting food from Annapurna.	I.S.203–1950
xii	Shiva and Parvati on the bull, Nandi.	I.S.204–1950
xiii	Balarama dancing on a lotus-flower.	I.S.205–1950
xiv	Shiva, Parvati and Ganesha.	I.S.206–1950
xv	Shiva, Parvati and Ganesha.	I.S.207–1950
xvi	Ganesha.	I.S.208–1950
xvii	Kusha and Lava carrying Hanuman bound.	I.S.212–1950
xviii	Gaur and Nitai.	I.S.214–1950
xix	Durga as Jagaddhatri.	I.S.216–1950
	Inscribed: *Parvati, wife of Siva.*	
xx	Lakshmi.	I.S.217–1950
xxi	Krishna killing Putana.	I.S.220–1950
xxii	Krishna mollifying Radha by stroking her feet.	I.S.221–1950
xxiii	Radha and Krishna.	I.S.222–1950
xxiv	Krishna and Balarama.	I.S.223–1950
xxv	Krishna and Balarama attacking Kansa.	I.S.224–1950
xxvi	Krishna as Kali holding a severed head.	I.S.225–1950
xxvii	Wrestler struggling with a tiger.	I.S.195–1950

Published: Archer (1953), figure 4.

NOTE: Later versions of this picture came to be associated with a particular *yogi*, Syamakanta Banerjee, famous in the eighteen-eighties and nineties for his wrestling matches with tigers. For an account of his career, see Archer (1962), 9.

| xxviii | Woman selling fish. | I.S.215–1950 |

NOTE: Perhaps an illustration to the Bengali folk-tale, *The Fish Supper* (see W. McCulloch, *Bengali Household Tales* (London, 1912), 125–8).

xxix	Two dancing-girls performing.	I.S.218–1950
xxx	Courtesan seated on a chair.	I.S.219–1950
xxxi	Englishman on an elephant shooting at a tiger (*Figure 1*)	I.S.209–1950

Published: Archer (1953), figure 1.

| xxxii | Jockeys horse-racing (*Figure 2*). | I.S.210–1950 |

Published: Archer (1953), figure 2.

NOTE: For possible British prototypes, see Introduction, p.5.

| xxxiii | Two sepoys fighting. | I.S.211–1950 |

NOTE: Of uncertain subject, since the unrealistic treatment and fanciful choice of colours make precise identification of the regiments impossible. The first sepoy, wearing a peaked cap, reddish-brown cut-a-ways, green breeches and top boots, attacks with a dagger; the second sepoy, wearing blue cut-a-ways, yellow breeches and black top-boots, defends himself with a spear.

xxxiv A pair of pigeons (*Figure 3*). I.S.213–1950
Published: Archer (1953), figure 3.
NOTE: Illustration to a Bengali proverb, perhaps of the type 'as like as two pigeons'. In treatment and composition, based on natural history drawings for the British for which there was a great vogue in Calcutta from *c.*1780–1850. See Mildred Archer, *Natural History Drawings in the India Office Library* (London, 1962). The device of showing a pair of birds, back-to-back, can be paralleled in a 'Company' painting by a Calcutta artist of a pair of sand-grouse (*c.*1800–1820), sold at Sotheby's, 10 July 1968 (Lot 157). For a further example, illustrating a pair of Nepal Kaleege pheasants in a similar stance, see Archer, *ibid.*, plate 20, and present *Figure 87*. This picture, now in the India Office Library (Wellesley collection, N.H.D. 29,f.73), was painted by an Indian artist under British supervision for Marquess Wellesley (Governor-General of Fort William, Calcutta, from 1798 to 1805) in *c.*1804–1805. The painter was probably a member of the team of Indian artists recruited and trained by Dr William Roxburgh, Superintendent (1793–1813) of the Company's Botanic Garden at Sibpur on the river Hooghly opposite Fort William. Artists from this team were seconded to paint birds and animals at the Barrackpore Menagerie, founded by Wellesley in 1804. For two thousand Bengali proverbs, see Rev E. Long, *Prabad Mala or the Wit and Wisdom of Bengali Ryots (peasants) and Women as shown in their Proverbs and Proverbial Sayings* (Calcutta, 1869). Among the proverbs recorded, the following are conceivably echoed by Kalighat pictures: (1) A fish in deep water: a great man, i.e., hard to find; (2) The *rui* fish weeps at falling into the hands of a bad cook, i.e., at being spoiled in the cooking; (3) A shrimp (freshwater prawn?) is frisky and noisy in a handful of water, i.e., a pretentious person with little means; (4) Like a *koi* fish swimming up current, i.e., a person behaving perversely; (5) In a jungle the jackal is king; (6) You are a shrimp who goes backwards, i.e., you do not keep your word; (7) Smear a musk-rat with attar of roses and still you won't be able to get rid of its stink; (8) He wants to catch fish but doesn't like getting wet; (9) A little fish makes a great stir in the water; (10) Where a snake is, there you will find its tail; (11) Like a snake swallowing a musk-rat; (12) A frog dancing on a snake's head; (13) What is in another's hand is not your own; (14) A sly cat: a false ascetic.

2,i–iv I.S.71 to 74–1959. A series of four pictures illustrating religious or mythological subjects.

Water-colour with lithographed outlines, silver details and traces of black margins. Average size: 17 × 11 ins.
Kalighat, *c.*1835–1840.
Acquired from G.S. Hill, Brighton, 1959.
NOTE: Similar in style and palette to series 1, with the same cool colouring (bluish-greens and maroon) and shallow shading. The marked recourse to

46

lithographed outlines suggests a slightly later date, by which time mechanical aids may have been speeding up production. The unusual iconography of (iv) suggests, however, that composition and subject-matter were still unstandardized.

i	Varaha (*Figure 5*).	I.S.71–1959
ii	Narasimha (*Figure 4*).	I.S.72–1959
iii	The wives of Kaliya appealing to Krishna for his life.	I.S.73–1959
iv	Krishna in a tree, fluting; beneath him, a hunter aiming an arrow.	I.S.74–1959

NOTE: Krishna, the feudal prince, died as a result of an arrow wound in his foot accidentally inflicted by a hunter while he was reclining beneath a tree. The only occasion when he actually climbed a tree and sat in its branches was when, as a boy among the cowherds, he stole the milkmaids' clothes. In the present picture, the two situations are either blended or confused.

3 An illustration of current Calcutta life. I.S.90–1955
The water-carrier (*Figure 6*).
Inscribed on the reverse in English: *'Bheestie' or Water Carrier. Considerable allowance must be made for Poetic or Painter's license in this representation. The Bheesti in reality is anything but a swell, and the beard and ornaments exist only in the vivid imagination of the painter. Moreover, the implement for carrying water is simply made of a sheepskin and in fact when full looks very much like a sheep blown out. The only garment worn by the gentleman in question (as represented on the other side) is of a dirty white colour and certainly has no spangles on it.*

Water-colour with silver details.
Size: 16 × 11 ins.
Kalighat *c.*1840.
Given by Stuart C. Welch, Cambridge, Mass., 1955.
NOTE: Similar to series 1 in its suave precision, narrow shading and employment of silver pigment. A special feature is the introduction of scroll-like patterns on the black water-container and utensil.

4,i–xvi D.652 to 667–1889. A series of sixteen pictures illustrating mythological or religious subjects.

Water-colour with lithographed outlines and silver details.
Average size: $17\frac{1}{2}$ × 11 ins.
Kalighat, *c.*1850.
Originally acquired from G. Wild by the Department of Prints and Drawings, 1889, and now on permanent loan to the Indian Section.
NOTE: A series in deep rich colours, marked by suave decisive contours and by notably more skilful shading. Limbs are fully rounded but while bold

simplifications are still employed, the general execution continues to evince considerable subtlety. As in series I, silver pigment is lavishly employed.

In 1954, nineteen paintings in identical style, measuring $17\frac{3}{4} \times 11\frac{1}{4}$ ins and including exact duplicates of (v) and (vi), were in the private collection of Rhodes Robertson of 316, Oak Grove Street, Minneapolis 3, Minnesota. According to Mr Robertson's aunt, who was then aged 94, the pictures reached the family through his grandfather, who brought them to America from India in 1856. Allowing for a margin of six years, this would give a date of c.1850 for their execution. An article on Kalighat paintings by Frank Davis in *The Illustrated London News* (10 October 1953) first drew Mr Rhodes Robertson's attention to their possible significance. He was later good enough to check and confirm this date with his aunt.

i Kali. D.652–1889
Inscribed: *Goddess Kalee.*

ii Balbhadra, Subhadra and Jagannatha. D.653–1889
Inscribed: *Jagannatha (an incarnation of Vishnu) and Valarama with their sister Subhadrai*, and other notes.

iii Ravana and Sita in the beak of Jatayu. D.654–1889
Inscribed: *Jatayu the Son of Garuda*, and other notes.

iv Radha and Krishna. D.655–1889
Inscribed: *Krishna, Radhika.*

v Krishna quelling Bakasura. D.656–1889
Inscribed: *Bakasura, Krishna*, and other notes.
Published: Archer (1953), figure 8.

vi Vamana quelling Bali (*Figure 8*). D.657–1889
Inscribed: *Vali king of the whole world and the heavens, Vamana incarnation of Vishnu*, and other notes.
Published: Archer (1953), figure 6; also reproduced Bhattacharya (1967), plate 5.

vii Krishna and Balarama. D.658–1889
Inscribed: *Valarama with his horn, Krishna with his flute.*

viii Shiva Panchanana. D.659–1889
Inscribed: *The five-headed Shiva.*

ix Durga and Ganesha. D.660–1889
Inscribed: *Durga with her son Ganesha reclining on a pillow.*

x Radha at Krishna's feet (*Figure 7*). D.661–1889
Inscribed: *Krishna, Radhika wife of Ayana Ghosha*, and other notes.
Published: Archer (1953), figure 9; also reproduced Bhattacharya (1967), plate 24.

xi Karttikeya. D.662–1889.
Inscribed: *.... of gods on his favori(te).*

xii	Saraswati.	D.663–1889

Inscribed: *Saraswatee, wife of Vishnu and the goddess of learning*, and other notes.

xiii	Bala Krishna.	D.664–1889

Inscribed: *Krishna in his childhood.*

xiv	Ganga.	D.665–1889

Inscribed: *Ganga on an acquatic animal.*

xv	Ganesha.	D.666–1889

Inscribed: *Ganesha on his rat*, and other notes.

xvi	Rama, Sita, Lakshmana and Hanuman.	D.667–1889

Inscribed: *Hanuman assisted Rama in his war against Ravana for regaining Sita*, and other notes.

Period II: 1850–1870

5,i–xiv I.M.2–1917: sub-numbers 61, 62, 72, 74 to 83 and 85. A series of fourteen pictures illustrating religious or mythological subjects.

Water-colour with lithographed outlines and silver details.
Average size: 16 × 11 ins.
Kalighat, *c*.1855–1860.
From the J. Lockwood Kipling collection, given by Rudyard Kipling, 1917.
NOTE: The date at which these pictures were collected has unfortunately not been recorded. Rudyard Kipling's father, Lockwood Kipling, first went to India in 1865 and served, for the next ten years, as Architectural Sculptor at the Bombay School of Art. In 1875 he was made Principal of the Mayo School of Art, Lahore, and held this post until his retirement in 1893. During his stay in India, he contributed articles on the Art-manufactures of the Punjab to the *Journal of Indian Art and Industry* and also published a book, *Beast and Man in India* (London, 1891), analysing the representation in art of men and animals. There is no mention in his writings, however, of Kalighat painting and it can only be presumed that it was during some casual visits to Calcutta between the years 1865 and 1893 that he obtained the pictures.

The collection falls into four parts—the present series (5), a second series (14), a third series (22) and a fourth (32). The style of the last three series would suggest that they were probably obtained in 1880 or a little later, though the possibility cannot be excluded that the present series was also purchased at that time. Such a circumstance, however, would not preclude their having been executed at an earlier date since Kalighat pictures were sometimes obtainable at the stalls

twenty to thirty years after they had been painted. On the other hand, the present series might well have been bought soon after Lockwood Kipling's arrival in India and the remaining series shortly before his departure.

A similar collection—also in more than one part—was made by Sir Monier-Williams during the course of three visits to India between the years 1860 and 1883. The purpose of these visits was to collect Indian materials and to 'obtain sympathy and help' for the starting of an Indian Institute at Oxford. The Institute was founded in 1883 and Monier-Williams then presented to it a large library of Sanskrit and Hindi books together with more than one hundred Kalighat paintings. These pictures are clearly the products of more than one period—a set of twenty-eight in a bound book, entitled *Indian Gods*, being exactly similar in style to the present Kipling set while the remainder, on loose sheets, correspond more nearly to series 32. It is noteworthy that the bound book while devoted almost entirely to religious subjects, also includes a study of a snake swallowing a fish—an illustration of a Bengali proverb—while the loose sheets are notable for studies of animals, birds and fishes—also illustrations of proverbs—as well as for some satirical scenes of Bengali life. As in the case of Lockwood Kipling's collection, there is no proof that the two Monier-Williams series were not collected at the same time, but the marked differences in style suggest that the bound book was more probably obtained soon after 1860 and the loose sheets in about the year 1880. (For illustrations of the pictures from the bound book, see Archer (1953), figures 16 and 17 and of those on loose sheets *ibid*, figures 20–5 and present *Figure 82*.

Further confirmation of the earlier date is provided by a group of twenty-nine pictures in similar style deposited in the India Office Library (Add.Or. 891–919) and originally bearing circular exhibition labels marked 'c. INDIA. Bengal. Class I. Heading I. No.216'. Each picture possesses a neatly written caption in English and a serial number of which the lowest is '1' and the highest '76'. Since 'eighty common pictures executed by natives in the Calcutta bazaar' are listed under Section C in the Catalogue of the London International Exhibition of 1871 and no serial number on the India Office Library pictures exceeds 80, it seems reasonable to conclude that these pictures were amongst those shown at this exhibition and that they must therefore have been executed prior to 1870, possibly in *c*.1860.

The twenty-nine India Office Library pictures are of three kinds. The first consists of twelve wood-cuts which range in serial numbers from '58' to '76' and include religious and mythological subjects, railway trains, a stage-coach and a ferry steamer. The second is a single Kalighat picture inscribed '38. Ganesh janani' (the birth of Ganesha) and in the same style as series 7. The third group contains sixteen Kalighat paintings identical in style to the present Museum series 5 and to the Monier-Williams 'bound book' and comprising twelve religious or mythological subjects and the following four scenes from

Bengali life—*Two courtesans standing* (inscribed '11. Two public women'), *A Courtesan seated cross-legged* (inscribed '42. A public woman'), *Woman selling fish* (inscribed '46. A Baboo bargaining for fishes') and *A courtesan nursing a peacock* (inscribed '54. An Figure from imagination').

In general style, present series 5 is obviously very close to series 2, 3 and 4. There is the same minute finish, the same deft precision and the same control of subtly rounded forms. The rhythmical arrangement of limbs, however, seems to have achieved a greater flexibility, shading is used to give an even stronger effect of roundness and the forms have sometimes an almost tubular simplicity. In view of these developments, it is likely that the pictures are approximately fifteen years later than series 2.

i	Ganga.	I.M.2(61)–1917
	Inscribed: *Bengal*.	
	Published: Archer (1953), figure 15.	
ii	Krishna and Balarama (*Figure 9, Colour frontispiece*)	I.M.2(62)–1917
	Published: Archer (1953), figure 14.	
iii	Ravana and Sita in the beak of Jatayu.	I.M.2(72)–1917
iv	Annapurna, seated, giving rice to Shiva.	I.M.2(74)–1917
v	Shiva and Parvati mounted on Nandi.	I.M.2(75)–1917
vi	Krishna and Balarama.	I.M.2(76)–1917
vii	Saraswati.	I.M.2(77)–1917
viii	Narasimha.	I.M.2(78)–1917
	Published: Archer (1953), figure 13, also reproduced Bhattacharya (1967), plate 4.	
ix	Durga killing Mahishasura (*Figure 10*).	I.M.2(79)–1917
x	Shiva Panchanana.	I.M.2(80)–1917
xi	The wives of Kaliya appealing to Krishna for his life.	I.M.2(81)–1917
xii	Ganesha.	I.M.2(83)–1917
xiii	Brahma.	I.M.2(85)–1917
xiv	Winged *apsaras* spearing a stag.	I.M.2(82)–1917
	Published: Archer (1953), figure 12.	

6,i–vi I.S.75 to 80–1959. A series of six pictures illustrating religious or mythological subjects.

Water-colour with lithographed outlines and silver details.
Size: $17\frac{1}{2} \times 11$ ins.
Kalighat, *c.*1860.
Acquired from G.S. Hill, London, 1959.
NOTE: A series notable for its lemon-yellow and pale blue backgrounds, shallow forms, restrained shading and sharply phrased contours. Comparable

to series 7, though slightly starker in general effect, with less intricate line-work and fewer silver strokes.

i	Balbhadra, Subhadra and Jagannatha (*Figure 11*).	I.S.75–1959
ii	Hanuman in combat with Ravana (*Figure 14*).	I.S.76–1959
iii	Shiva Panchanana.	I.S.77–1959
iv	Kali dancing on Shiva (*Figure 13*).	I.S.78–1959
v	Ganesha.	I.S.79–1959
vi	Durga in majesty killing Mahishasura (*Figure 12*).	I.S.80–1959

NOTE: Based on an ivory group of a standard type, made and marketed by ivory carvers of Khagra, a quarter of Berhampore, Murshidabad district, Bengal. An example of such a group was shown at the 1851 Exhibition, London, and was published in H.H. Cole, *Catalogue of the objects of Indian Art* (London, 1874), facing p.131. Close commercial and artistic links existed between Berhampore and Murshidabad, on the one hand, and Calcutta, on the other. Ivory objects of this type, therefore, could well have been current in Calcutta and its suburbs from the mid-eighteenth century on until the late nineteenth. For a note on ivory carving for the British at Berhampore, see M. and W.G. Archer, *Indian Painting for the British* (Oxford, 1955), 23.

7,i–vii I.S.462 to 468–1950. A series of seven pictures illustrating religious or myth-ological subjects.
Water-colour with silver details and black margins.

Average size: 20 × 13 ins.
Kalighat, *c.*1860.
Given by John Irwin, London, 1950.
NOTE: A series not unlike series 5 but with the following distinctive features—wash backgrounds in pale lemon yellow, hard black borders, a lavish use of tiny dots and lines, the whole as if besprinkled with silver pigment. Identical in style to a painting of Parvati with Ganesha (inscribed '38, Ganesh janani') deposited with the India Office Library, London, after exhibition at the London Inter-national Exhibition, 1871 (India Office Library, Add.Or.901). For reasons given under series 5, this picture with its pale yellow background, narrow shading and profuse use of silver pigment must be dated *c.*1860.

i	Krishna and Balarama.	I.S.462–1950
	Inscribed: *God Krishna & Balaram.*	
	Published: Archer (1953), figure 19.	
ii	Shiva Panchanana.	I.S.463–1950
	Inscribed: *God Mahadeb or Seeva.*	
iii	Annapurna bestowing rice on Shiva.	I.S.464–1950
	Inscribed: *God Bissessur and Goddess Unnopoorna.*	

| iv | Rama, Sita, Lakshmana and Hanuman (*Figure 15*). | I.S.465–1950 |

Inscribed: *God Rama with his wife Seeta & brother Lutchman & follower Hunooman.*

| v | Ganesha. | I.S.466–1950 |

Inscribed: *God Ganesh.*

| vi | Shiva, with consort and Ganesha. | I.S.467–1950 |

Inscribed: *God Seeva with his wife goddess Doorga and Son God Ganesh.*

| vii | Saraswati. | I.S.468–1950 |

Inscribed: *Goddess Sorosatty.*

8 An illustration of a religious subject. I.S.5–1949
The goddess Kali.

Water-colour with silver details.
Size: $17\frac{3}{4} \times 14$ ins.
Kalighat, *c.*1865.
Given by Mrs E. Mary Milford on behalf of the Church Missionary Society, London, 1949.
NOTE: Similar to series 6 and 7 but with a plain background and less silver.

9,i,ii I.S.2 and 3–1955. Two pictures illustrating religious subjects.

Water-colour with lithographed outlines and silver details.
Average size: 17×11 ins.
Kalighat, *c.*1865.
Acquired from Mrs H. Wagner, London, 1955.
NOTE: Similar to series 6, 7 and 8 but with uncoloured backgrounds and a positive use of lithographed outlines in (ii) for indicating Kali's garland of heads.

| i | Shiva and Parvati riding on the bull, Nandi. | I.S.2–1955 |

Inscribed: *Hurro Parbati.*

| ii | Kali (*Figure 16*). | I.S.3–1955 |

Inscribed: *Debee Kally.*

10,i–xvii I.S.231 to 247–1953. A series of seventeen pictures illustrating:

(a) fifteen mythological or religious subjects (i–xv)
(b) a proverb (xvi)
(c) a scene of current Calcutta life (xvii).

Water-colour with lithographed outlines and silver details.
Average size: 17×11 ins.
Kalighat, *c.*1865–1870.
Given by the University Museum of Archaeology and Ethnology, Cambridge, to which the series was presented by Mrs Western of Langrookside, Havant, Hampshire.

NOTE: A series transitional in style from series 5 with its smooth, precise forms, and crinkly treatment of hair to series 21, notable for much broader shading, bolder brush strokes, more summary compositions and bounding rhythms. Other features: a use of bright blues and yellows, uncoloured backgrounds, maroon and silver pigments. The large face and bust of (xvii) foreshadows the ample treatment and bold abandon favoured in period IV.

i Hanuman with Rama and Sita in his heart. I.S.231–1953
ii Krishna mollifying Radha. I.S.232–1953
iii The bird, Jatayu, attempting to rescue Sita from Ravana. I.S.233–1953
iv The wives of Kaliya appealing to Krishna to spare their husband. I.S.234–1953
v Rama fighting with Kusha and Lava. I.S.235–1953
vi Garuda carrying Krishna and Balarama (*Figure 17*). I.S.236–1953
vii Radha and Krishna. I.S.237–1953
viii Hanuman as Mahabir carrying Rama and Lakshmana on his shoulders. I.S.238–1953

ix Shiva as Mahayogi (*Figure 19*). I.S.240–1953
x Hanuman before Rama, Sita and Lakshmana. I.S.241–1953
xi Brahma. I.S.242–1953
xii Nitai and Gaur. I.S.243–1953
xiii Two goddesses standing on lotuses. I.S.244–1953
xiv Shiva and Parvati. I.S.245–1953
xv Narasimha. I.S.246–1953
xvi The sheepish lover; a courtesan with rose, leading a sheep with man's head (*Figure 18*). I.S.239–1953
NOTE: For 'the sheep husband', a phrase employed at Bengali weddings for taunting or teasing the bridegroom, but perhaps also used for satirizing female domination, see Introduction, p.11.

xvii Courtesan nursing a peacock. I.S.247–1953
NOTE: Similar in style and theme to a picture in the India Office Library (Add.Or.904), exhibited at the London International Exhibition of 1871 and captioned '54. An figure from imagination'. Although parrots appear in painting as standard symbols of the lover, peacocks, especially in miniature paintings from Rajasthan, Central India and the Punjab Hills, are also shown as if drugged by a girl's charm—the peacock's traditional thirst for rain suggesting the bemused lover's impassioned longing. For a discussion of poetic imagery in Indian painting, see W.G. Archer, *Indian Paintings from Rajasthan* (Arts Council of Great Britain, London, 1957).

Period III: 1870–1885

11,i,ii 08144 (a) and (b) I.S. Two pictures illustrating:

(a) a scene from current Calcutta life (i)
(b) a proverb (ii).

Water-colour with silver details.
Average size: 17 × 11 ins.
Kalighat, *c*.1870.
Transferred to the Indian Section, Victoria and Albert Museum, from the India Office, 1879.
NOTE: Broadly similar to series 4 but with greater shading, a more rounded treatment of limbs and physique, and a more summary treatment of trees and foliage. The jackal in the bottom right-hand corner of (ii) wears the uniform of an English midshipman, current from 1830 onwards. Further British influence is seen in the European-style chair on which the fashionably-attired musician is seated. The fact that both pictures reached the Museum in 1879, having first belonged to the India Office, suggests that they cannot have been executed much later than *c*.1870, and may have been produced slightly earlier.

i A smart fop, seated on a chair, playing a *sitār*. 08144(a) I.S.
Published: Archer (1953), figure 11.

ii The Jackal Raja's Court (*Figure 20*). 08144(b) I.S
Published: Archer (1953), figure 10.
NOTE: A jackal, seated on a string-bed and smoking a hookah, is waited on by two jackal attendants—one holding a regal umbrella over him, the other a hookah. Below, the Jackal Raja, now seated in a Western-style chair, pronounces judgment on two tied and bound animals which are led before him by a Jackal jailor, dressed in black top-hat and midshipman's uniform. Illustration to the Bengali proverb: 'In the jungle even a jackal is king.'

12 An illustration of a proverb. I.S.117–1958
The musk rats' music party (*Figure 21*).

Water-colour with silver outlines and details.
Size: 17 × 10 ins.
Kalighat, *c*.1870.
Acquired from Howard Hodgkin, London, 1958.

NOTE: A young fop, wearing a pleated *dhotī*, and holding in one hand a walking-stick, in the other a rose, stands beside a huge black moth; behind is a theatre with musk-rats playing music and processing with banners. Illustration of the Bengali proverb: *gharete chhunchor kīrtan bāhire konchār pattan* (At home the musk-rats make music; outside the fop parades a pleated *dhotī*). The fact that in the picture the young fop also holds a rose suggests that he is on his way to a prostitute. The large black moth is introduced to underline the fact that he is a nocturnal reveller or 'fly-by-night'. The implication of the proverb is that when a young man 'goes to the bad' his house and its affairs become so neglected that even the musk-rats can play in the rooms with impunity. See Introduction, p.11.

13,i–x N.M.W.1 to 10. A series of ten pictures illustrating:

(a) two mythological subjects (i,ii)
(b) four scenes from current Calcutta life (iii–vi)
(c) a scene from Anglo-Indian life (vii)
(d) two proverbs (viii–ix)
(e) an episode from the Tarakeshwar murder case (x).

Water-colour with silver outlines and details.
Average size: $17\frac{1}{2} \times 11$ ins.
Kalighat, *c*.1875.
Deposited by the National Museum of Wales, 1954.
NOTE: Similar in style to series 12. Special features: boldly simplified shapes, skilful shading, rounded forms, intricate silver necklaces, large details, bright colouring (violet, orange-red), use of brilliant yellow for flesh tones. The inclusion of a picture illustrating an episode from the Tarakeshwar murder case (Introduction, q.v.) proves that the series cannot be earlier than 1873.

 i The mule, Dul Dul. N.M.W.1
NOTE: A pink-spotted horse-like animal bearing spears and two pennants, the latter inscribed in silver lettering with the English words: *this horse*. The grey mule, Dul Dul, is one of the figures carried in procession during the Muslim festival of Muharram. The original Dul Dul served as mount for the Prophet Muhammad during his campaigns.

 ii A winged *apsaras* blowing a horn. N.M.W.10
 iii Two musicians. N.M.W.2
NOTE: A courtesan plays a *sitār* while her lover accompanies her on a drum. Each is seated on a Western-style chair.

 iv Courtesan nursing a peacock (*Figure 23*). N.M.W.3
 v Courtesan with mirror putting a rose in her hair (*Figure 22, Colour Plate B*).
 N.M.W.6

vi A young landowner goes riding. N.M.W.9

NOTE: The white horse, drawn sword and smart dress suggest the upper-class origins of the rider.

vii Two sepoys marching. N.M.W.7

viii A fish (*Figure 25*). N.M.W.4

NOTE: Of uncertain species but possibly a snake-head, a member of the family of Ophicephalidae. Of snakeheads, in general, Francis Day (*Fishes of India* (1878), 362–3) states: 'They are rather voracious, but appear to consider a frog, mouse or rat as luscious a morsel as fellow fish. They assist in keeping water pure by destroying either animal or vegetable substances which may come in their way. They prefer dirty to clean water, perhaps for purposes of conceal-ment. As soon as clean water is given them, they become excited as if they imagined the time has arrived when they should change their abode. All these fish are useful as food, those which inhabit rivers being better flavoured than the others which live in sluggish or stagnant water. Some classes, however, object to them on account of the resemblance their heads bear to those of serpents.' G. Sterba (*Fresh-water Fishes of the World*, 1962) states that they can exist in very dirty water or even wriggle overland during droughts; also that they are typical predators which can prey on fishes as long as them-selves.

ix A water-snake swallowing a fish (*Figure 24*). N.M.W.5

NOTE: Like (viii), an illustration of a proverb, perhaps of the kind exemplified by sayings attributed to the Bengali Vaishnava poet, Chandidas (*fl.* 1420). Of Chandidas's cult of *sahaja* (controlled passion), Coomaraswamy writes: 'The lovers must refuse each other nothing, yet never fall. Inwardly, the woman will sacrifice all for love, but outwardly she will appear indifferent. This secret love must find expression in secret; but she must not yield to desire. Of the man, Chandidas says, he must be able to make a frog dance in the mouth of a snake, or to bind an elephant with a spider's web. In this restraint, or rather, in the temper that makes it possible, lies his salvation.' (A.K. Coomaraswamy, *The Dance of Shiva* (revised edition; New York, 1957, 127–8). In this view, the im-plied meaning of the picture would be of the order: 'It is harder to escape from debauchery once you have taken to it than it is for a fish to escape alive from the mouth of a snake.'

It is uncertain whether the exact colourings of the water-snake and fish are significant: the water-snake is bright yellow and brown with large black spots, the fish is pink and blue with brown fins. The water-snake is conceivably either *Enhydris enhydris*, quiet and timid by disposition, but a great feeder on fish, or *Natrix piscator*, an excellent swimmer, exceedingly vicious, an inhabitant of ponds rather than of rivers and a feeder on fish and frogs (Day, q.v.).

For a version of the picture in the Monier-Williams collection, Indian Institute, Bodleian Library, Oxford, see Archer (1953), figure 16.

x Nabin is told by friends of Elokeshi's adultery (*Figure 33*). N.M.W.8
 Inscribed: *Young Baboos or merchants.*
 NOTE: Illustration of the episode in the Tarakeshwar murder case of 1873 when
 Nabin Chandra Banerjee, a young clerk employed in the office of the Super-
 intendent of Government Printing, Calcutta, returned to his village home at
 Kurnool, Hooghly district, and learnt from friends that his wife, Elokeshi, had
 been involved in an intrigue with the Mahant of the Shiva temple at Tara-
 keshwar, some distance away. See Introduction, p.13.

 In the picture, Nabin, arriving in the village, is greeted by two friends who
 acquaint him with the scandal. As in other illustrations of the crime, he reveals
 his identity through two westernized attributes—a European hold-all or 'grip'
 in which he has brought his week-end necessities, and an umbrella for warding
 off the extreme heat which is usual in Bengal in the month of May.

14 I.M.2–1917; sub-number 86. An illustration of an episode from the Tara-
 keshwar murder case of 1873.
 Elokeshi meets the Mahant at the Tarakeshwar shrine (*Figure 27*).

 Water-colour with silver outlines and details.
 Size 16 × 11 ins.
 Kalighat, *c.*1875.
 From the J. Lockwood Kipling collection, given by Rudyard Kipling, 1917.
 Published: Archer (1953), figure 18.
 NOTE: The Mahant (high priest) of the Shiva temple, Tarakeshwar, is shown
 seated on a striped rug in front of the temple, a second man, perhaps his agent,
 Kinaram, sitting behind him. Before him stand three women—Elokeshi, the
 young wife of the clerk Nabin Chandra Banerjee, veiling her face with her
 right hand and holding up a plate of rice or sweetmeats with her left, her
 younger sister, Muktakeshi, standing with veiled face behind her, and finally,
 to the right, Telebo, the female servant in the family, who acted as procuress,
 looking boldly at the waiting Mahant. In style similar to series 15. For further
 details, see Introduction, pp.12–13

15,i–iii I.S.12 and 13–1954; I.S.240–1962. A series of three pictures illustrating:
 (a) two scenes from current Calcutta life (i,ii)
 (b) an episode from the Tarakeshwar murder case of 1873 (iii).

 Water-colour with silver outlines and details.
 Average size: 17 × 10½ ins.
 Kalighat, *c.*1875.
 Nos. (i) and (ii) from the Gayer-Anderson collection, given by Colonel T.G.
 Gayer-Anderson and his twin brother Major R.G.Gayer-Anderson Pasha, 1954;
 (iii) from the same series, acquired from Howard Hodgkin, London, 1961.

NOTE: Similar in style to series 12 and 13 with the same tubular forms, pronounced shading and bright yellow flesh tones. Not earlier than 1873 on account of (iii) but probably contemporary with the scandal, i.e., c.1875.

i Courtesan with barber. I.S.12–1954
Mis-inscribed in English: *Native Dr. attending sick Bibi or woman.*
NOTE: The courtesan is seated on a chair, holding a hookah, while the barber pierces her ear before inserting an ear-ring. His general attire is much more ordinary than the fashionable get-up of her richer clients, thus suggesting a more menial profession. Three further barbed pins are stuck in his turban.

ii Courtesan and client. I.S.13–1954
Inscribed: *Nautch Girl from Chuman Gully eating Pan Suparra and sircar waiting until she has done.*
NOTE: The courtesan, seated, as in (i), on a Western-type chair, is shown eating *pān* (betel-leaf), a further supply of it, on two trays, being visible through a doorway. A young rake, also eating *pān*, stands in front of her, wearing smart town shoes. Bright yellow flesh tones.

iii After the murder (*Figure 37*). I.S.240–1961
NOTE: Nabin, a fish-knife hanging limply at his side, supports the body of his wife Elokeshi, whose head he has almost severed. See Introduction, p.14.

16 An episode from the Tarakeshwar murder case. I.S.25–1952
The fatal blow (*Figure 35*).

Line drawing with plain background.
Size: $17\frac{3}{4} \times 10\frac{3}{4}$ ins.
By Nibaran Chandra Ghosh, Kalighat, c.1875.
Given by W.G Archer, 1952. Obtained from Mukul Dey of Calcutta, who had acquired it in Kalighat in about 1920 from the artist, Nibaran Chandra Ghosh (c.1835–1930).
Published: Archer (1953), figure 35.
NOTE: In style, notable for its abandonment of colour, recourse to black line drawing, stark simplification, bold and fluent rhythm and air of passionless drama. It is significant that as in 13,x, Nabin's attributes—the westernized hand-bag or 'hold-all' and an umbrella for keeping off the sun—are again included, the hand-bag lying on the ground at his feet, the umbrella loosely dangling from his left hand.

17,i–xiii I.S.103 to 113–1965. A series of thirteen pictures illustrating:
(a) four mythological or religious subjects (i–iv)
(b) two scenes from current Calcutta life (v–vi)

(c) two proverbs (vii–viii)

(d) five episodes from the Tarakeshwar murder case (ix–xiii)

Water-colour with silver outlines and details.

Average size: 18 × 11 ins.

Kalighat, *c*.1880.

Acquired from Mrs Kitty Gregory, New York, 1965.

NOTE: Broadly similar in style to series 15, though, in certain cases, slightly rougher in execution. Characterized by brusque and summary treatment, especially of details such as trees, household furniture, utensils. Has, none the less, a vigorous vitality, seen particularly in the free use of bold curves, broad shading and bright yellow flesh tones. Datable on grounds of style and the inclusion of episodes from the 1873 murder case to *c*.1880.

i	Shiva slaying Kama with a glance.	I.S.103–1965
ii	Radha, in male dress, standing with Krishna and embracing him.	I.S.103a–1965

Inscribed: *Krishna and Radha in male dress.*

NOTE: On the reverse of I.S.103–1965.

| iii | Rama slaying the ogress Surpanakha. | I.S.104–1965 |
| iv | Rama fighting Kusha and Lava with bow and arrows. | I.S.104a–1965 |

Inscribed: *War between Nob and Kush sons of Ram.*

NOTE: On the reverse of I.S.104–1965.

| v | Courtesan and client. | I.S.105–1965 |

NOTE: A version of 15,ii, showing a courtesan seated on a chair, chewing *pān*, with two trays of it beside her, and a doorway with draped curtains beyond. In this case, however, the client does not himself eat *pān* but appears to be tapping at the entrance for admission.

| vi | The fish seller. | I.S.106–1965 |

NOTE: A version of 1,xxviii, and like that picture, perhaps an illustration of a folk-tale.

| vii | Two fish (*Figure 42*). | I.S.107–1965 |

NOTE: The fish on the left-hand side is pale green with a crimson belly and a single under-fin; the fish on the right-hand side is grey with dark bands and two fins, one of them an under-fin, the other a dorsal. The first, though lacking barbels, is possibly a cat-fish, the second is a snake-head (see 13,viii). Both live in stagnant water. Like other Kalighat pictures portraying fishes, this is based, in treatment and composition, on natural history drawings of fishes made for British patrons by Indian artists in Calcutta, though it is clearly intended to illustrate a proverb.

| viii | A fishing-eagle rending a fish. | I.S.108–1965 |

NOTE: A brown fishing-eagle perched on a grey fish with brown fins—perhaps a snakehead (see 13,viii)—pecks at its head. An illustration of the proverb: 'Take care of your fish or a fishing eagle will get it.'

For a version of the subject in identical style, see Archer (1953), figure 23, from the Monier-Williams collection, Indian Institute, Bodleian Library, Oxford.

ix The Mahant of Tarakeshwar rides out on an elephant (*Figure 26*). I.S.109–1965
Inscribed: *Mohonto. Commencement of the tale.*
NOTE: Illustrations of fifteen episodes from the Tarakeshwar scandal have so far come to light (see List of Episodes, pp.24–26 and *Figures 22–41*). The present picture as suggested by the inscription, may well be the first of the series since, by giving an idea of the Mahant's power and affluence, it sets the stage for the ensuing drama.

x The Mahant fans Elokeshi. (*Figure 29*). I.S.110–1965
NOTE: Elokeshi, the young wife of the clerk, Nabin Chandra Banerjee, is shown seated in a chair, while the Mahant, dressed only in a *dhotī*, stands beside her, fanning her with a punkah. The heat is perhaps suggestive of mounting tension. Following her first visit to the Tarakeshwar shrine, Elokeshi was prevailed upon to become the Mahant's mistress—the present picture hinting at the slavish subservience to which she appears to have reduced him. For female ascendancy, and the theme of woman as master, see Introduction, pp.11–12.

xi The Mahant plies the reluctant Elokeshi with liquor (*Figure 30*). I.S.111–1965
Inscribed: *Mohonto and Alokashi (a tale) contd.*
NOTE: Elokeshi, seated, as in (x), in a chair, averts her veiled face from the Mahant who approaches her with a glass of liquor. For a Calcutta 'man-about-town' carousing, glass in hand, with a courtesan, see 18,i.

xii The Mahant arrives in jail (*Figure 39*). I.S.112–1965
Inscribed: *Mohonto tale contd.*
NOTE: The Mahant, dressed only in a *dhotī* and shawl and roped to a jailer, stands before a British or Anglo-Indian Jail Superintendent who sits in a black chair, holding the Mahant's warrant of commitment. The purplish-pink colour of the Superintendent's face, his hair-style and dress connote British or Anglo-Indian nationality. For the conviction of the Mahant on the criminal charge of adultery following Nabin's conviction for murder, see Introduction, p.14. Under Indian law, adultery is both a criminal and a civil offence.

xiii The Mahant works as a prison gardener (*Figure 40*). I.S.113–1965
Inscribed: *Mohonto (a tale) contd.*
NOTE: Following his conviction and sentence to two years' rigorous imprisonment (hard labour), the Mahant was given various menial tasks, including working an oil-press (31,xxxiii). Here he is shown working as prison gardener. He holds a large black watering-can and waters a pot-plant with a large flower, appropriately coloured red. (For red roses as marks of the courtesan, and by implication, illicit passion, see 37,i and iii.) Above the Mahant towers a prison warder, more than twice his height, wearing a black top-hat with silver stripes, black coat with cut-a-ways, black shoes, grey trousers and

holding a long black staff. As in (xii), his complexion and hair-style suggest British or Anglo-Indian nationality.

18,i–iii I.S.23, 24 and 26–1952. A series of three pictures illustrating:

(a) two scenes from current Calcutta life (i,ii)
(b) an episode from the Tarakeshwar murder case (iii).

Line-drawings in black with plain backgrounds.
Average size: $17\frac{3}{4} \times 10\frac{3}{4}$ ins.
By Nibaran Chandra Ghosh, Kalighat, c.1880.
Given by W.G Archer, 1952. The drawings were obtained in Calcutta in 1932 from Mukul Dey of Calcutta, who had purchased them at Kalighat in about 1920 from the artist, Nibaran Chandra Ghosh (c.1835–1930).
NOTE: The series, which is possibly five years later than series 16, illustrates the increasing use of black brush strokes and a recourse to summary outline. It is significant that in (ii) the male figure is shown with an 'Albert' hair-style, so called from its supposed connection with the Prince Consort (Rasul (1967), 13) in marked contrast to the much simpler hair-style of earlier fashion. The 'Albert' cut was fashionable in Calcutta in the years 1880–1920. As in series 17, the inclusion of episodes from the Tarakeshwar murder case precludes a date earlier than 1873.

i Courtesan and client carousing. I.S.23–1952
Published: Archer (1952), figure 1.
NOTE: A smartly-dressed 'gallant' sits beside a courtesan, holding a glass of spirits in his hand. For the same type of glass—a product of Western competition in Calcutta and hence regarded by painters and pilgrims as an evident sign of depravity—see 17,xi.

ii Lovers embracing. I.S.26–1952
iii Elokeshi protests her innocence; Nabin forgives and embraces her (*Figure 34*).
 I.S.24–1952
Published: Archer (1953), figure 36.
NOTE: Despite village opinion to the contrary, Nabin was loath to believe that his wife Elokeshi had been guilty of misconduct with the Mahant. Following her protests of innocence, he therefore forgave her and readily accepted her explanations. The pair are here shown standing together, Elokeshi with her arms around her husband's neck and Nabin, with 'Albert' hair-style, embracing her. For a version of the same subject in identical style, though perhaps by Nibaran Chandra Ghosh's brother, Kali Charan Ghosh, see Archer (1962), plate 17.

19,i,ii I.S.27 and 28–1952. A series of two pictures illustrating religious subjects.

Line drawings in black with plain backgrounds.

Sizes: (i) $19\frac{3}{4} \times 12\frac{3}{4}$ ins (ii) $17\frac{1}{2} \times 11$ ins.
By Kali Charan Ghosh, Kalighat, *c.*1880.
Given by W.G Archer, 1952. These drawings were obtained from Mukul Dey of Calcutta who had acquired them in Kalighat in about 1920 from the artist Kali Charan Ghosh (1844–1930), brother of Nibaran Chandra Ghosh.
NOTE: Like series 18, both drawings employ vigorous black outlines. The elimination of colour and of intricate detail may be due to increasing public demands and the need for quick mass production.

i	Shiva as musician.	I.S.27–1952
ii	Saraswati.	I.S.28–1952

20,i–iv I.S.256 to 259–1953. A series of four pictures illustrating:

(a) two religious subjects (i,ii)
(b) two scenes from current Calcutta life (iii,iv).

Water-colour with silver and pencil outlines.
Average size: $17 \times 10\frac{1}{2}$ ins.
Kalighat, *c.*1880.
Given by Colonel T.G. Gayer-Anderson and his twin brother, Major R.G. Gayer-Anderson Pasha, 1953.
NOTE: A series characterized by bold simplifications, thick black oval margins (iii,iv) and bright yellow flesh tones.

i	Krishna mollifying Radha.	I.S.258–1953
	Inscribed: *Krishna and Radhika—'his wife'*.	
ii	Durga nursing Ganesha.	I.S.259–1953
	Inscribed: *Durga and her son Guinees*.	
iii	Oval portrait of a courtesan.	I.S.256–1953
	Inscribed: *Jumpa*.	
iv	Oval portrait of a Calcutta dandy (*Figure 43*).	I.S.257–1953
	Mis-inscribed: *Nautch Bibi*	

NOTE: With (iii), modelled on portrait miniatures on ivory, executed between 1780 and 1830 by British artists in India and by Indian artists working for the British. The 'blown-up' features have the florid magnificence characteristic of later Kalighat painting. The inscriptions on all four paintings seem to be by a European, perhaps writing to the painter's dictation; the effeminate appearance of the youth in (iv) possibly accounts for his mis-identification as a *nautch bibi* (dancing girl). 'Jumpa' is perhaps the name of a famous Calcutta courtesan.

21,i–iii I.S.3, 75 and 77–1949. A series of three pictures illustrating religious or mythological subjects.

Water-colour with silver outlines and details.
Average sizes: $17\frac{3}{4} \times 11$ ins.

Kalighat, *c*.1880.

Acquired from the Church Missionary Society, London, through Mrs E. Mary Milford, 1949.

NOTE: A series notable for large flat areas of red colour, scant detail and summary treatment, transitional in style to the massive simplifications of the 1890–1900 period.

i	Shiva as ascetic and musician.	I.S.3–1949
	Published: Archer (1953), figure 28.	
ii	Ravana and Sita in the beak of Jatayu (*Figure 44*).	I.S.75–1949
iii	Lakshmi lustrated by elephants.	I.S.77–1949

22,i–vi I.M.2–1917; sub-numbers 170, 186, 191 and 193 to 195. A series of six pictures illustrating religious subjects.

Water-colour with silver details.
Average size: 17 × 11 ins. Kalighat, *c*.1880.
From the J. Lockwood Kipling collection, given by Rudyard Kipling, 1917.
NOTE: Shading almost completely abandoned, colouring red, violet and yellow, tones harsh and strident.

i	Balbhadra, Subhadra and Jagannatha.	I.M.2(170)–1917
ii	Durga on her lion killing Mahishasura.	I.M.2(186)–1917
iii	Ganesha enthroned, with his rat.	I.M.2(191)–1917
	Inscribed: *Ganesh Luck*.	
iv	Kali.	I.M.2(193)–1917
	Inscribed: *Kali Destruction*.	
v	Brahma enthroned with his goose.	I.M.2(194)–1917
vi	Rama, Sita and Lakshmana, with Hanuman at their feet.	I.M.2(195)–1917

23,i–lxi I.S.634 to 694–1950. A series of sixty-one pictures illustrating:

(a) sixty religious or mythological subjects (i–lx)
(b) an historical subject (lxi).

Water-colour with silver outlines and details.
Average size: 18 × 11 ins.
Kalighat, *c*.1885.
Acquired from Miss M. Steele, 1950, the series being part of a collection inherited from her mother, a scholar in Sanskrit at Cambridge in 1894. When delivering the pictures, Miss Steele reported that her grand-mother had also lived in India for some time and that it was possible that the pictures were originally collected by her.
NOTE: In style, comparable to series 22 with yellow, violet and red predominating, and with minimal shading.

i	Kali (*Figure 46*).	I.S.658–1950
	Inscribed: *Kali*.	
ii	Kali dancing on Shiva	I.S.677–1950
iii	Durga.	I.S.679–1950
	Inscribed: *Durga*.	
iv	Durga holding Ganesha.	I.S.661–1950
	Inscribed: *Durga*.	
v	Durga with Ganesha on her lap.	I.S.664–1950
	Inscribed: *Durga with Ganesh*.	
vi	Durga as Jagaddhatri.	I.S.689–1950
vii	Durga on her lion killing Mahishasura	I.S.682–1950
	Inscribed: *Durga*.	
viii	Ganesha enthroned.	I.S.675–1950
ix	Narasimha.	I.S.681–1950
	Inscribed: *Incarnation of Vishnu Narasingha*.	
x	Vishnu as Matsya.	I.S.685–1950

Inscribed: *Vishnu in the incarnation of fish when he saved mankind at the Time of Deluge by towing the ark; God of Preservation*.

xi	Vamana towering above Bali.	I.S.693–1950

Inscribed: *King Bali and Vishnu*.

NOTE: Bali is shown with 'Albert' hair style. See series 18.

xii	Jasoda, carrying a pitcher, leading the baby Krishna by the hand.	I.S.638–1950

NOTE: Compare Archer (1953), figure 30.

xiii	Krishna stealing butter behind Jasoda's back.	I.S.637–1950
	Inscribed: *Jashoda and Krishna the latter stealing butter*	
xiv	Krishna being weighed by the sage Narada, Jasoda watching.	I.S.678–1950
	Inscribed: *Krisna being weighed by Narad and Jasoda*.	
xv	Jasoda with Krishna and Radha in her arms.	I.S.671–1950
	Inscribed: *Jasoda with Krishna and Radha in her arms*.	
xvi	Vasudeva fleeing with the infant Krishna (*Figure 48*).	I.S.672–1950
xvii	Krishna and Balarama standing beneath a tree, Balarama nursing a calf.	
		I.S.636–1950
xviii	Krishna and Balarama dancing.	I.S.644–1950
	Inscribed: *Krishna and Balram*.	
xix	Krishna playing the flute.	I.S.662–1950
	Inscribed: *Krishna*.	
xx	Krishna milking a cow.	I.S.684–1950
xxi	Radha enthroned as a raja with Krishna attending.	I.S.634–1950
	Inscribed: *Radhika in the shape of queen*.	
xxii	Krishna in a tree with the milkmaids' clothes.	I.S.639–1950
xxiii	Krishna ferrying Radha and a milkmaid over the Jumna.	I.S.690–1950
	Inscribed: *The Gopis crossing the Jamuna in a boat with Krishna at the back*.	

xxiv	Chaitanya as partial incarnation of Rama and Krishna.	I.S.691–1950
	Misinscribed: *Krishna and Radhika in one carnation.*	
xxv	Krishna killing Bakasura.	I.S.676–1950
	Inscribed: *Krishna.*	
xxvi	Krishna killing Kansa.	I.S.635–1950
	Inscribed: *Krisna killing Kanksa his uncle.*	
xxvii	Krishna quelling the snake Kaliya, two of Kaliya's wives imploring him for mercy.	I.S.640–1950
	Inscribed: *Krishna killing snakes and the female snakes praying for its relief.*	
xxviii	Balarama.	I.S.642–1950
	Inscribed: *Balaram brother of Krisna.*	
xxix	Balarama and his wife.	I.S.641–1950
	Inscribed: *Balaram and his Wife.*	
xxx	Nitai and Gaur.	I.S.643-1950
	Inscribed: *Nitai and Gaur worshipers of Krisna.*	
xxxi	Bala Krishna enthroned.	I.S.694–1950
xxxii	Balbhadra, Subhadra and Jagannatha.	I.S.687–1950
	Inscribed: *Jagan-nath, Balaram and Savadhra.*	
xxxiii	Balarama and Krishna seated on the shoulders of Garuda.	I.S.665–1950
	Inscribed: *Garur (the king of birds) taking Krisna and Balaram on his shoulders.*	
xxxiv	Shiva Panchanana.	I.S.648–1950
	Inscribed: *Mohadeva.*	
xxxv	Shiva as a musician.	I.S.674–1950
	Inscribed: *Siva God of Destruction 1 of Hindu Trinity.*	
xxxvi	Hari-Hara.	I.S.651–1950
xxxvii	Shiva on the bull Nandi.	I.S.645–1950
xxxviii	Shiva, Parvati and the bull Nandi.	I.S.650–1950
xxxix	Parvati decking Shiva with a necklace.	I.S.646–1950
	Inscribed: *Mahadev and Parvati.*	
xl	Annapurna seated, Shiva standing.	I.S.663–1950
	Inscribed: *Anna-purna and Mahadev.*	
xli	Shiva carrying the dead Sati on his shoulder.	I.S.667–1950
xlii	Shiva destroying Kama.	I.S.649–1950
	Inscribed: *Mohadeva.*	
xliii	Shiva bearing the infant Ganesha on his shoulders.	I.S.647–1950
	Inscribed: *Mahadeva and Ganesh.*	
xliv	Mahabir carrying Rama and Lakshmana.	I.S.656–1950
	Inscribed: *Hanuman King of the Monkeys carrying Rama Lakshmi on his shoulders.*	
xlv	Rama, Lakshmana and Sita, with Hanuman at their feet.	I.S.657–1950
	Inscribed: *Ram Lakshman and Sita with Hanuman.*	
xlvi	Hanuman bowing before Sita.	I.S.692–1950
	Inscribed: *Hanuman the monkey holding the feet of Sita.*	

| xlvii | Kusha and Lava, with the horse intended for the Asvamedha sacrifice, fighting Rama and Hanuman, who were sent to retrieve it. | I.S.686–1950 |

xlvii Kusha and Lava, with the horse intended for the Asvamedha sacrifice, fighting Rama and Hanuman, who were sent to retrieve it. I.S.686–1950
 Inscribed: (first letter illegible) *eghnath fighting with Rama.*

xlviii Kusha and Lava carrying Hanuman bound. I.S.669–1950

xlix Jatayu attacking Ravana as he abducts Sita. I.S.660–1950
 Inscribed: *Jatayu attacking Ravan.*

l Lakshmi with her owl. I.S.654–1950
 Inscribed: *Lakshmi goddes of wealth.*

li Lakshmi lustrated by two elephants. I.S.652–1950
 Inscribed: *Lakshmi* but the words *The Goddess Ganga* have been crossed out first.

lii Lakshmi and Saraswati. I.S.653–1950
 Inscribed: *Lakshmi and Saraswati.*

liii Balarama. I.S.659–1950
 Mis-inscribed: *(Yama) the God of Death.*

liv Savitri begging Yama to restore her husband, Satyavan. I.S.688–1950
 Inscribed: *Satyaban, Savitri and Yama.*
 Published: Archer (1953), figure 26; also reproduced Ions (1967), p. 77.

lv Brahma seated on a throne and goose. I.S.670–1950
 Inscribed: *He has 4 heads though originally five, Bramha God of Creation of Hindoo Trinity.*

lvi Karttikeya riding on the peacock Paravani. I.S.680–1950
 Inscribed: *Kartika son of Durga.*

lvii A winged *apsaras* dancing with a snake (*Figure 47*). I.S.683–1950

lviii A winged bull, with human face, bearing a house on its back. I.S.673–1950
 NOTE: Illustration of a *tazia*, representing Burak (the steed on which the prophet Muhammad ascended to heaven) taken out in procession at the Muharram festival.

lix Rama worshipping Durga. I.S.666–1950

lx Nala and Damayanti in the forest. I.S.668–1950
 Inscribed: *Raja Nal and Damayanti his wife.*
 Published: Archer (1953), figure 27.

lxi The Mutiny heroine, Rani Lakshmi Bai of Jhansi. I.S.655–1950
 Inscribed: *Lakshmi Bhai Queen of Ghansi.*
 NOTE: Rani Lakshmi Bai of Jhansi was principal widow of Raja Gangadhar Rao whose state had been annexed by the British under Lord Dalhousie by the doctrine of lapse. On 10 June 1857, following a massacre of Europeans by local Indian troops, she was proclaimed ruler by the State people. In alliance with Tantia Topi, general of Nana Sahib of Cawnpore, she then fiercely resisted the British, being killed at Gwalior in June 1858, wearing male attire and fighting bravely. As a Mutiny heroine, she achieved legendary significance and thus became almost a popular goddess.

24,i–iii I.S.2, 4 and 76–1949. A series of three pictures illustrating religious subjects.

Water-colour with silver details.
Average size: 18 × 11 ins.
Kalighat, *c*.1885.
Acquired from the Church Missionary Society, London, through Mrs E. Mary Milford, 1949.
NOTE: Similar in style to series 22.

i	Rama, Sita, Hanuman and Lakshmana.	I.S.2–1949
ii	Radha and Krishna dancing.	I.S.4–1949
iii	Ganesha with his rat (*Figure 49*).	I.S.76–1949

Inscribed on cardboard mount: *Ganesa the God of Wisdom.*

25,i–lxxv I.S.534 to 608–1950. A series of seventy-five pictures illustrating religious or mythological subjects.

Water-colour on brown paper, with bluish-green wash backgrounds, black borders and white outlines.
Average size: 20 × 13 ins.
Kalighat, *c*.1885.
Acquired from Miss M. Steele—the series being a further part of the collection inherited from her mother (see series 23).
NOTE: Characterized by garish metallic colouring and by the use of dead white in place of silver; each picture, comparable in other idioms to series 31, is inscribed on the face in Bengali characters.

i	Krishna disguised as a stranger in woman's dress playing a violin to Radha (*Figure 52*).	I.S.534–1950
	Inscribed: *bideshini* (female stranger).	
ii	Radha enthroned as a Raja; Krishna acting as her body-guard.	I.S.535–1950
	Inscribed: *rāi rājā* (Radha as raja).	
iii	Krishna mollifying Radha.	I.S.536–1950
	Inscribed: *rādhā raman* (Radha's lover).	
iv	Krishna milking a cow.	I.S.537–1950
	Inscribed; *gābhidohan* (milking the cow).	
v	Krishna as Kali worshipped by Radha.	I.S.538–1950
	Inscribed: *krishna kālī*.	
vi	Krishna quelling Kaliya.	I.S.539–1950
	Inscribed: *kāliyadaman*.	
vii	Balarama.	I.S.540–1950
	Inscribed: *balarāma*.	
viii	Krishna killing Bakasura.	I.S.541–1950
	Inscribed: *vakāsura*.	

ix	Jasoda churning milk while Krishna pilfers butter.	I.S.542–1950
	Inscribed: *dadhi manthan* (churning curd).	
x	Vasudeva fleeing with the infant Krishna.	I.S.543–1950
	Inscribed: *vasudeva*.	
xi	Radha mollifying Krishna.	I.S.544–1950
	Inscribed: *krishner man* (Krishna's (feigned) crossness).	
xii	Krishna ferrying the milkmaids across the Jumna.	I.S.545–1950
	Inscribed: *dāna khanda* (a special service).	
xiii	The young Krishna eating rice as the sage Gargamuni imagines it.	I.S.546–1950
	Inscribed: *gargamunir paramānna* (Gargamuni's meal).	
xiv	Jasoda tying Krishna's head-dress.	I.S.547–1950
	Inscribed: *churā bāndhā* (tying the headdress).	
xv	Chaitanya as partial incarnation of Rama and Krishna.	I.S.548–1950
	Inscribed: *shara bhuja* (the six armed).	
xvi	Vishnu's quoit (*chakra*) pursuing Shiva to destroy the corpse of Sati, which he carries.	I.S.549–1950
	Inscribed: *satī anga* (the limbs of Sati).	
xvii	Rama attacked by his twin sons, Lava and Kusha.	I.S.550–1950
	Inscribed: *lava kusher yuddha* (the battle of Lava and Kusha).	
xviii	Durga permitting her premature worship by Rama.	I.S.551–1950
	Inscribed: *akāl bodhan* (untimely worship) i.e., out of the proper season—in spring rather than autumn.	
xix	Rama.	I.S.552–1950
	Inscribed: *rāma*.	
xx	Sita fetching water accompanied by her son, Lava.	I.S.553–1950
	Inscribed: *sītār jalānayan* (Sita fetching water).	
xxi	Ravana, disguised as a mendicant, preparing to kidnap Sita.	I.S.554–1950
	Inscribed: *yogī bhikshā* (yogi begging).	
xxii	Lava and Kusha carrying Hanuman bound (*Figure 50*).	I.S.555–1950
	Inscribed: *lava kusha*.	
xxiii	Indra riding on his elephant.	I.S.556–1950
	Inscribed: *indra*.	
xxiv	Ganga.	I.S.557–1950
	Inscribed: *ganga*.	
xxv	Surya, the sun god, seated in his city, Vivaswati.	I.S.558–1950
	Inscribed: *surya*.	
xxvi	Durga	I.S.559–1950
	Inscribed: *dashabhujā devī* (the ten-armed goddess).	
xxvii	Vamana sending Bali to rule over Patala, the infernal regions.	I.S.560–1950
	Inscribed: *valir pātāl* (Vali and the nether world).	
xxviii	Parvati with Ganesha on her lap.	I.S.561–1950
	Inscribed: *ganeshajananī* (Ganesha's mother).	

xxix	Rama and Sita on a couch, Hanuman attending, with Satyabhama, Krishna's second consort, on the ground beneath.	I.S.562–1950
	Inscribed: *satyabhāmār darpachurna* (the snubbing of Satyabhama).	
xxx	Parasurama dispatching a Kshatriya king.	I.S.563–1950
	Inscribed: *parasurāma*.	
xxxi	Arjuna shooting at the eye of a fish to obtain Draupadi in marriage.	I.S.564–1950
	Inscribed: *draupadīr svayambar* (the wedding tournament for Draupadi).	
xxxii	Ravana, disguised as a mendicant, begging alms from Sita.	I.S.565–1950
	Inscribed: *sītā yogī*.	
xxxiii	Pavana, the wind god.	I.S.566–1950
	Inscribed: *pavana*.	
xxxiv	Vishnu sleeping on the serpent Ananta (*Figure 51*).	I.S.567–1950
	Inscribed: *ananta* (serpent of eternity).	
xxxv	Balarama and his wife, Revati.	I.S.568–1950
	Inscribed: *revati balarāma*.	
xxxvi	Visvakarma on a black elephant.	I.S.569–1950
	Inscribed: *visvakarmā*.	
xxxvii	Kalki mounted on the white horse.	I.S.570–1950
	Inscribed: *kalkī avatāra*.	
xxxviii	Lakshmana killing Ravana's son, Indrajit.	I.S.571–1950
	Inscribed: *indrajit*.	
xxxix	Dhumavati, a form of Durga, on her chariot.	I.S.572–1950
	Inscribed: *dhumāvatī*.	
xl	Haragauri (Shiva and Parvati joined).	I.S.573–1950
	Inscribed: *haragaurī*.	
xli	Shashthi, goddess of children, standing on a cat (*Figure 53*).	I.S.574–1950
	Inscribed: *shashthī*.	
xlii	Balbhadra, Subhadra and Jagannatha.	I.S.575–1950
	Inscribed: *jagannātha*.	
xliii	Bindubasini, a form of Devi.	I.S.576–1950
	Inscribed: *bindubāsinī*.	
xliv	Parvati taking her son, Ganesha, to her father's house.	I.S.577–1950
	Inscribed: *āgamanī*.	
xlv	Kali.	I.S.578–1950
	Inscribed: *kālīghāter kālī* (the Kali of Kalighat).	
xlvi	Chandi standing on a crow.	I.S.579-1950
	Inscribed: *chandī*.	
xlvii	Rajarajesvari, a form of Devi, displaying her mastery over Shiva.	I.S.580–1950
	Inscribed: *rājarājeshvarī*.	
xlviii	Chandra, the moon god.	I.S.581–1950
	Inscribed: *chandra*.	

xlix	Kurma, the tortoise incarnation of Vishnu.	I.S.582–1950
	Inscribed: *kurma avatāra*.	
l	Bhima killing Kichaka, brother-in-law of the king of Virata, who had made love to Draupadi.	I.S.583–1950
	Inscribed: *kīchakabadha*.	
li	Bhima killing Jarasandha, king of Magadha.	I.S.584-1950
	Inscribed: *jarāsandhabadha* (the destruction of Jarasandha).	
lii	Bhima and Duryodhana fighting with clubs.	I.S.585–1950
	Inscribed: *duryodhanabadha* (the destruction of Duryodhana).	
liii	Gaur and Nitai.	I.S.586–1950
	Inscribed: *gaurnitāī*.	
liv	Saraswati as her consort, Brahma.	I.S.587–1950
	Inscribed: *brahmānī*.	
lv	Uma leaving the house of her father, Himavat.	I.S.588–1950
	Inscribed: *vijayā* (the victorious).	
lvi	The temple of Taraknath at Tarakeshwar; a priest sitting outside the temple smoking a *nārgila* pipe.	I.S.589–1950
	Inscribed: *taraknāth*.	
lvii	Bhairavi (Shiva's consort, in one of her terrifying forms) standing on a prostrate man.	I.S.590–1950
	Inscribed: *bhairavī*.	
lviii	The wife of Yama, god of death, seated on a crow.	I.S.591–1950
	Inscribed: *yamapatnī* (wife of Yama).	
lix	Matsya, the fish incarnation of Vishnu.	I.S.592–1950
	Inscribed: *matsya avatāra*.	
lx	Mahabir carrying Rama and Lakshmana on his shoulders.	I.S.593–1950
	Inscribed: *mahāvīro* (great hero).	
lxi	The primeval world resting on a tortoise.	I.S.594–1950
	Inscribed: *brahmānda* (the primeval egg).	
lxii	The churning of the ocean.	I.S.595–1950
	Inscribed: *samudra manthana* (churning of the ocean).	
lxiii	Shorashi (a form of Devi).	I.S.596–1950
	Inscribed: *shorashī*.	
lxiv	Vishnu with Garuda.	I.S.597–1950
	Inscribed: *vishnu*.	
lxv	Durga on her lion killing Mahishasura.	I.S.598–1950
	Inscribed: *durgā*.	
lxvi	Krishna as Kali standing on Shiva.	I.S.599–1950
	Inscribed: *kālī*.	
lxvii	Brahma seated on his vehicle, the goose.	I.S.600–1950
	Inscribed: *brahmā*.	

lxviii	Annapurna feeding her consort, Shiva.	I.S.601–1950
	Inscribed: *annapurnā*.	
lxix	Ganesha, with his vehicle, the rat.	I.S.602–1950
	Inscribed: *ganesha*.	
lxx	Vamana, the dwarf incarnation of Vishnu.	I.S.603–1950
	Inscribed: *vāmana*.	
	Published: Hogben (1955), cover plate.	
lxxi	Shiva as ascetic and musician.	I.S.604–1950
	Inscribed: *mahādeva*.	
lxxii	The sage Narada.	I.S.605–1950
	Inscribed: *nārada*.	
lxxiii	Bagala (Devi in a terrifying form) slaying a victim.	I.S.606–1950
	Inscribed: *bagalā*.	
lxxiv	Sitala, goddess of small-pox.	I.S.607–1950
	Inscribed: *shītalā*.	
lxxv	Dura as Jagaddhatri	I.S.608–1950
	Inscribed: *jagaddhātrī* (sustainer of the world).	

Period IV: 1885–1930

26,i–xxi I.S.261 to 281–1955. A series of twenty-one pictures illustrating:

(a) nineteen religious or mythological subjects (i–xix)
(b) a scene from current Calcutta life (xx)
(c) a proverb or satire (xxi).

Water-colour with silver details.
Average size: 18 × 11 ins.
Kalighat, *c*.1890.
Given by M. Varvill, 1955.
NOTE: Midway in style between series 20 to 24 and 31 and 36, the courtesan in (xx) having broad black borders to her *sari* reminiscent of the black surrounds in series 20. At the same time, her opulent form, her pinkish-brown flesh tones and pale blue *sārī* with prominent folds anticipate the bold and curvaceous style of series 36.

i	Kali in a shrine.	I.S.272–1955
	Inscribed: *Kallee in another shape*.	
ii	Shiva as Mahayogi with trident and horn.	I.S.263–1955
	Inscribed: *Mohadeva of another shape*.	

iii	Shiva as the great musician.	I.S.264–1955
	Inscribed: *Mohadeva.*	
iv	Shiva with the dead Sati.	I.S.265–1955
	Inscribed: *Suttee's dead body on Mohadeva's shoulder.*	
v	Annapurna giving food to Shiva	I.S.266–1955
	Inscribed: *Arna Poorna.*	
vi	Shiva and Parvati seated on a throne with Nandi below.	I.S.267–1955
	Inscribed: *Hurro Gouree.*	
vii	Parvati standing before Shiva with a garland in her hands.	I.S.268–1955
	Inscribed: *Matrimonial Ceremony of Mohadeva with Bhujubuttee.*	
viii	Ganesha seated on a throne with the rat below.	I.S.269–1955
	Inscribed: *Gonesh.*	
ix	Durga with the infant Ganesha in her arms.	I.S.270–1955
x	Rama worshipping Durga.	I.S.271–1955
	Inscribed: *Rama Worshipping Goddess Doorga.*	
xi	Mahabir carrying Rama and Lakshmana on his shoulders.	I.S.273–1955
	Inscribed: *Mohabir Rama and Luchmon on the shoulders.*	
xii	Krishna killing Kansa.	I.S.275–1955
	Inscribed: *Kunsa Badhu.*	
xiii	Krishna and Balarama standing beneath a tree, Balarama nursing a calf.	I.S.277–1955
	Mis-inscribed: *Kristo or Krishna Radhica.*	
xiv	Krishna mollifying Radha by caressing her feet.	I.S.278–1955
	Inscribed: *Hiley.*	
xv	Krishna and Balarama standing together.	I.S.279–1955
	Inscribed: *Krishna Bulloram.*	
xvi	Balarama with a horn.	I.S.280–1955
	Inscribed: *Bulloram.*	
xvii	Mohini distributing nectar between a God and a demon.	I.S.276–1955
	Inscribed: *Krishna's Moheenee Moortee when distributing Amrita to the Gods but the Rukhashas threatening not to give them but to the Rukhashas.*	
xviii	Vamana striding over the kneeling Bali.	I.S.274–1955
xix	Saraswati seated amidst lotuses playing the *sitār*.	I.S.281–1955
	Inscribed: *Surosutee or Goddess of Wisdom.*	
xx	A Bengali courtesan (*Figure 54*).	I.S.262–1955
	Inscribed: *Bengali woman Public.*	
xxi	Cat with a fish in its mouth (*Figure 55*).	I.S.261–1955
	Inscribed: *Cat caught a fish.*	

NOTE: Illustration of a proverb, described by Dey (1932) as 'Fair Game', but perhaps intended to be satirical of false ascetics and their hypocritical claims- Vaishnava mendicants were supposed to forswear fish, but were often notorious for eating it in private. Although the present picture shows a bright yellow

cat with large black markings, the vertical sandal-wood marks which are the badge of Vaishnavas are missing from the forehead. This would suggest that the present picture is a late and somewhat careless version in contrast to Archer (1953), figure 21 (from the Monier-Williams collection, Indian Institute, Bodleian Library, Oxford) where the cat has a fresh-water prawn in its mouth and Vaishnava *tilak* marks are plainly visible. As in 13,viii and 17,vii and viii, the fish is possibly a snake-head.

27,i–xliv I.S.1 to 44–1959. A series of forty-four pictures illustrating:

(a) thirty-seven episodes from the *Rāmāyana* (i–xxxvii)
(b) four episodes from the *Mahābhārata* (xxxviii–xli)
(c) three other religious subjects (xliii–xliv).

Water-colour on card with silver details.
Average size: $5\frac{3}{8} \times 3\frac{3}{8}$ ins.
Kalighat, *c*.1890.
Given by Robert Skelton, London, 1959.
NOTE: With series 28 to 30, part of a group of about one thousand pictures, originally owned by the Baldur Bookshop, Richmond Hill, and dispersed in 1959 to a group of friends from whom the Museum's examples were subsequently obtained.

Although a number of pictures, especially those which illustrate Calcutta life (series 28 and 29), are in the style of Kalighat pictures of the 1890–1900 decade, the group as a whole departs from standard practice in its midget scale ($5\frac{3}{8} \times 3\frac{3}{8}$ ins) and in being painted on card instead of paper. In this respect, it may have been influenced by British coloured post-cards. Examples of these were current in Calcutta and South India, where they had been imitated by the Indian oil-painter, Ravi Varma.

No other examples of small-scale Kalighat paintings have, so far, come to light; and it is possible that the entire group was especially prepared for either a British resident in Calcutta, interested in Bengali literature, culture and society and in Indian religion, iconography, mythology and astrology, or, conceivably, for a western-educated Bengali gentleman of similar tastes and interests. The presence on many pictures of identificatory inscriptions in Bengali suggests that the original owner must either have known Bengali himself or have been in a position to have the inscriptions translated or explained to him. The fact that the Baldur Bookshop acquired the group from an English family, resident near Worthing, supports the inference that it was probably prepared for an English scholar, educationalist or missionary and that it reached England on the owner's retirement. For Kalighat pictures collected by missionaries, scholars and educationalists, see series 1,5,8,21 to 25, 32 to 34 and 38, and the Monier-Williams collection, Indian Institute, Bodleian Library, Oxford. The South Coast of

England was a favourite place of retirement for British civilians. Fanny Parks, widow of a Company Collector in the Bengal Presidency, retired to St. Leonards-on-Sea in 1845 and J.C. French, a member of the Indian Civil Service in Bengal, settled in Worthing in 1931.

In contrast to other Kalighat pictures in the Museum's collection, series 27,28 and 30 illustrate in great detail scenes and characters from the *Rāmāyana* and the *Mahābhārata*, planets, constellations and lunar mansions, as well as many recondite aspects of the goddess Devi. For detailed descriptions and explanations of this subject matter, the student is referred to the following works: T.A. Gopinath Rao, *Elements of Hindu Iconography* (Madras, 1914–1920); A.L. Basham, *The Wonder that was India* (London, 1954); H.P.Shastri, *The Rāmāyana of Valmiki* (London, 1957); A. Daniélou, *Hindu Polytheism* (New York, 1964); B. Walker, *The Hindu World* (London, 1968).

i King Dasaratha with Sumantra. I.S.1–1959
Inscribed in Bengali: *dasharatha sumantra sārathī* (Dasaratha with the charioteer Sumantra).

ii Rama's stepmother, Kaikeyi, with Rama and Lakshmana in her arms.
 I.S.2–1959
Inscribed in Bengali: *kaikeyī*.

iii The churning of the ocean. I.S.3–1959
Inscribed in Bengali: *samudra manthana* (churning of the ocean).

iv Rama and Lakshmana release Ahalya from her husband's curse. I.S.4–1959
Inscribed in Bengali: *pāshānā uddhār ahalyā*.

v Parasurama, with king Janaka, challenges Rama to shoot with Vishnu's bow.
 I.S.5–1959
Inscribed in Bengali: *parushurām janak rishī*.

vi Rama accepts Parasurama's challenge. I.S.6–1959
Inscribed in Bengali: *parashurāmer darpa churna* (humiliating the proud Parasurama).

vii Rama, Sita and Lakshmana go into exile. I.S.7–1959
Inscribed in Bengali: *rāmer vanāgaman* (Rama's departure for the forest).

viii Vasishtha tries to persuade Rama to return to his kingdom. I.S.8–1959
Inscribed in Bengali: *vasishta rām*.

ix Rama, Sita and Lakshmana in the Panchavati forest. I.S.9–1959
Inscribed in Bengali: *panchavatī*,

x Lakshmana mutilates Surpanakha. I.S.10–1959
Inscribed in Bengali: *surpanakhār nāsikā chhedan* (cutting off Surpanakha's nose).

xi Surpanakha persuades her brother, Ravana, to avenge her by seducing Sita.
 I.S.11–1959
Inscribed in Bengali: *rāvan surpanakhā*.

xii Rama and Lakshmana with the dying Jatayu. I.S.12–1959
Inscribed in Bengali: *jatāyur prānatyāg* (the death of Jatayu).

| xiii | Hanuman takes Rama and Lakshmana to Sugriva. | I.S.13–1959 |

Inscribed in Bengali: *rāma lakshmana haran* (Rama and Lakshmana being taken away).

| xiv | Rama and Lakshmana meet Sugriva. | I.S.14–1959 |

Inscribed in Bengali: *sugrīva milan* (reunion with Sugriva).

| xv | The death of Bali. | I.S.15–1959 |

Inscribed in Bengali: *bāli badha* (the death of Bali).

| xvi | Hanuman watches over the captive Sita. | I.S.16–1959 |

Inscribed in Bengali: *ashoka ban* (Ashoka forest).

| xvii | Jambuvan gives counsel to Rama and Lakshmana. | I.S.17–1959 |

Inscribed in Bengali: *Jambuvāner mantranā* (Jambuvan's counsel).

| xviii | Sita hands Hanuman a jewel for Rama. | I.S.18–1959 |

Inscribed in Bengali: *sītār anguri dān* (Sita gives her ring).

| xix | Two female demons discover Hanuman in the forest. | I.S.19–1959 |

Inscribed in Bengali: *patanpuri*.

| xx | Hanuman, by a ruse, obtains Mandodari's weapon. | I.S.20–1959 |

Inscribed in Bengali: *mandādhrir nikat bān haran* (removing the weapon from Mandodari by means of a ruse).

NOTE: Mandodari was Ravana's favourite queen.

| xxi | Ugrachanda protects Hanuman. | I.S.21–1959 |

Inscribed in Bengali: *ugrachandā*.

| xxii | Hanuman a captive before Ravana. | I.S.22–1959 |

Inscribed in Bengali on reverse: *rāvan*.

| xxiii | Hanuman reveals Rama and Sita in his heart. | I.S.23–1959 |

| xxiv | Rama and Lakshmana worship the lingam at Cape Comorin. | I.S.24–1959 |

Inscribed in Bengali: *set(u) bandha rāmeshwar* (Rama's bridge).

| xxv | Rama and Lakshmana hold conference before the Straits of Comorin. | I.S.25–1959 |

Inscribed in Bengali: *samudra pār mantranā* (council on crossing the sea).

| xxvi | Rama slays Ravana's brother, Kumbhakarna. | I.S.26–1959 |

Inscribed in Bengali: *kumbhakarna badha* (the death of Kumbhakarna).

| xxvii | Rama kills Makaraksha. | I.S.27–1959 |

Inscribed in Bengali: *makarāksha badha* (destruction of Makaraksha).

| xxviii | Rama asks Sushena to heal the wounded Lakshmana. | I.S.28–1959 |

Inscribed in Bengali: *sushena vaidya lakshmana murchchhā* (Sushena the physician and Lakshmana in a swoon).

| xxix | Lakshmana wounded by Ravana's *shakti* weapon. | I.S.29–1959 |

Inscribed in Bengali: *lakshmaner shakti shel* (Lakshmana hit by the *shakti* weapon).

| xxx | Rama and Lakshmana slay Gavaksha. | I.S.30–1959 |

Inscribed in Bengali: *gavāksha rākhasa badha* (the slaying of the demon Gavaksha).

| xxxi | Rama and Lakshmana slay Gaya. | I.S.31–1959 |

Inscribed in Bengali: *gayā rākhasa badha* (the slaying of the demon Gaya).

xxxii	Rama and Lakshmana fight Viravahu.	I.S.32–1959
	Inscribed in Bengali: *vīravāhur juddha* (battle with Viravahu).	
xxxiii	Rama and Lakshmana slay Tarani Sen.	I.S.33–1959
	Inscribed in Bengali: *taranī sen badha* (the slaying of Tarani Sen).	
xxxiv	Rama and Sita enthroned; Lakshmana holding a royal umbrella; Hanuman prostrated before them.	I.S.34–1959
	Inscribed in Bengali: *rām rājā*.	
xxxv	Hanuman leaps up to catch the sun (thinking it to be a ripe red fruit).	I.S.35–1959
	Inscribed in Bengali: *hanumān surya* (Hanuman and the sun god).	
xxxvi	Hanuman's conflict with Indra.	I.S.36–1959
	Inscribed in Bengali: *indra hanumān*.	
xxxvii	Rama's meeting with his sons Lava and Kusha.	I.S.37–1959
	Inscribed in Bengali: *lava kusha parichaya* (the recognition of Lava and Kusha).	
xxxviii	Bhima serving king Virata as a cook.	I.S.38–1959
	Inscribed in Bengali: *bhīm*.	
xxxix	Arjuna's son Abhimanyu with his wife Uttara.	I.S.39–1959
	Inscribed in Bengali: *abhimanyu*.	
xl	Arjuna shooting arrows at Bhishma.	I.S.40–1959
	Inscribed in Bengali: *bhīshmā arjun*.	
xli	Drona (Bharadwaja) in combat with his son Aswatthaman.	I.S.41–1959
	Inscribed in Bengali: *aswathāmā bharadwāj*.	
xlii	Radha with Durga.	I.S.42–1959
	Inscribed in Bengali: *rādhā durgā*.	
xliii	Garuda worshipping the sage Saubhari.	I.S.43–1959
	Inscribed in Bengali: *saubharimunir garuda stav* (Garuda worshipping the sage Saubhari).	
xliv	Sankhachur and Tulsi.	I.S.44–1959
	Inscribed in Bengali: *sankhachur tulasī*.	

28,i–cxi I.S.82 to 192–1959. A series of one hundred and eleven pictures illustrating:

(a) nine scenes from current Calcutta life (i–ix)
(b) ninety-two mythological and religious subjects (x–cxi).

Water-colour on card, with silver details.
Average size: $5\frac{3}{8} \times 3\frac{3}{8}$ ins.
Kalighat, *c.*1890.
Acquired from Miss M. Saunders, Epsom, Surrey, 1959.
NOTE: See comment to series 27.

i	A man kneeling at the feet of his wife or mistress (*Figure 56*).	I.S.82–1959

| ii | A wife kneeling at her husband's feet (*Figure 57*). | I.S.83–1959 |
| iii | Bengali husband and wife (*Figure 58*). | I.S.84–1959 |

iv A man, Sudeva, conversing with a woman, Malati (*Figure 59*). I.S.85–1959
Inscribed in Bengali: *sudeva mālatī*.

v A courtesan reclining on a string-bed, being fanned by a man. I.S.86–1959
Inscribed in Bengali: *bilva mangal*.
NOTE: The term, *bilva mangal*, is applied to the poet Sur Das when, as a young man, he was given to frequenting courtesans. It is also the title of one of his more famous poems.

vi A courtesan and client, seated together, embracing. I.S.87–1959

vii A courtesan seated holding a rose in each hand. I.S.88–1959
Inscribed in Bengali on the reverse: *gulāb bibi* (the lady with a rose).

viii A courtesan seated holding a rose in each hand. I.S.89–1959
Inscribed in Bengali: *shulochanā* (the soft-eyed beauty).

ix A courtesan seated on a chair smoking a hookah. I.S.90–1959

x Lakshmana (?) listening to the conversation of two women. I.S.91–1959
Inscribed in Bengali: *muktāban* (pearl forest).

xi Indrajit, son of Ravana, approaching Sita in the Ashoka forest. I.S.92–1959
Inscribed in Bengali: *indra sītā*.

xii Bharata aiming an arrow at Hanuman, who flies through the air bearing a mountain on his head. I.S.93–1959
Inscribed in Bengali: *bharata*.

xiii A demon attempting to bend the bow of Shiva watched by two men.
I.S.94–1959
Inscribed in Bengali: *haradhanu rashi* (stringing the bow of Shiva).

xiv A combat between Tiyasena and Dhanuka. I.S.95–1959
Inscribed in Bengali: *tiyasen dhanuka*.

xv Prahlada, son of Hiranyakasipu, attacked by an elephant sent by his father, prays to Vishnu and is saved. I.S.96–1959
Inscribed in Bengali: *pralhāda*.

xvi The goddess Bagala, one of the ten manifestations of Devi, destroying a demon.
Inscribed in Bengali on the reverse: *bagalā*. I.S.97–1959

xvii Two men fighting with bows and arrows. I.S.98–1959
Inscribed in Bengali: *drupad sikhandī*.
NOTE: Sikhandin, son of Drupad, is alleged in one account to have shot the arrow which killed Bhishma.

xviii Indra in combat with Drona. I.S.99–1959
Inscribed in Bengali: *dronāchārya indra*.

xix Two warriors in combat. I.S.100–1959
Inscribed in Bengali: *bhurisravā kritavarmā*.
NOTE: Bhurisrava and Kritavarma both fought on the side of the Kauravas in the great war.

xx Duhshashana, younger brother of the Kaurava, Duryodhana, in combat with Bhagadatta, king of Kamrup and ally of the Pandavas. I.S.101–1959
Inscribed in Bengali: *duhshāsan bhaga datta.*

xxi Two men in combat with clubs. I.S.102–1959
Inscribed in Bengali: *ushnā jayadratha.*
NOTE: Ushna was a descendant of Kuru.
Jayadratha, an ally of the Kauravas, was also of the lunar race.

xxii Satyaki, a kinsman of Krishna, being killed in revenge for the death of Kritavarma. I.S.103–1959
Inscribed in Bengali: *satyaki badha* (the destruction of Satyaki).

xxiii Nala about to leave Damayanti asleep in the forest. I.S.104–1959
Inscribed in Bengali: *nala rājā.*

xxiv Rohini, the fourth or ninth lunar mansion, personified as the daughter of Rohan or Daksh, favourite wife of the moon, on a snake vehicle. I.S.105–1959
Inscribed in Bengali: *rohinī.*

xxv Adra, the sixth lunar mansion, personified as a woman holding a fly-whisk.
Inscribed in Bengali: *ādra.* I.S.106–1959

xxvi A woman holding a tray and a bunch of grass symbolizing either the month Paus, or the eighth lunar mansion, Pushya. I.S.107–1959
Inscribed in Bengali: *pushyā.*

xxvii A woman standing on a bull holding a thunder-bolt and lightning-shaft, representing Magha, the tenth lunar mansion. I.S.108–1959
Inscribed in Bengali: *māgha.*

xxviii A woman with four arms holding a cup, representing Purvaphalguni, the eleventh lunar mansion. I.S.109–1959
Inscribed in Bengali: *purva phālgunī.*

xxix A woman holding a cresset and bunch of grass, representing the twelfth lunar mansion, Uttaraphalguni. I.S.110–1959
Inscribed in Bengali: *uttara phālgunī.*

xxx A woman holding a pot containing live coals or charcoal, representing the thirteenth lunar mansion, Hasta. I.S.111–1959
Inscribed in Bengali: *hastā.*

xxxi A woman on a serpent holding unidentified symbols, representing the fifteenth lunar mansion, Svati (Arcturus). I.S.112–1959
Inscribed in Bengali: *svātī.*

xxxii A woman standing on a lotus flower, holding a bunch of grass and a brass pot, representing the seventeenth lunar mansion, Anuradha. I.S.113–1959
Inscribed in Bengali: *anurādhā.*

xxxiii A woman, four-armed, riding a crocodile, and representing the eighteenth lunar mansion, Jyeshtha. I.S.114–1959
Inscribed in Bengali: *jeshthā.*

xxxiv A woman riding a ram, holding a bunch of grass and a dish of flames, repre-

senting Purvasharha, the eighteenth or twentieth lunar mansion. I.S.115–1959
Inscribed in Bengali: *purvashārhā*.

xxxv A woman riding a bird, four-armed, with attributes including a noose, bunch of grass and goad, representing Dhanishtha, the twenty-third lunar mansion.
Inscribed in Bengali: *dhanishthā*. I.S.116–1959

xxxvi A woman seated on an owl holding a dish, representing Varuni, the twenty-fourth lunar mansion. I.S.117–1959
Inscribed in Bengali: *varunī*.

xxxvii A woman riding a hound and holding a quoit, representing Shatabhisha, the twenty-fifth lunar mansion. I.S.118–1959
Inscribed in Bengali: *shatabhishā*.

xxxviii A woman riding a bird-headed hound, holding a bunch of grass and a pot, representing Uttarabhadrapad, the twenty-sixth lunar mansion. I.S.119–1959
Inscribed in Bengali: *uttarabhādrapad*.

xxxix A woman standing on a black swan (?) holding a lightning shaft, representing Purvabhādrapad, the twenty-sixth lunar mansion. I.S.120–1959
Inscribed in Bengali: *purvabhādrapad*.

xl A woman holding a snake, representing the twenty-seventh (or fifth) lunar mansion, Revati. I.S.121–1959
Inscribed in Bengali: *revatī*.

xli A youth holding a pair of scales, representing Tularashi, the sign Libra of the Zodiac. I.S.112–1959
Inscribed in Bengali: *tulā rāshi*.

xlii A kneeling woman balancing a water pot on her head, representing Kumbharashi, the sign Aquarius. I.S.123–1959
Inscribed in Bengali: *kumbha rāshi*.

xliii A four-armed woman bearing a water vessel, tray and goad, probably representing the full moon, Purnavasi. I.S.124–1959
Inscribed in Bengali: *puna vāru*.

xliv A woman holding a sieve, representing Chaitra, the twelfth month, March–April. I.S.125–1959
Inscribed in Bengali: *chaitrā*.

xlv A woman standing pouring water from two pots, representing Sravan, the fourth month, July–August. I.S.126–1959
Inscribed in Bengali: *shrāvan*.

xlvi A woman standing holding a goad and fly-whisk. I.S.127–1959
Inscribed in Bengali: *āsnāsha*.

xlvii A goddess riding upon a ram. I.S.128–1959

xlviii Lakshmi lustrated by elephants. I.S.129–1959
Inscribed in Bengali: *gaja lakshmī (nakhī)*.

xlix Lakshmi seated in a lotus plant above her owl. I.S.130–1959

l Lakshmi seated in a lotus plant above her owl. I.S.131–1959

Inscribed in Bengali: *nakhī (lakshmī)*.

li Lakshmi standing on a lotus. I.S.132–1959

Inscribed in Bengali: *jagad nakhī (lakshmī)*.

lii Ganga riding on a marine monster preceded by a dwarf. I.S.133–1959

Inscribed in Bengali: *gangā*.

liii Saraswati standing on a lotus in a dance posture holding a wand. I.S.134–1959

Inscribed in Bengali on the reverse: *nitya saraswatī*.

liv Saraswati seated in a lotus plant holding a *sitār*. I.S.135–1959

lv Saraswati seated in a lotus plant playing the *sitār*. I.S.136–1959

Inscribed in Bengali: *saraswatī*.

lvi Kamala Kamini seated in a lotus plant nursing a baby elephant. I.S.137–1959

Inscribed in Bengali: *kamalā kāminī*.

Reverse: a pencil sketch of Sahadeva, youngest of the Pandavas, in combat with Sakuni, the uncle of the Kauravas.

Inscribed in Bengali: *sahadeva sakuni*.

lvii Kamala Kamini seated in a lotus plant nursing a baby elephant. I.S.138–1959

lviii Parvati enthroned with Ganesha in her arms. I.S.139–1959

Inscribed in Bengali: *ganesha jananī* (mother of Ganesha).

lix Parvati seated with Ganesha in her arms. I.S.140–1959

lx Shashthi seated with two boys and a cat. I.S.141–1959

Inscribed in Bengali: *shashthī* (Devi as the goddess of children and fertility).

lxi Devi seated on a blue lotus blessing a female votary. I.S.142–1959

Inscribed in Bengali: *abhayā* (fearless).

lxii Olai Chandi seated on a pink lotus holding a conch shell and a discus.

 I.S.143–1959

Inscribed in Bengali: *olāichandī* (Devi as the preventer and curer of cholera).

lxiii Manasa Devi seated on a blue lotus above a snake vehicle. I.S.144–1959

lxiv Devi as Sarva Mangala. I.S.145–1959

Inscribed in Bengali: *sarva mangalā* (always auspicious).

lxv The goddess Bhuvanesvari seated on a pink lotus. I.S.146–1959

Inscribed in Bengali: *bhuvanesvarī*.

lxvi Matangi Devi seated on a blue lotus. I.S.147–1959

Inscribed in Bengali: *mātangī*.

lxvii Durga slaying Mahishasura. I.S.148–1959

Inscribed in Bengali: *mahishāsura badha*.

lxviii Durga slaying Mahishasura. I.S.149–1959

lxix Durga slaying Mahishasura. I.S.150–1959

lxx Durga on horseback slaying the demon Sambara. I.S.151–1959

Inscribed in Bengali: *sambara asura durgā*.

lxxi Durga slaying the demon Nisumbha. I.S.152–1959

Inscribed in Bengali: *nisambhu badha*.

lxxii	The goddess Kshemankari, holding a sword and a severed head, seated on a pink lotus.	I.S.153–1959
	Inscribed in Bengali: *kshemānkarī*.	
lxxiii	Kali.	I.S.154–1959
lxxiv	Kali.	I.S.155–1959
	Inscribed in Bengali: *kālī*.	
lxxv	Kali.	I.S.156–1959
	Inscribed in Bengali: *kālī mātā thākurānī* (respected mother Kali).	
lxxvi	Durga as Jagaddhatri	I.S.157–1959
	Inscribed in Bengali: *jagāddhātrī* (sustainer of the world).	
lxxvii	Durga as Jagaddhatri.	I.S.158–1959
	Inscribed in Bengali: *jagāddhatrī*.	
lxxviii	Kali seated on a blue lotus above the prostrate Shiva.	I.S.159–1959
	Inscribed in Bengali: *shava shiva*.	
lxxix	Kali standing on the prostrate Shiva.	I.S.160–1959
	Inscribed in Bengali: *shiva kālī*.	
lxxx	Kali, as Tara, standing on the prostrate Shiva.	I.S.161–1959
	Inscribed in Bengali: *tārāmurtī*.	
lxxxi	Durga as Rajarajesvari seated on a blue lotus above the prostrate Shiva.	
		I.S.162–1959
	Inscribed in Bengali: *rājarājesvarī*.	
lxxxii	Durga as Annapurna giving food to Shiva, who comes to her as a mendicant.	
		I.S.163–1959
	Inscribed in Bengali: *anna purnā*.	
lxxxiii	Durga as Annapurna giving food to Shiva, who comes to her as a mendicant.	
		I.S.164–1959
	Inscribed in Bengali: *anna purnā*.	
lxxxiv	Durga as Annapurna giving food to Shiva, who comes to her as a mendicant.	
		I.S.165–1959
lxxxv	Devi engaged in argument with a woman while Shiva steals away with the infant Ganesha.	I.S.166–1959
	Inscribed in Bengali on the reverse: *vijayā* (the victorious).	
lxxxvi	Shiva seated with his consort.	I.S.167–1959
	Inscribed in Bengali: *shiva durgā*.	
lxxxvii	Shiva mourning over the dead Sati.	I.S.168–1959
	Inscribed in Bengali: *bhagavatīr prānatyāg* (the death of Bhagavati).	
lxxxviii	Shiva bearing the dead Sati on his trident.	I.S.169–1959
	Inscribed in Bengali: *satīr dehatyāg* (the burning of Sati?).	
lxxxix	Shiva bearing the dead Sati upon his shoulders.	I.S.170–1959
xc	Shiva blasting Kama (Madana) with fire from his third eye.	I.S.171–1959
	Inscribed in Bengali: *madana bhashna* (Madana reduced to ashes).	

xci	Rati, the wife of Kama, kneeling before Shiva.	I.S.172–1959
	Inscribed in Bengali: *ratī mahādeva*.	
xcii	Shiva with consort on a low throne above Nandi.	I.S.173–1959
	Inscribed in Bengali: *shiva durgā*.	
xciii	Shiva's consort applying kohl to Shiva's eyebrows.	I.S.174–1959
xciv	Shiva praising his consort.	I.S.175–1959
	Inscribed in Bengali: *durgā mahādevastav*.	
xcv	Shiva and his consort mounted on Nandi.	I.S.176–1959
	Inscribed in Bengali: *shiva durgā*.	
xcvi	Shiva taking leave of his consort.	I.S.177–1959
xcvii	Shiva reclining with his consort.	I.S.178–1959
xcviii	Shiva being lustrated by his consort.	I.S.179–1959
	Inscribed in Bengali: *mahādevir jaladhālā*.	
xcix	Shiva Ardhanarishvara.	I.S.180–1959
c	Hari-Hara (Vishnu and Shiva combined).	I.S.181–1959
ci	Shiva mounted on Nandi.	I.S.182–1959
	Inscribed in Bengali: *sārerupara mahādeva*.	
cii	Shiva on Nandi confronted by an ascetic.	I.S.183–1959
	Inscribed in Bengali: *mahādeva*.	
ciii	Shiva seated on Mount Kailasa holding a *sitār*; an ascetic seated nearby.	
		I.S.184–1959
civ	Shiva seated in a shrine.	I.S.185–1959
	Inscribed in Bengali: *vidyānāth* (Lord of Knowledge).	
cv	Shiva as ascetic and musician.	I.S.186–1959
cvi	Shiva Panchanana.	I.S.187–1959
	Inscribed in Bengali: *panchānan mahādeva*.	
cvii	Shiva Panchanana.	I.S.188–1959
	Inscribed in Bengali: *panchāmukha mahādeva*.	
cviii	Shiva Panchanana.	I.S.189–1959
	Inscribed in Bengali: *panchāmukha mahādeva*.	
cix	Shiva attended by a monkey with a trident; an ascetic seated nearby.	
		I.S.190–1959
	Inscribed in Bengali: *mahādevā*.	
cx	A celestial musician praising Shiva.	I.S.191–1959
	Inscribed in Bengali: *ghāndharva mahādevir stav*.	
cxi	Mandodari worshipping at a Shiva shrine.	I.S.192–1959
	Inscribed in Bengali: *mandādarī shiva pujā*.	

29,i–xii I.S.46 to 57–1961. A series of twelve pictures illustrating:
(a) eleven scenes from current Calcutta life (i–xi)
(b) an astrological sign (xii).

Water-colour on card, with silver details.
Size: $5\frac{1}{2} \times 3\frac{1}{2}$ ins.
Kalighat, *c.*1890.
Given by Stuart Durant, Surbiton, Surrey, 1961.
NOTE: From the same set as series 27,28 and 30.

i	A courtesan kneeling, holding a bird in her right hand, a rose in her left.	I.S.46–1961
ii	A courtesan seated on a cushion, holding a rose in her right hand.	I.S.47–1961
iii	A courtesan combing her hair.	I.S.48–1961
iv	Seated courtesan worshipping a lingam.	I.S.49–1961
v	Courtesan and client embracing (*Figure 60*).	I.S.50–1961
vi	A client holding two roses approached by a courtesan (*Figure 61*).	I.S.51–1961
vii	A turbaned lover and his mistress (*Figure 62*).	I.S.52–1961
viii	A courtesan embracing her lover (*Figure 63*).	I.S.53–1961
ix	Courtesan and client carousing.	I.S.54–1961
x	A turbaned lover and his mistress.	I.S.55–1961
xi	A courtesan embracing her lover.	I.S.56–1961
xii	A woman seated in a boat, representing Kanya Rashi, the constellation Virgo.	I.S.57–1961

Inscribed in Bengali: *kanyā rāshi*.

30,i–c I.S.264 to 363–1961. A series of one hundred paintings illustrating religious and mythological subjects.

Water-colour on card with silver details.
Size: $5\frac{3}{8} \times 3\frac{1}{2}$ ins.
Kalighat, *c.*1890.
Acquired from Howard Hodgkin, London, 1961.
NOTE: From the same set as series 26–9.

i	Karttikeya riding the peacock.	I.S.264–1961
	Inscribed in Bengali: *kārtik*.	
ii	Kuvera standing outside a palace.	I.S.26–51961
	Inscribed in Bengali: *kuber*.	
iii	Indra riding on his elephant.	I.S.266–1961
	Inscribed in Bengali: *indra*.	
iv	Puru Raja enthroned with attendants.	I.S.267–1961
	Inscribed in Bengali: *puru rāja*.	
v	Shiva Panchanana.	I.S.268–1961
	Inscribed on reverse in Bengali: *mahādeva*.	
vi	Shiva Dakshinamurti.	I.S.269–1961
	Inscribed in Bengali: *mahādeva*.	

vii	Krishna riding off with Rukmini.	I.S.270–1961
	Inscribed on reverse in Bengali: *rukminī haran* (the rape of Rukmini).	
viii	Priests worshipping Mahakala.	I.S.271–1961
	Inscribed in Bengali: *ma (hā) kāla*.	
ix	Yudhishthira and his women worshipping the lingam.	I.S.272–1961
	Inscribed on reverse in Bengali: *lingeshvara*.	
x	Shiva protecting a female devotee from a king.	I.S.273–1961
	Inscribed in Bengali: *mākand* (Markand (?)).	
xi	Shiva being revived after drinking poison.	I.S.274–1961
	Inscribed in Bengali: *nīlkantha* (the blue-throated).	
xii	Kama shooting at Shiva with his arrow.	I.S.275–1961
	Inscribed in Bengali: *shiver dhyān bhanga* (the awakening of Shiva).	
xiii	A man being sacrificed to Kali.	I.S.276–1961
	Inscribed on reverse in Bengali: *kālīr nikate nara bali dān*.	
xiv	Bhagirathi appearing to Bhagirath.	I.S.277–1961
	Inscribed in Bengali: *bhagirathi*.	
xv	The goddess Asita destroying Shataskandha.	I.S.278–1961
	Inscribed in Bengali: *asitā o shataskandha*.	
xvi	Bhima drinking the blood of Duhshashana.	I.S.279–1961
	Inscribed in Bengali: *duhshāshaner raktapān*.	
xvii	Devi in her form as the 'Ever-rising One' (*Figure 64*).	I.S.280–1961
	Inscribed in Bengali: *debī ujjyahanī*.	
xviii	Devi in her aspect as the 'Powerful One' (*Figure 65*).	I.S.281–1961
	Inscribed in Bengali: *debī bahubalā*.	
xix	Devi in her aspect as the 'Daughter of Daksha' (*Figure 66*).	I.S.282–1961
	Inscribed in Bengali: *debī dakshyā*.	
xx	Devi as the 'Subduer of Demons' (*Figure 67*).	I.S.283–1961
	Inscribed in Bengali: *debī daityadalanī*.	
xxi	Devi as Bagala subduing a demon.	I.S.284–1961
	Inscribed in Bengali: *bagalā debī*.	
xxii	Devi as Bagala subduing a demon.	I.S.285–1961
	Inscribed in Bengali: *bagalā*.	
xxiii	Devi as Bagala subduing a demon.	I.S.286–1961
	Inscribed in Bengali: *bagalā*.	
xxiv	Radha worshipping the combined form of Krishna and Kali.	I.S.287–1961
	Inscribed in Bengali: *krishna kālī*.	
xxv	Devi in her aspect as 'Destroyer of Passions', trampling on the demon in whom they are incarnate (*Figure 68*).	I.S.288–1961
	Inscribed in Bengali: *dēbi matta mardinī*.	
xxvi	Devi in her aspect as the 'Angry One' (*Figure 69*).	I.S.289–1961
	Inscribed in Bengali: *dēbi ugrā*.	

xxvii	Devi destroying the demon Sindhu (*Figure 70*).	I.S.290–1961
	Inscribed in Bengali: *sindhu datta badha.*	
xxviii	Devi distributing ambrosia (*Figure 71*).	I.S.291–1961
	Inscribed in Bengali: *sudhā bantan* (distributing ambrosia).	
xxix	Devi as Chhinnamastaka, the one who has beheaded herself.	I.S.292–1961
	Inscribed in Bengali: *debī chhinna mastā.*	
xxx	Devi as Chhinnamastaka, the one who has beheaded herself.	I.S.293–1961
	Inscribed in Bengali: *debī chhinna mast(ā).*	
xxxi	Devi as Chhinnamastaka, the one who has beheaded herself.	I.S.294–1961
	Inscribed in Bengali: *debī chhinna mastā.*	
xxxii	Devi as Chhinnamastaka, the one who has beheaded herself.	I.S.295–1961
	Inscribed in Bengali: *debī chhinna mastā.*	
xxxiii	Kali as the 'Protecting One', standing on the prostrate Shiva.	I.S.296–1961
	Inscribed on the reverse in Bengali: *rakshā kālī.*	
xxxiv	Tara standing on Sakala and Nishkala Shiva.	I.S.297–1961
	Inscribed in Bengali: *tārā.*	
xxxv	Kali standing on the prostrate Shiva.	I.S.298–1961
	Inscribed in Bengali: *kālī.*	
xxxvi	Kali standing on the prostrate Shiva.	I.S.299–1961
	Inscribed in Bengali: *kālī.*	
xxxvii	Tara standing on Sakala and Nishkala Shiva.	I.S.300–1961
	Inscribed in Bengali: *tārā.*	
xxxviii	Devi as the 'Victorious One'.	I.S.301–1961
	Inscribed in Bengali: *debī vijayā.*	
xxxix	Shraddha, wife of Angiras.	I.S.302–1961
	Inscribed on reverse in Bengali: *shraddhā.*	
xl	The goddess 'Peace' worshipping the lingam.	I.S.303–1961
	Inscribed on the reverse in Bengali: *shanti debī.*	
xli	Basumati, the earth goddess, surrounded by worshippers.	I.S.304–1961
	Inscribed in Bengali: *basumatī.*	
xlii	Devi in her aspect as a warrior, Matangi.	I.S.305–1961
	Inscribed in Bengali: *mātangī.*	
xliii	Rama releasing Ahalya.	I.S.306–1961
	Inscribed in Bengali: *ahalyār pāshān uddhār.*	
xliv	Lakshmana cutting off Surpanakha's nose.	I.S.307–1961
	Inscribed in Bengali: *surpanakhar nāsika chhed.*	
xlv	The combat between Bali and Sugriva.	I.S.308–1961
	Inscribed in Bengali: *bālī o sugrīber juddha.*	
xlvi	Rama and Sugriva.	I.S.309–1961
	Inscribed in Bengali: *rāma o sugrīb.*	
xlvii	Angada asking Rama for a boon.	I.S.310–1961
	Inscribed in Bengali: *angāder bārjachingā.*	

xlviii	Hanuman revealing Rama and Sita in his heart.	I.S.311–1961
	Inscribed in Bengali: *hanumān*.	
xlix	Hanuman carrying Rama and Lakshmana.	I.S.312–1961
	Inscribed in Bengali: *hanumān garh*.	
l	Hanuman carrying away the weapon destined to destroy Ravana.	
		I.S.313–1961
	Inscribed in Bengali; *rāvaner mrityubān haran*.	
li	Lava and Kusha carrying Hanuman bound.	I.S.314–1961
	Inscribed in Bengali: *lāva kusha*.	
lii	Valmiki admonishing Sita.	I.S.315–1961
	Inscribed in Bengali: *vālmikī*.	
liii	King Dasaratha lying prone, attended by three women.	I.S.316–1961
	Inscribed in Bengali: *dasharatha*.	
liv	Lava and Kusha fighting Hanuman after detaining the sacrificial white horse.	
		I.S.317–1961
	Inscribed in Bengali: *lāva kusha*.	
lv	Kumbhakarna being awakened.	I.S.318–1961
	Inscribed in Bengali: *kumbha karner nidrā bhanga*.	
lvi	Rama approaching as Sita rests.	I.S.319–1961
	Inscribed in Bengali: *sītā debī*.	
lvii	Duhshashana stripping off Draupadi's veils.	I.S.320–1961
	Inscribed in Bengali: *dra(u)padīr bastra haran*.	
lviii	Aswatthaman showing the five heads to Duryodhana.	I.S.321–1961
	Inscribed in Bengali: *ashvatthāmā*.	
lix	Duhshashana stripping off Draupadi's veils.	I.S.322–1961
	Inscribed in Bengali: *drā(u)padīr bastra haran*.	
lx	Aswatthaman attacking Shiva with a branch.	I.S.323–1961
	Inscribed in Bengali: *asvāthama*.	
lxi	Dushanta admonishing Shakuntala.	I.S.324–1961
lxii	Risyasringa with his wife, Santa.	I.S.325–1961
lxiii	The destruction of Kacha.	I.S.326–1961
	Inscribed in Bengali: *kacha sanhār*.	
lxiv	Vasudeva and Devaki in prison.	I.S.327–1961
	Inscribed in Bengali: *basudevo o debakīr kārā bandha*.	
lxv	Radha and her companions watching Krishna.	I.S.328–1961
	Inscribed on reverse in Bengali: *srī rādhār krishna darshan*.	
lxvi	Krishna as the ferryman.	I.S.329–1961
	Inscribed in Bengali: *krishna kāndārī*.	
lxvii	Viraja (Vishnu's sister) and Krishna.	I.S.330–1961
	Inscribed on reverse in Bengali: *birajā o krishna*.	
lxviii	Krishna with the milkmaids' clothing.	I.S.331–1961
	Inscribed on reverse in Bengali: *bastra haran*.	

lxix Krishna dallying with the milkmaids. I.S.332–1961
Inscribed on the reverse in Bengali: *gopi līlā*.

lxx Radha and Krishna on a swing for the Spring festival. I.S.333–1961
Inscribed in Bengali: *dol līlā*.

lxxi Krishna and Subal (Balarama) with the lost calf. I.S.334–1961
Inscribed on reverse in Bengali: *subal krishna*.

lxxii The death of Putana. I.S.335–1961
Inscribed in Bengali: *putānā*.

lxxiii Krishna as Vishnu seated on the hill. I.S.336–1961
Inscribed in Bengali: *dandakinī parbat*.

lxxiv Prahlada being thrown into the sea. I.S.337–1961
Inscribed in Bengali: *pralhādke samudre nikshep*.

lxxv Krishna washing the feet of a Brahmin. I.S.338–1961
Inscribed on reverse in Bengali: *srī krishna o brāhman*.

lxxvi Pushkar and the messenger. I.S.339–1961
Inscribed in Bengali: *puskar dyut*.

lxxvii Devaki and Vasudeva in prison. I.S.340–1961
Inscribed in Bengali: *debakī o bāsudeva kārāgāre abaddha*.

lxxviii A child being sold to a Brahmin. I.S.341–1961
Inscribed in Bengali: *brahmaner kācche bikraya*.

lxxix A Vaishnava mendicant being chastised with a broom. I.S.342–1961
Inscribed in Bengali: *abhojir jhāntā* (a broom for the starving).
NOTE: Compare Archer (1962), plate 7.

lxxx The sage Gautama and his wife in their hut. I.S.343–1961
Inscribed in Bengali: *gautam munī*.

lxxxi The Pandavas fighting rival suitors at Draupadi's wedding tournament. I.S.344–1961
Inscribed in Bengali: *dra(u)padīr svayambar*.

lxxxii The death of Krishna. I.S.345–1961
Inscribed in Bengali: *srī krishna dehatyāg*.

lxxxiii Krishna enthroned as king at Mathura. I.S.346–1961
Inscribed in Bengali: *mathurāya krishna rājā*.

lxxxiv Savitri pleading with Yama for Satyavan's life. I.S.347–1961
Inscribed in Bengali: *sābitrī satyabān*.

lxxxv A female ape embracing a man. I.S.348–1961
Inscribed in Bengali: *anganaya ālingana*.

lxxxvi Indra calling on Dantiniki. I.S.349–1961
Inscribed in Bengali: *dantinīker nikote indrer gaman* (the approach of Indra to Dantiniki).

lxxxvii Ruru fighting the sea serpent. I.S.350–1961
Inscribed in Bengali: *rurur sarpahinsā*.

| lxxxviii | A king and queen enthroned with a snake coiled around their throne. | |
| | | I.S.351–1961 |

Inscribed in Bengali: *takshaker māhātmya* (the greatness of Takshaka).

| lxxxix | Indra's fight with Dandin. | I.S.352–1961 |

Inscribed in Bengali: *dandir sahit indrer yuddhā.*

| xc | Varuna's fight with Dandin. | I.S.353–1961 |

Inscribed in Bengali: *dandir sahit barun yuddhā.*

| xci | Dandin calls on Draupadi. | I.S.354–1961 |

Inscribed in Bengali: *draupadīr nikat dandir gaman.*

| xcii | Dandin seeking Bhima's protection. | I.S.355–1961 |

Inscribed in Bengali: *dandir bhīmer āshraya grahān.*

| xciii | Dandin reaches Ashvini. | I.S.356–1961 |

Inscribed in Bengali: *dandir rājā ashvinī prāpta.*

| xciv | A woman passing by a hermit. | I.S.357–1961 |

Inscribed in Bengali: *laksha hīrā.*

| xcv | A widow pleading for the return of her son from a warrior. | I.S.358–1961 |

Inscribed in Bengali: *chāndī.*

| xcvi | Srimanta seated in the arms of a widow receives an assurance of protection. | |
| | | I.S.359–1961 |

Inscribed in Bengali: *srīmantake abhay dān.*

| xcvii | The sage Vyasa with attendants. | I.S.360–1961 |

Inscribed in Bengali: *vyāsa muni.*

| xcviii | Sarapa throws himself into the sea. | I.S.361–1961 |

Inscribed in Bengali: *sarapu.*

| xcix | Sarojini's ordeal by fire. | I.S.362–1961 |

Inscribed in Bengali: *sarojinī.*

| c | Two devotees worshipping a snake-god. | I.S.363–1961 |

Inscribed in Bengali: *nāg yangya.*

1,i–xxxvii I.M.106 to 141–1914 and 146–1914. A series of thirty-seven pictures illustrating:

(a) thirty-one mythological or religious subjects (i–xxxi)
(b) three episodes from the Tarakeshwar murder case (xxxii–xxxiv)
(c) three scenes from current Calcutta life (xxxv–xxxvii).

Water-colour with silver outlines and details.
Average size: $17\frac{3}{4} \times 11$ ins.
Kalighat, *c.*1890.
Given by Ernest H. Hindley, 1914.
NOTE: A series characterized by a markedly bold treatment of the human form and by sumptuously rounded contours. Silver pigment present but used sparingly. A strong preference for bright yellow flesh tones, and pale blue shading. For a similar series, compare the loose sheets in the Monier-Williams collection, Indian Institute, Bodleian Library, Oxford (note to series 5) and Archer

(1953), figures 20–25. The presence of pictures illustrating the Tarakeshwar murder case of 1873 provides crucial evidence for the late dating.

i	Saraswati.	I.M.106–1914
ii	Narasimha.	I.M.107–1914
iii	Krishna as Kali worshipped by Radha.	I.M.108–1914
iv	Durga as Jagaddhatri	I.M.109–1914
v	Durga on her lion killing Mahishasura.	I.M.110–1914
vi	Durga nursing Ganesha.	I.M.111–1914
vii	Kamala Kamini nursing Ganesha.	I.M.112- 1914
viii	Ganesha.	I.M.113–1914
ix	Shiva Ardhanarishvara.	I.M.114–1914
x	Shiva carrying the dead Sati.	I.M.115–1914
xi	Shiva Panchanana.	I.M.116–1914
xii	Shiva Panchanana	I.M.117–1914

NOTE: A duplicate of (xi).

xiii Shiva as musician I.M.118–1914
Published: Archer (1953), figure 32.

xiv Jasoda nursing Krishna (*Figure 72, Colour Plate C*). I.M.119–1914
Published: Archer (1953), figure 31; also reproduced Bhattacharya (1967) plate 12.

xv Jasoda, with a pitcher, taking the infant Krishna for a walk (*Figure 73*).
 I.M.120–1914
Published: Archer (1953), figure 30.

xvi	Krishna and Balarama standing beneath a tree.	I.M.121–1914
xvii	Krishna and Balarama standing and embracing.	I.M.122–1914
xviii	Krishna and Balarama on Garuda.	I.M.123–1914
xix	Krishna milking a cow.	I.M.124–1914
xx	Jasoda carrying the infant Krishna.	I.M.125–1914
xxi	Krishna fluting.	I.M.126–1914
xxii	Chaitanya as partial incarnation of Rama and Krishna.	I.M.127–1914
xxiii	Krishna and Balarama beneath a tree, Balarama holding a calf.	I.M.128–1914
xxiv	Krishna mollifying Radha by stroking her feet.	I.M.129–1914
xxv	Radha placating Krishna by touching his feet.	I.M.130–1914

NOTE: The reverse situation to (xxiv).

| xxvi | Two goddesses, one of them Saraswati. | I.M.132–1914 |
| xxvii | Hanuman revealing Rama and Sita in his heart. | I.M.133–1914 |

Published: Archer (1953), figure 33.

xxviii Hanuman before Rama, Sita and Lakshmana. I.M.134–1914

xxix Mythological figure in an oval surround encircled by a group of archers, shooting arrows at him. I.M.146–1914

xxx Rama fighting with his sons, Kusha and Lava. I.M.135–1914

| xxxi | Savitri pleading with Yama, the god of death, for the life of her dead husband, Satyavan. | I.M.136–1914 |

| xxxii | Elokeshi, installed with the Mahant, offers him *pān* (*Figure 31*). | I.M.137–1914 |

NOTE: Like (xxxiii) and (xxxiv), an illustration of an episode in the Tarakeshwar murder case of 1873 (Introduction, p.12).

The Mahant, shown in 17,x, as standing beside Elokeshi and fanning her with a hand *punkah*, is now depicted wearing a pleated *dhotī*, bare to the waist, seated in a black western-style chair and smoking a *nārgila* pipe. For the 'pleated *dhotī*' as symptomatic of dissolute living, compare the proverb cited in the note to series 12.

| xxxiii | The Mahant turns an oil press (*Figure 41*). | I.M.138–1914 |

NOTE: During his time in jail, the Mahant was given various tasks including the watering of plants (see 17,xiii). He is here shown working an oil-press, a warder with gun and black cap urging him on.

| xxxiv | The fatal blow (*Figure 36*). | I.M.140–1914 |

Published: Archer (1953), figure 34.

NOTE: The clerk Nabin stands poised to behead his wife, Elokeshi, with a fish-knife. Elokeshi, with bright yellow skin in a maroon *sārī*, kneels before him, her face averted and a hand raised to ward off the blow. The black 'grip' or hold-all, used by the painters as an essential attribute of Nabin, is on the ground below her. The other attribute, an umbrella, hangs limply from Nabin's left hand. For another version of the same scene, see series 16.

| xxxv | Domestic violence (*Figure 74*). | I.M.141–1914 |

NOTE: An enraged husband has taken off one of his shoes, thrown his wife to the ground, caught her by the hair and has raised the shoe in order to strike her. The wife wields a small broom or birch.

For a similar study, see Archer (1962), plate 19.

| xxxvi | Two dancing-girls performing. | I.M.131–1914 |
| xxxvii | A water-carrier. | I.M.139–1914 |

NOTE: For an earlier, more accomplished version, see series 3.

| 32,i–vii | I.M.2-1917; sub-numbers 73, 185, 187 to 190, 197. A series of seven pictures illustrating religious subjects. |

Water-colour with silver details.
Average size: 17 × 11 ins.
Kalighat, *c*.1890.
From the J. Lockwood Kipling collection, given by Rudyard Kipling, 1917.
NOTE: Notable in style for bold brush-strokes in black and for its lavish use of flat red areas.

| i | Kali. | I.M.2(73)–1917 |
| ii | Kali dancing on the prostrate Shiva (*Figure 45*). | I.M.2(185)–1917 |

iii	Shiva on the bull Nandi (*Figure 75*).	I.M.2(190)–1917
	Published: Archer (1953), figure 29.	
iv	Annapurna offering food to Shiva	I.M.2(187)–1917
v	Lakshmi with her owl.	I.M.2(189)–1917
vi	Saraswati.	I.M.2(197)–1917
vii	Hanuman revealing Rama and Sita in his heart.	I.M.2(188)–1917

33 A picture illustrating a religious subject. I.S.226–1950
 Kali enthroned.

Water-colour with silver details.
Size: $17\frac{3}{4} \times 10\frac{1}{2}$ ins.
Kalighat, *c*.1890.
Acquired from a Roman Catholic Missionary College, England, 1950.
NOTE: Similar in style to series 32.

34 A picture illustrating a religious subject. I.P.N.2574
 Jasoda milking a cow, assisted by the baby Krishna (*Figure 76*).

Water-colour.
Size: $18 \times 10\frac{3}{4}$ ins.
Kalighat, *c*.1890.
Given by E.B. Havell, date unrecorded.
NOTE: E.B. Havell, writer and art-historian, was appointed Principal of the
Government School of Art, Madras, 1884, and became Principal of the Govern-
ment School of Art, Calcutta, in 1896. He retired in 1905. For a reference by
him to Kalighat paintings, comparing them in their 'strong rhythmic flow of
line' to the murals of Bagh and Ajanta, see Havell (1926). The present picture
may have been collected by Havell in Calcutta shortly after his appointment
and certainly no later than 1905. For style, compare series 35.

35 A picture illustrating a religious subject. I.S.187–1949
 Krishna milking a cow.

Water-colour.
Size: 18×11 ins.
By Nibaran Chandra Ghosh, Kalighat, *c*.1890.
Acquired from A.B. Bartlett, London, 1949.
NOTE: Originally obtained along with series 37 by W.G. Archer at Kalighat
in 1932 from the descendants of Nibaran Chandra Ghosh (*c*.1835–1930) and
attributed to this artist by family tradition. Presented by Archer in 1939 to
A.B. Bartlett, from whom it was acquired for the Museum in 1949. For style,
see series 37.

36,i–v I.S.37 to 41–1952. A series of five pictures illustrating:

(a) two religious subjects (i,ii)
(b) three scenes from current Calcutta life (iii–v)

Water-colour with pencil.
Average size: 18 × 11 ins.
By Kali Charan Ghosh, Kalighat, *c.*1900.
Given by W.G. Archer, 1952.
NOTE: Purchased at Kalighat from the descendants of the artist, Kali Charan Ghosh (1884–1930), and attributed to him by family tradition. All five pictures are in a large and sumptuous style, red and black predominating.

i	Krishna at Jasoda's breast.	I.S.40–1952
	Published: Archer (1953), figure 41.	
ii	Karttikeya astride his peacock.	I.S.41–1952
iii	Courtesan dressing her hair. (*Colour Plate D*).	I.S.37–1952
	Published: Archer (1953), figure 40.	
iv	Courtesan smoking a hookah (*Figure 79*).	I.S.38–1952
v	Courtesan trampling on her lover (*Figure 77*).	I.S.39–1952
	Published: Archer (1953), figure 42.	

37,i–viii I.S.29 to 36–1952. A series of eight pictures illustrating scenes of current Calcutta life.

Water-colour and pencil, two unfinished.
Average size: 20 × 13 ins.
By Nibaran Ghandra Ghosh, Kalighat, *c.*1900.
Given by W.G. Archer, 1952.
NOTE: Originally purchased at Kalighat in 1932 from the descendants of Nibaran Chandra Ghosh (*c.*1835–1930), and attributed to him by family tradition. The finished pictures are on a large and florid scale employing broad washes of colour, sweeping black curves and little shading.

i	Courtesan with rose and mirror.	I.S.29–1952
	Published: Archer (1953), figure 39.	
ii	Courtesan playing a *sitār*.	I.S.30–1952
	Published: Archer (1953), figure 38.	
iii	Courtesan with roses (*Figure 78*).	I.S.31–1952

Published: Archer (1952), figure 8, also reproduced Archer (1953), cover plate (col.); Mookerjee (1956), colour plate 50.

iv	The suppliant lover (a).	I.S.32–1952

NOTE: Unfinished study (first stage). Pencilled outlines of a standing courtesan, with her lover squatting to touch her feet. Head, arms and feet lightly tinted in brown and pink.

v The suppliant lover (b). I.S.33–1952

Published: Archer (1953), figure 37.

NOTE: Unfinished study (second stage). Similar to (iv) but with addition of features and black hair.

vi The suppliant lover (c). I.S.34–1952

NOTE: Unfinished study (third stage). Similar to (iv) but in reverse, the features added but not the hair. *Sārī* and dress in pale blue wash.

vii Domestic violence (a). I.S.35–1952

NOTE: Unfinished study. A man beating his wife with a shoe (compare 31,xxxv). Features in black outline, arms and legs pink and brown, *dhotī* and *sārī* pale blue.

viii Domestic violence (b) (*Figure 80*). I.S.36–1952

NOTE: Unfinished study. A wife bowing at her husband's feet, as he stands over her, wrenches her veil aside and prepared to strike her. Features in black outline, arms, legs and faces pink and brown, *dhotī* and *sārī* pale blue.

38,i–vi I.P.N.2575 to 2580. A series of six pictures illustrating:

(a) three religious subjects (i–iii)

(b) three scenes from current Calcutta life (iv–vi).

Line drawings.

Various sizes (i–iii, $17\frac{1}{2} \times$ 11 ins; iv, 18 × 11 ins; v, $17\frac{1}{4} \times 10\frac{3}{4}$ ins; vi, $19\frac{1}{2} \times$ 13 ins.)

Kalighat, *c.*1900.

Given by E.B. Havell, date unrecorded.

NOTE: Similar in style to series 37. For E.B. Havell and his connection with Calcutta, see note to series 34 and Archer (1959), 17–37.

i Shiva and Parvati sitting under a tree, a parrot in the branches. I.P.N.2577

ii Krishna and Balarama standing beneath a tree, Balarama holding a calf.

 I.P.N.2578

iii Radha and Krishna standing and embracing. I.P.N.2580

iv Courtesan dressing her hair. I.P.N.2575

v Two dancing-girls performing. I.P.N.2579

vi Courtesan seated before a shrine to Shiva fingering the tip of the lingam.

 I.P.N.2576

NOTE: For a line-drawing in similar style showing a courtesan preparing for the night by trimming an oil-lamp, see Archer (1962), plate 11.

39,i– v I.S.42 to 46–1952. A series of five pictures illustrating:

(a) two scenes of current Calcutta life (i,ii)

(b) three proverbs or folk-tales (iii–v).

Line drawings (i–iv), water-colour and pencil (v).
Average size: 18 × 11 ins.
By Kanai Lal Ghosh, Kalighat, c.1920.
Given by W.G. Archer, 1952.
NOTE: Purchased by W.G. Archer at Kalighat in 1932 from the artist, Kanai Lal Ghosh (born 1907), a relation of Nibaran and Kali Charan Ghosh, and claimed by him to be his own work. When the pictures were acquired, he was no longer painting, the school having ended.

i Courtesan dressing her hair. I.S.42–1952
ii Gentleman with lap-dogs. I.S.43–1952
NOTE: A fop with thin walking stick and handkerchief in hand stands beside a pair of lap-dogs who prance at his feet. Perhaps intended to satirize effeteness.
iii A crow on a branch. I.S.44–1952
NOTE: Illustration of a proverb or folk-tale.
iv A cat with a fish in its mouth. I.S.45–1952
NOTE: See Note to 26,xxi, where, again, *tilak* marks are omitted.
v The pet parrot. I.S.46–1952
NOTE: A green parrot with yellow feet is chained up in a black cage. Illustration of a proverb or folk-tale.

40,i,ii I.S.469 and 470–1950. Two pictures illustrating:

(a) a religious subject (i)
(b) a proverb (ii)

Tinted woodcuts based on Kalighat models.
Average size: 17 × 10½ ins.
Calcutta, c.1890.
Given by John Irwin, 1950.
NOTE: Acquired in Calcutta in 1943 from Jamini Roy, who had purchased them not later than the year 1930. Woodcuts, frequently modelled on Kalighat pictures, were produced by Bengali wood-engravers in the Simula, Battala, Hogalkunda and Sobhabazaar suburbs of Calcutta. For inscribed examples, see India Office Library, London (Add.Or.908–919, 1860–1866, 1905–1908).

i Krishna stealing the milkmaids' clothes. I.S.470–1950
ii Hand with a bunch of fresh-water prawns (*Figure 86*). I.S.469–1950
NOTE: A hand with striped coat-sleeve enters horizontally from the right-hand side of the picture, holding in it (1) a small cat-fish (2) a bunch of fresh-water prawns and (3) a small gourd-like object held by a stalk or cord. The prawns are bluish-green in colour with red eyes and tail and black whiskers and claws. For other examples of Kalighat painting involving prawns, see Archer (1953), figure 25 and Archer, M. (1967), figure 60. For a comparison of these

pictures with a work by the modern French painter, Fernand Léger, dated 1924, Le Siphon (*Figure 85*), see Introduction (Note 2).

41,i-iii I.S.47 and 48–1952; I.S.50–1968. A series of three Kalighat-type colour-lithographs illustrating scenes of current Calcutta life.

Printed at the Kansaripara Art Studio, 26, Kristo Das Pal's Lane, Calcutta.
Average size: 16 × 12 ins.
Calcutta, *c.*1930.
Given by W.G. Archer, (i) and (ii), 1952, (iii) 1968.
Purchased in Calcutta, 1932.
NOTE: For the role of colour-lithographs in destroying Kalighat painting, see Introduction, p.15.

i Courtesan with rose. I.S.47–1952
ii Courtesan with *nārgila* pipe. I.S.48–1952
iii Courtesan with violin (*Figure 81*). I.S.50–1968

42 Copy of a Kalighat painting illustrating a proverb. I.S.2–1954
 A fresh-water prawn with three cat-fishes (*Figure 83*).

Water-colour.
Size: $19\frac{3}{4} \times 13\frac{1}{4}$ ins.
Calcutta, *c.*1940(?).
Given by Dr Suniti Kumar Chatterji, Calcutta, 1954.
NOTE: Copy of a Kalighat painting made at Dr Chatterji's instance by a modern Calcutta painter. The fresh-water prawn is shown with pale blue body and black markings, red tail and whiskers and two long black claws. Three small cat-fishes, in white and brown, each with two long and drooping barbels, swim about its head.

43 A picture illustrating a religious subject. I.S.269–1951
 Shiva and consort enthroned, Nandi sitting by them.
 Inscribed: *Shiva and Doorga.*

Water-colour.
Size: 13 × $10\frac{1}{2}$ ins.
Variant on, or perhaps a near precursor of, Kalighat painting, *c.*1850.
Acquired from Walter T. Spencer, London, 1951.
NOTE: Compare series 1.

Glossary of
Principal Proper Names

NOTE: For further information on Indian gods and goddesses the general reader is referred to Veronica Ions, *Hindu Mythology* (London, 1967), J. Dowson, *A Classical Dictionary of Hindu Mythology and Religion, Geography, History and Literature* (London, ninth edition, 1957), and, for Krishna, to W. G. Archer, *The Loves of Krishna* (London, 1957).

ANANTA. 'The infinite', a name given to Sesha, serpent of eternity, who acted as a couch for Vishnu when he slept during the intervals of creation. (*Figure 51*)

ANNAPURNA. 'Giver of food and plenty'. A benign form of Devi and thus a consort of Shiva.

APSARAS. The Apsarases were celestial beauties, courtesans or dancing-girls in Indra's heaven, often serving as wives or mistresses of the Gandharvas, the heavenly musicians. (*Figure 47*)

ARDHANARISHVARA. Shiva as half-male, half-female, combining in one person both the male and female energies.

ARJUNA. The third of the five Pandava brothers and with them joint husband of Draupadi. During their great battle with the Kaurava princes, Krishna acted as his charioteer. Also husband of Krishna's sister, Subhadra.

BAKASURA. A crane demon which swallowed Krishna and the cowherds, but was forced to release them when Krishna became too hot. Krishna then killed him by tearing his beak apart.

BALARAMA. Seventh son of Vasudeva and Devaki and elder brother of Krishna. He was reared with Krishna in the family of the cowherd Nanda and shared his idyllic boyhood in Brindaban. He assisted Krishna in killing many demons. He is usually shown with a white complexion, carrying a horn or a ploughshare. (*Figures 9, 17*)

BALBHADRA. Pseudonym for Balarama, used especially in association with the form of Krishna known as Jagannatha at Puri, Orissa. (*Figure 11*)

BALI (i) A titan king who through his devotions gained supremacy over the three worlds—heaven, earth and the nether regions, and thus humbled the gods. At the gods' instance, Vishnu took the form of Vamana, a Brahmin dwarf, deprived Bali of heaven and earth but, in recognition of his piety, allowed him to retain the nether regions. (*Figure 8*)
(ii) Monkey chief, brother of Sugriva, whose kingdom of Kishkindhya he endeavoured to seize. He was later killed and his brother reinstated. (*Figure 88*)

BHAIRAVI. Wife of Shiva in his terrible form of Bhairava.

BHIMA. Second of the five Pandava brothers. A great warrior of vast strength.

BRAHMA. Creator and first member of the Hindu trinity, possessing four heads and arms. His consort is Saraswati, his vehicle a swan or goose.

CHAITANYA. A Vaishnava reformer (1486–1533), regarded in parts of Bengal as an incarnation of Krishna. See also GAUR and NITAI.

CHANDI. An aspect of Durga.

CHANDRA. The moon god.

DAMAYANTI. See NALA.

DEVAKI. Mother of Krishna, wife of Vasudeva and cousin of Kansa.

DEVI. 'The goddess', wife of Shiva and reflecting Shiva's contradictory qualities in her many aspects. In her benign forms she is known as Uma, 'light'; Gauri, 'yellow or brilliant'; Parvati, 'of the mountains'; Jagaddhatri, 'sustainer of the world' and Sati, 'virtuous'. In her ferocious and terrifying aspects, she is Durga, 'the inaccessible'; Kali, 'the black', and Chandi, 'the fierce'. For other forms and roles, chiefly ferocious, see *Figures 64–71*.

DRAUPADI. Joint wife of the five Pandava brothers. Obtained by them as a result of a wedding tournament.

DURGA. 'The inaccessible'. Wife of Shiva and an aspect of Devi in her more menacing forms. She is shown normally riding on a lion or tiger, her ten arms holding the weapons of the gods. Among the many demons killed by her, the buffalo demon, Mahishasura, was chief. (*Figures 10, 12*)

DURYODHANA. Eldest son of King Dhritarashtra and leader of the Kaurava princes in the great war against the Pandavas. An expert in the use of clubs with which he fought a mortal duel with Bhima.

ELOKESHI. Wife of Nabin. Victim of the Tarakeshwar murder. See Introduction, pp 12–15 (*Figures 27–32, 34–8*)

GANDHARVAS. Celestial singers and musicians in Indra's heaven.

GANESHA. Son of Shiva and Parvati; god of wisdom and remover of obstacles. He is represented as short and fat with an elephant's head and four arms. He rides upon a rat and carries a shell, discus, club and lotus. (*Figure 49*)

GANGA. A holy river, elder daughter of Himavat and Mena. She was married to the gods and, being unwilling to descend to earth, threatened to fall and engulf the world. Shiva agreed to break the violence of her fall and caught her in his hair from which she descended in seven separate streams, one of them being the holy river Ganges. In paintings she is often shown seated on a crocodile.

GARGAMUNI. Priest of Krishna and his kinsmen, the Yadavas.

GARUDA. Mythical king of the birds and Vishnu's mount. He has the head, wings, talons and beak of an eagle and the body and limbs of a man. (*Figure 17*)

GAUR. With Nitai, a disciple of Chaitanya (*q.v.*).

HANUMAN. A monkey chief with supernatural powers who assisted Rama, seventh incarnation of Vishnu, in quelling Ravana, demon king of Ceylon, and in rescuing his wife, Sita, from Ravana's clutches. In battle, Hanuman could grow to the size of a mountain and fly through the air. When asked by Ravana the whereabouts of Rama and Sita, he is said to have replied, 'In my heart'. (*Figures 14, 15, 50*)

HARAGAURI. Shiva in bi-sexual form, from Hara (one of Shiva's names) and Gauri 'yellow' or 'brilliant' (a name of Parvati, his consort).

HARI-HARA. Vishna and Shiva combined.

HIMAVAT. The Himalayas; father of Parvati and Ganga.

HIRANYAKASIPU. See NARASIMHA.

HIRANYAKSHA. Twin-brother of Hiranyakasipu. See VARAHA.

INDRA. King of the gods and lord of clouds. He rides the white elephant, Airavata, wields thunderbolts and lightning and controls storms.

INDRAJIT. Pseudonym of Meghanada, son of Ravana, who in a battle with the god Indra captured him and took him to Ceylon as a hostage. The gods released Indra but gave Meghanada the name of Indrajit, 'conqueror of Indra'. During the battle between Ravana and Rama, Indrajit twice injured Rama and Lakshmana but eventually Lakshmana beheaded him while he was engaged in a sacrifice.

JAGADDHATRI. 'Sustainer of the world'; Devi in one of her benign forms.

JAGANNATHA. 'Lord of the World'; a form of Krishna and, in Bengal and Orissa, often regarded in place of Buddha as the ninth incarnation of Vishnu. He is worshipped particularly at Puri in Orissa. According to legend, Krishna was killed by a hunter. His bones were found and Vishnu directed a devout king, Indradyumna, to make an image of Jagannatha and place the bones inside it. Viswakarma, carpenter and architect of the gods, agreed to make the image on condition he was left undisturbed. On being interrupted by Indradyumna, he lost his temper and refused to finish the image. This is said to explain the crude form taken by the Jagannatha image at Puri, where the body resembles a wooden stump with a large and blunt head. In paintings, Jagannatha appears black-faced in the company of Subhadra, his sister, and Balbhadra (Balarama), his brother. In appearance, the three often conform to the simplified images in the temple, but at times are shown more realistically with developed bodies, hands and feet. (*Figure 11*)

JARASANDHA. Demon king of Magadha, two of whose daughters were married to Kansa, King of Mathura. When Krishna killed Kansa, Jarasandha besieged Mathura and attacked Krishna eighteen times. He was ultimately killed at Krishna's instance in single combat with Bhima.

JASODA. Wife of the cowherd Nanda and foster-mother of Krishna. (*Figures 72, 73, 76*)

JATAYU. King of the vultures and son of Vishnu's mythical bird-mount, Garuda. Like Hanuman, a firm ally of Rama. When Ravana, demon king of Ceylon, abducted Sita and carried her off in his chariot through the air, Jatayu attempted to rescue her with his beak. He was overpowered, however, by Ravana and left mortally wounded. Rama found Jatayu dying and learnt from him Sita's fate. (*Figures 44, 88*)

KALI. 'Black'. Wife of Shiva and an aspect of the Devi in her most terrifying form. She is shown as four-armed, black-skinned, dripping with blood, her tongue out and wearing a garland of skulls and human heads. In one hand she holds a head. It was in honour of Kali that the temple at Kalighat was dedicated and goats were constantly slaughtered. See Introduction, note 13. (*Figures 13, 16, 45, 46*)

KALIYA. A multi-headed serpent king who dwelt with his serpent wives in a deep pool in the Jamuna river. They fouled the water to which the cowherds in Brindaban took their cattle to drink. The young Krishna leapt into the water and subdued the snake. On the intervention of the snake's wives, he spared his life but banished him from the river.

KALKI. The white horse, the tenth and last incarnation of Vishnu, due to appear at the end of the Iron Age to destroy the wicked and restore purity.

KAMA. God of Love, lord of the *apsarases*, and, according to some accounts, the son of Lakshmi. He is armed with a bow made of sugar cane, stringed with bees, and arrows tipped with lotuses, and is represented as a handsome youth riding on a parrot. On infuriating Shiva by arousing him from a dejected trance, he was reduced to ashes by a fiery glance from Shiva's third eye.

KAMALA KAMINI. 'The lotus one'; an aspect of Lakshmi.

KANSA. Tyrannical king of Mathura and cousin of Devaki, mother of Krishna. It was foretold that a son of Devaki would kill him, so he endeavoured to destroy all her children. Balarama and Krishna both escaped and eventually killed him.

KARTTIKEYA. God of war and son of Shiva and Parvati. He is shown riding on a peacock holding a bow and arrow.

KINARAM. Agent of the Mahant of Tarakeshwar. See Introduction, p.14. (*Figure 27*).

KRISHNA. Eighth incarnation of the god Vishnu and at times regarded as his direct manifestation. Born in prison, the eighth son of Vasudeva and Devaki, he was smuggled out at birth in order to avoid slaughter by his cousin Kansa, the tyrant king of Mathura. He was brought up in the forests of Brindaban in northern India, by cowherd foster-parents, Nanda and Jasoda, spending his youth amongst the cowherds and milkmaids.

His romantic love for a married milkmaid Radha became a popular subject of poetry and an elaborate allegory for the soul's relationship with God. During his sojourn with the cowherds he killed many demons. In Indian painting he is usually shown with a blue complexion, often playing on a flute and wearing a crown of peacock feathers. For other incidents in his life, including his subsequent career as a feudal prince and husband, see W.G.Archer, *The Loves of Krishna* (London, 1957). (*Figures 7, 9, 17, 48, 52, 72, 73*)

KURMA. The Tortoise, second incarnation of Vishnu. During the deluge in the first age of the world, various precious things were lost in the sea of milk. Vishnu appeared as a tortoise, placed himself at the bottom of the sea and made his back the pivot for the mountain Mandara. The gods and demons twisted the serpent Vasuki round the mountain like a rope, each held an end and churned the sea until the objects, such as the water of life, the cow of plenty and the conch-shell of victory, were recovered.

KUSHA. With Lava, one of the twin sons of Rama and Sita. They were born in the hermitage of Valmiki where Sita had retired after Rama had sent her into exile as a result of unjust suspicions that she had been unfaithful to him when abducted by Ravana. They unwittingly became involved in a battle with their father, Rama, concerning a horse turned loose by him for sacrifice and mistakenly captured by them in ignorance of their father's designs. Efforts by Satrugha, Lakshmana, Bharata and Hanuman to recover the horse failed and in the course of them Hanuman was bound and carried off captive. Rama intervened and after a brief battle recognized Kusha and Lava as his own sons. They returned together to Rama's kingdom of Ayodhya where Rama performed the horse sacrifice. (*Figure 50*)

LAKSHMANA. Brother of Rama. (*Figures 15, 18*)

LAKSHMI. Goddess of fortune and giver of wealth. Wife of the god, Vishnu, and mother of Kama, the god of Love. According to legend she was born either from the ocean holding a lotus in her hand or floating on a lotus at the time of creation. Her connection with water is expressed through the presence of two elephants lustrating her with water from their trunks. She rides on an owl.

LAVA. See KUSHA. (*Figure 50*)

MADHAV CHANDRA GIRI. Mahant (chief priest) of the Shiva temple, Tarakeshwar. See Introduction, p.12. (*Figures 26–32, 38–41*)

MAHABIR. 'Great hero'. Pseudonym for Hanuman.

MAHADEVA. 'The great god'. Pseudonym for Shiva.

MAHANT OF TARAKESHWAR. See Madhav Chandra Giri.

MAHAYOGI. Shiva as the Great Ascetic. (*Figure 19*)

MAHISHASURA. A demon in buffalo form killed by Durga. (*Figures 10, 12*)

MATSYA. The Fish, first incarnation of Vishnu. Various stories are recounted about this incarnation. One relates how during the deluge, Matsya saved Manu, progenitor of the human race, from extinction. The fish had a vast horn on to which Manu's boat was tied until the waters subsided.

MOHINI. Vishnu in a female form used by him when apportioning ambrosia between the gods and demons after the churning of the ocean.

MUKTAKESHI. Younger sister of Elokeshi. See Tarakeshwar murder case, Introduction, p.13. (*Figure 27*)

NABIN. Nabin Chandra Banerjee. Husband of Elokeshi and accused of the Tarakeshwar murder. See Introduction, p.12. (*Figures 33–8*)

NALA. A Hindu king married to Damayanti, a princess. As a result of gambling, he lost his whole property, even his clothes. His rival then succeeded to the kingdom and Nala and his wife were forced to rove the forests. When birds flew away with Nala's only garment, he resolved to abandon Damayanti in the hope that she would return to her father's court. He accordingly removed her sole remaining garment while she slept, divided it in two, and left her. In the sequel, Nala regains his kingdom with the aid of a serpent ruler, and Damayanti receives a beatific reward for her wifely constancy.

NANDI. A white bull; the mount of Shiva and his consort. (*Figure 75*)

NARADA. Inventor of the *vina* and chief of the Gandharvas or heavenly musicians.

NARASIMHA. The Man-lion, fourth incarnation of Vishnu. The demon king, Hiranyakasipu, had attempted to kill his son, Prahlada, who claimed that Vishnu was everywhere. The king asked his son if Vishnu was present even in the stone pillars of the hall. To vindicate Prahlada and assert his might, Vishnu at once took the form of a Man-lion, issued from a pillar and tore the king to pieces. (*Figure 4*)

NITAI. With Gaur, a disciple of Chaitanya (*q.v.*).

PANCHANANA. Shiva in his five-headed form; 'five-headed' since he is believed to rule 'the five directions, the five elements, the five human races and the five senses'.

PARASURAMA. Rama with the axe, sixth incarnation of Vishnu.

PARVATI. Consort of Shiva, daughter of Himavat (*q.v.*) and mother of Ganesha. In Bengal, often interchangeable with Durga.

PAVANA. The wind god.

PUTANA. A female demon, daughter of Bali. She attempted to kill the infant Krishna by suckling him with poisoned breasts, but was instead sucked to death by him.

RADHA. Krishna's principal milkmaid love; wife of Jasoda's brother, Ayana, one of the cowherds amongst whom Krishna was reared. Her romance with Krishna is interpreted as an allegory of the soul's union with God and as symbolizing the claims of love over duty. (*Figures 7, 52*)

RADHIKA. Diminutive of Radha.

RAMA. Eldest son of Raja Dasaratha of Ayodhya. Seventh incarnation of the god Vishnu. His life story is given in the epic, the *Ramayana*. Most popular in Indian painting are the episodes relating to his exile with his wife Sita and brother Lakshmana, the abduction of Sita by Ravana, demon king of Ceylon, and the war with Ravana that followed. (*Figures 15, 88*)

RAVANA. Demon king of Lanka (Ceylon) who abducted Sita, wife of Rama, thus provoking a long war in which Rama, assisted by his monkey and bear allies, eventually overcame and slew Ravana and his demon hosts. (*Figures 14, 44*)

REVATI. Wife of Balarama.

SARASWATI. Goddess of learning and patroness of art, music and the sciences. Consort first of Vishnu and later of Brahma. She is often shown seated on lotuses and holding a *vina*.

SATI. Wife of Shiva, daughter of Daksha (son of Brahma). Because of a quarrel between her father and her husband, she burnt herself to death on her father's sacrificial fire. Shiva expressed his grief by dancing with her

body in his arms. His wild dance so disturbed the universe that Vishnu cut her body into fifty pieces with his quoit, each place where a portion of her body fell becoming sacred. Sati was later reborn as Shiva's wife, Parvati.

SATYABHAMA. Daughter of Satrajit and second of Krishna's eight wives. Krishna took her to Indra's heaven where she persuaded him to bring back the Parijata (heavenly wishing tree).

SATYAVAN. See SAVITRI.

SAVITRI. Daughter of King Aswapati and lover of Satyavan. Although she was warned by a seer that Satyavan had only a year to live, she insisted on marrying him. When the day of his death arrived, he went to the forest to cut wood. Savitri followed him and as he fell dying she caught him in her arms. Yama, the god of death, came to take his spirit away to the underworld, but Savitri followed and refused to turn back. Yama offered her three boons as long as she did not ask for the life of her husband; but still Savitri followed and at last the god of death, moved by her pleading, relented and restored her husband to life.

SHASHTHI. Goddess of childbirth and children; her vehicle a cat. (*Figure 53*)

SHIVA. Procreator and Destroyer. Third member of the Hindu trinity, though regarded by his special followers as the supreme deity. Consort of Devi in her various forms. Under the names of Mahakala and Bhairava, he is the great destroying power. As Shiva or Mahadeva, on the other hand, he perpetually restores what has been destroyed. In this role he is symbolized by the *lingam* or phallus, typical of reproduction, and under this form alone or combined with the *yoni* or female organ, representative of female energy, he is normally worshipped. As Mahayogi, the great ascetic, he exemplifies the power of austere penance and abstract meditation to influence life and the universe. As Panchanana, the five-faced, he controls the five directions and the five senses. In his role of destroyer and ascetic he wears matted locks and a necklace of human heads, with snakes coiled around his arms and neck. He sits upon the skin of a tiger or an elephant, his body white with ashes, and holds a deer horn in his hand. The river Ganges flows from his head. In his forehead he has a third eye underlined by a small crescent moon. His vehicle is the white bull Nandi, a further symbol of reproduction. Although active and

powerful in his own right, he is subservient to his consort Devi, who as Kali, tramples him underfoot in a dance of victory. (*Figures 13, 19, 45, 75*)

SITA. Wife of Rama. She was abducted by Ravana, demon king of Lanka (Ceylon) but later rescued by her husband and his brother, Lakshmana, with the help of bear and monkey armies. On their victorious return, Rama, after making her pregnant, sent her into exile because of unjust doubts concerning her chastity while in captivity. During her exile she gave birth to twin sons, Kusha and Lava. She was at length recalled by Rama and while declaring her innocence was swallowed up by Earth in proof of her virtue. She later came to symbolize the Hindu ideals of feminine purity and conjugal devotion. In paintings, Sita is frequently shown enthroned with Rama and his brother, Lakshmana, and attended by Hanuman, the monkey chief. (*Figures 15, 44*)

SITALA. Goddess of smallpox who rides on an ass; a form of Devi as goddess of disease.

SUBHADRA. Daughter of Vasudeva, sister of Krishna and wife of Arjuna. She is chiefly associated with Krishna in his form of Jagannatha and appears with him and Balbhadra (Balarama) as the third member of a trinity worshipped at the Jagannatha temple, Puri, Orissa. (*Figure 11*)

SUGRIVA. A monkey king dethroned by his brother Bali, but later reinstated by Rama as king of Kishkindhya. With his adviser, Hanuman, and their army of monkeys he acted as an ally of Rama in his war against Ravana. (*Figure 88*)

SURPANAKHA. Sister of Ravana, demon king of Lanka (Ceylon). She fell in love first with Rama and then with Lakshmana, who both spurned her advances. Suspecting that Lakshmana was in love with Rama's wife, Sita, she tried to swallow her. Lakshmana, however, attacked Surpanakha, cutting off her breasts, nose and ears. In revenge for this treatment, she instigated Ravana to abduct Sita. Later she was killed by Rama.

SURYA. The sun god.

TARAKESHWAR. A Shaivite temple near Calcutta and a rival to Kalighat. See Introduction, p.12.

TELEBO. Maid-servant in Elokeshi's house and procuress for the Mahant of Tarakeshwar. See Introduction, p.13. (*Figures 27, 28*)

UMA. 'Light'; pseudonym for Parvati, wife of Shiva.

VAMANA. The Brahmin dwarf, fifth incarnation of Vishnu. By piety and devotions, Bali, a titan king, had acquired power over the three worlds to the chagrin and discomfiture of the gods. To rectify the situation, Vishnu intervened. As Vamana, he asked Bali for as much land as he could step over in three paces. The request was granted and Vishnu then took two steps over the whole of heaven and earth. In recognition of Bali's devotion, he halted and left him the nether regions. (*Figure 8*)

VARAHA. The Boar, third incarnation of Vishnu. As destroyer of the demon Hiranyaksha, persecutor of men and gods, he retrieved the earth and holy books, the Vedas, which the demon had dragged down under the waters. (*Figure 5*)

VASUDEVA. Father of Krishna. He had seven wives of whom the youngest, Devaki, was the mother of Krishna. After Krishna's birth, he smuggled the baby out of the prison and took him to the house of the cowherd, Nanda, in Brindaban. (*Figure 48*)

VISHNU. Loving Preserver and Restorer; second member of the Hindu trinity; consort of Lakshmi. He is often portrayed seated on a lotus or on his bird-vehicle Garuda, or lying on the serpent of eternity (*Figure 51*). He is handsome and blue in colour. For his ten incarnations, in which he appeared on earth in order to correct evils, see (1) Matsya; (2) Kurma; (3) Varaha; (4) Narasimha; (5) Vamana; (6) Parasurama; (7) Rama; (8) Krishna; (9) Jagannatha or Buddha; (10) Kalki.

VISVAKARMA. Architect and carpenter of the gods. In making a wooden elephant, he is supposed to have succeeded first in only making a creature as small as a mouse—thus leading to a Bengali pun on *hati* ('elephant' and 'nothing'). See Archer (1962), plate 21 (note).

YAMA. God of death and judge of the dead.

Concordance

Museum number	Catalogue number	Figure number	Museum number	Catalogue number	Figure number
08144(a)	11,i		I.M.120–1914	31,xv	73
08144(b)	11,ii	20	I.M.121–1914	31,xvi	
D.652–1889	4,i		I.M.122–1914	31,xvii	
D.653–1889	4,ii		I.M.123–1914	31,xviii	
D.654–1889	4,iii		I.M.124–1914	31,xix	
D.655–1889	4,iv		I.M.125–1914	31,xx	
D.656–1889	4,v		I.M.126–1914	31,xxi	
D.657–1889	4,vi	8	I.M.127–1914	31,xxii	
D.658–1889	4,vii		I.M.128–1914	31,xxiii	
D.659–1889	4,viii.		I.M.129–1914	31,xxiv	
D.660–1889	4,ix		I.M.130–1914	31,xxv	
D.661–1889	4,x	7	I.M.131–1914	31,xxxvi	
D.662–1889	4,xi		I.M.132–1914	31,xxvi	
D.663–1889	4,xii		I.M.133–1914	31,xxvii	
D.664–1889	4,xiii		I.M.134–1914	31,xxviii	
D.665–1889	4,xiv		I.M.135–1914	31,xxx	
D.666–1889	4,xv		I.M.136–1914	31,xxxi	
D.667–1889	4,xvi		I.M.137–1914	31,xxxii	31
I.M.106–1914	31,i		I.M.138-1914	31,xxxiii	41
I.M.107–1914	31,ii		I.M.139–1914	31,xxxvii	
I.M.108–1914	31,iii		I.M.140–1914	31,xxxiv	36
I.M.109–1914	31,iv		I.M.141–1914	31,xxxv	74
I.M.110–1914	31,v		I.M.146–1914	31,xxix	
I.M.111–1914	31,vi		I.M.2(61)–1917	5,i	
I.M.112–1914	31,vii		I.M.2(62)–1917	5,ii	9
I.M.113–1914	31,viii		I.M.2(72)–1917	5,iii	
I.M.114–1914	31,ix		I.M.2(73)–1917	32,i	
I.M.115–1914	31,x		I.M.2(74)–1917	5,iv	
I.M.116–1914	31,xi		I.M.2(75)–1917	5,v	
I.M.117–1914	31,xii		I.M.2(76)–1917	5,vi	
I.M.118–1914	31,xiii		I.M.2(77)–1917	5,vii	
I.M.119–1914	31,xiv	72	I.M.2(78)–1917	5,viii	

Museum number	Catalogue number	Figure number	Museum number	Catalogue number	Figure number
I.M.2(79)–1917	5,ix	10	I.S.204–1950	I,xii	
I.M.2(80)–1917	5,x		I.S.205–1950	I,xiii	
I.M.2(81)–1917	5,xi		I.S.206–1950	I,xiv	
I.M.2(82)–1917	5,xiv		I.S.207–1950	I,xv	
I.M.2(83)–1917	5,xii		I.S.208–1950	I,xvi	
I.M.2(85)–1917	5,xiii		I.S.209–1950	I,xxxi	I
I.M.2(86)–1917	14	27	I.S.210–1950	I,xxxii	2
I.M.2(170)–1917	22,i		I.S.211–1950	I,xxxiii	
I.M.2(185)–1917	32,ii	45	I.S.212–1950	I,xvii	
I.M.2(186)–1917	22,ii		I.S.213–1950	I,xxxiv	3
I.M.2(187)–1917	32,iv		I.S.214–1950	I,xviii	
I.M.2(188)–1917	32,vii		I.S.215–1950	I,xxviii	
I.M.2(189)–1917	32,v		I.S.216–1950	I,xix	
I.M.2(190)–1917	32,iii	75	I.S.217–1950	I,xx	
I.M.2(191)–1917	22,iii		I.S.218–1950	I,xxix	
I.M.2(193)–1917	22,iv		I.S.219–1950	I,xxx	
I.M.2(194)–1917	22,v		I.S.220–1950	I,xxi	
I.M.2(195)–1917	22,vi		I.S.221–1950	I,xxii	
I.M.2(197)–1917	32,vi		I.S.222–1950	I,xxiii	
I.S.2–1949	24,i		I.S.223–1950	I,xxiv	
I.S.3–1949	21,i		I.S.224–1950	I,xxv	
I.S.4–1949	24,ii		I.S.225–1950	I,xxvi	
I.S.5–1949	8		I.S.226–1950	33	
I.S.75–1949	21,ii	44	I.S.462–1950	7,i	
I.S.76–1949	24,iii	49	I.S.463–1950	7,ii	
I.S.77–1949	21,iii		I.S.464–1950	7,iii	
I.S.187–1949	35		I.S.465–1950	7,iv	15
I.S.192–1950	I,i		I.S.466–1950	7,v	
I.S.193–1950	I,ii		I.S.467–1950	7,vi	
I.S.194–1950	I,iii		I.S.468–1950	7,vii	
I.S.195–1950	I,xxvii		I.S.469–1950	40,ii	86
I.S.196–1950	I,iv		I.S.470–1950	40,i	
I.S.197–1950	I,v		I.S.534–1950	25,i	52
I.S.198–1950	I,vi		I.S.535–1950	25,ii	
I.S.199–1950	I,vii		I.S.536–1950	25,iii	
I.S.200–1950	I,viii		I.S.537–1950	25,iv	
I.S.201–1950	I,ix		I.S.538–1950	25,v	
I.S.202–1950	I,x		I.S.539–1950	25,vi	
I.S.203–1950	I,xi		I.S.540–1950	25,vi	

Museum number	Catalogue number	Figure number	Museum number	Catalogue number	Figure number
I.S.541–1950	25,viii		I.S.580–1950	25,xlvii	
I.S.542–1950	25,ix		I.S.581–1950	25,xlviii	
I.S.543–1950	25,x		I.S.582–1950	25,xlix	
I.S.544–1950	25,xi		I.S.583–1950	25,l	
I.S.545–1950	25,xii		I.S.584–1950	25,li	
I.S.546–1950	25,xiii		I.S.585–1950	25,lii	
I.S.547–1950	25,xiv		I.S.586–1950	25,liii	
I.S.548–1950	25,xv		I.S.587–1950	25,liv	
I.S.549–1950	25,xvi		I.S.588–1950	25,lv	
I.S.550–1950	25,xvii		I.S.589–1950	25,lvi	
I.S.551–1950	25,xviii		I.S.590–1950	25,lvii	
I.S.552–1950	25,xix		I.S.591–1950	25,lviii	
I.S.553–1950	25,xx		I.S.592–1950	25,lix	
I.S.554–1950	25,xxi		I.S.593–1950	25,lx	
I.S.555–1950	25,xxii	50	I.S.594–1950	25,lxi	
I.S.556–1950	25,xxiii		I.S.595–1950	25,lxii	
I.S.557–1950	25,xxiv		I.S.596–1950	25,lxiii	
I.S.558–1950	25,xxv		I.S.597–1950	25,lxiv	
I.S.559–1950	25,xxvi		I.S.598–1950	25,lxv	
I.S.560–1950	25,xxvii		I.S.599–1950	25,lxvi	
I.S.561–1950	25,xxviii		I.S.600–1950	25,lxvii	
I.S.562–1950	25,xxix		I.S.601–1950	25,lxviii	
I.S.563–1950	25,xxx		I.S.602–1950	25,lxix	
I.S.564–1950	25,xxxi		I.S.603–1950	25,lxx	
I.S.565–1950	25,xxxii		I.S.604–1950	25,lxxi	
I.S.566–1950	25,xxxiii		I.S.605–1950	25,lxxii	
I.S.567–1950	25,xxxiv	51	I.S.606–1950	25,lxxiii	
I.S.568–1950	25,xxxv		I.S.607–1950	25,lxxiv	
I.S.569–1950	25,xxxvi		I.S.608–1950	25,lxxv	
I.S.570–1950	25,xxxvii		I.S.634–1950	23,xxi	
I.S.571–1950	25,xxxviii		I.S.635–1950	23,xxvi	
I.S.572–1950	25,xxxix		I.S.636–1950	23,xvii	
I.S.573–1950	25,xl		I.S.637–1950	23,xiii	
I.S.574–1950	25,xli	53	I.S.638–1950	23,xii	
I.S.575–1950	25,xlii		I.S.639–1950	23,xxii	
I.S.576–1950	25,xliii		I.S.640–1950	23,xxvii	
I.S.577–1950	25,xliv		I.S.641–1950	23,xxix	
I.S.578–1950	25,xlv		I.S.642–1950	23,xxviii	
I.S.579–1950	25,xlvi		I.S.643–1950	23,xxx	

Museum number	Catalogue number	Figure number	Museum number	Catalogue number	Figure number
I.S.644–1950	23,xviii		I.S.682–1950	23,vii	
I.S.645–1950	23,xxxvii		I.S.683–1950	32,lvii	47
I.S.646–1950	23,xxxix		I.S.684–1950	23,xx	
I.S.647–1950	23,xliii		I.S.685–1950	23,x	
I.S.648–1950	23,xxxiv		I.S.686–1950	23,xlvii	
I.S.649–1950	23,xlii		I.S.687–1950	23,xxxii	
I.S.650–1950	23,xxxviii		I.S.688–1950	23,liv	
I.S.651–1950	23,xxxvi		I.S.689–1950	23,vi	
I.S.652–1950	23,li		I.S.690–1950	23,xxiii	
I.S.653–1950	23,lii		I.S.691–1950	23,xxiv	
I.S.654–1950	23,l		I.S.692–1950	23,xlvi	
I.S.655–1950	23,lxi		I.S.693–1950	23,xi	
I.S.656–1950	23,xliv		I.S.694–1950	23,xxxi	
I.S.657–1950	23,xlv		I.S.269–1951	43	
I.S.658–1950	23,i	46	I.S.23–1952	18,i	
I.S.659–1950	23,liii		I.S.24–1952	18,iii	34
I.S.660–1950	23,xlix		I.S.25–1952	16	35
I.S.660–1950	23,xlix		I.S.26–1952	18,ii	
I.S.661–1950	23,iv		I.S.27–1952	19,i	
I.S.662–1950	23,xix		I.S.28–1952	19,ii	
I.S.663–1950	23,xl		I.S.29–1952	37,i	
I.S.664–1950	23,v		I.S.30–1952	37,ii	
I.S.665–1950	23,xxxiii		I.S.31–1952	37,iii	78
I.S.666–1950	23,lix		I.S.32–1952	37,iv	
I.S.667–1950	23,xli		I.S.33–1952	37,v	
I.S.668–1950	23,lx		I.S.34–1952	37,vi	
I.S.669–1950	23,xlviii		I.S.35–1952	37,vii	
I.S.670–1950	23,lv		I.S.36–1952	37,viii	80
I.S.671–1950	23,xv		I.S.37–1952	36,iii	
I.S.672–1950	23,xvi	48	I.S.38–1952	36,iv	79
I.S.673–1950	23,lviii		I.S.39–1952	36,v	77
I.S.674–1950	23,xxxv		I.S.40–1952	36,i	
I.S.675–1950	23,viii		I.S.41–1952	36,ii	
I.S.676–1950	23,xxv		I.S.42–1952	39,i	
I.S.677–1950	23,ii		I.S.43–1952	39,ii	
I.S.678–1950	23,xiv		I.S.44–1952	39,iii	
I.S.679–1950	23,iii		I.S.45–1952	39,iv	
I.S.680–1950	23,lv		I.S.46–1952	39,v	
I.S.681–1950	23,ix		I.S.47–1952	41,i	

Museum number	Catalogue number	Figure number	Museum number	Catalogue number	Figure number
I.S.48–1952	41,ii		I.S.272–1955	26,i	
I.S.231–1953	10,i		I.S.273–1955	26,xi	
I.S.232–1953	10,ii		I.S.274–1955	26,xviii	
I.S.233–1953	10,iii		I.S.275–1955	26,xii	
I.S.234–1953	10,iv		I.S.276–1955	26,xvii	
I.S.235–1953	10,v		I.S.277–1955	26,xiii	
I.S.236–1953	10,vi	17	I.S.278–1955	26,xiv	
I.S.237–1953	10,vii		I.S.279–1955	26,xv	
I.S.238–1953	10,viii		I.S.280–1955	26,xvi	
I.S.239–1953	10,xvi	18	I.S.281–1955	26,xix	
I.S.240–1953	10,ix	19	I.S.117–1958	12	21
I.S.241–1953	10,x		I.S.1–1959	27,i	
I.S.242–1953	10,xi		I.S.2–1959	27,ii	
I.S.243–1953	10,xii		I.S.3–1959	27,iii	
I.S.244–1953	10,xiii		I.S.4–1959	27,iv	
I.S.245–1953	10,xiv		I.S.5–1959	27,v	
I.S.246–1953	10,xv		I.S.6–1959	27,vi	
I.S.247–1953	10,xvii		I.S.7–1959	27,vii	
I.S.256–1953	20,iii		I.S.8–1959	27,viii	
I.S.257–1953	20,iv	43	I.S.9–1959	27,ix	
I.S.258–1953	20,i		I.S.10–1959	27,x	
I.S.259–1953	20,ii		I.S.11–1959	27,xi	
I.S.2–1954	42	83	I.S.12–1959	27,xii	
I.S.12–1954	15,i		I.S.13–1959	27,xiii	
I.S.13–1954	15,ii		I.S.14–1959	27,xiv	
I.S.2–1955	9,i		I.S.15–1959	27,xv	
I.S.3–1955	9,ii	16	I.S.16–1959	27,xvi	
I.S.90–1955	3	6	I.S.17–1959	27,xvii	
I.S.261–1955	26,xxi	55	I.S.18–1959	27,xviii	
I.S.262–1955	26,xx	54	I.S.19–1959	27,xix	
I.S.263–1955	26,ii		I.S.20–1959	27,xx	
I.S.264–1955	26,iii		I.S.21–1959	27,xxi	
I.S.265–1955	26,iv		I.S.22–1959	27,xxii	
I.S.266–1955	26,v		I.S.23–1959	27,xxiii	
I.S.267–1955	26,vi		I.S.24–1959	27,xxiv	
I.S.268–1955	26,vii		I.S.25–1959	27,xxv	
I.S.269–1955	26,viii		I.S.26–1959	27,xxvi	
I.S.270–1955	26,ix		I.S.27–1959	27,xxvii	
I.S.271–1955	26,x		I.S.28–1959	27,xxviii	

Museum number	Catalogue number	Figure number	Museum number	Catalogue number	Figure number
I.S.29–1959	27,xxix		I.S.95–1959	28,xiv	
I.S.30–1959	27,xxx		I.S.96–1959	28,xv	
I.S.31–1959	27,xxxi		I.S.97–1959	28,xvi	
I.S.32–1959	27,xxxii		I.S.98–1959	28,xvii	
I.S.33–1959	27,xxxiii		I.S.99–1959	28,xviii	
I.S.34–1959	27,xxxiv		I.S.100–1959	28,xix	
I.S.35–1959	27,xxxv		I.S.101–1959	28,xx	
I.S.36–1959	27,xxxvi		I.S.102–1959	28,xxi	
I.S.37–1959	27,xxxvii		I.S.103–1959	28,xxii	
I.S.38–1959	27,xxxviii		I.S.104–1959	28,xxiii	
I.S.39–1959	27,xxxix		I.S.105–1959	28,xxiv	
I.S.40–1959	27,xl		I.S.106–1959	28,xxv	
I.S.41–1959	27,xli		I.S.107–1959	28,xxvi	
I.S.42–1959	27–xlii		I.S.108–1959	28,xxvii	
I.S.43–1959	27,xliii		I.S.109–1959	28,xxviii	
I.S.44–1959	27,xliv		I.S.110–1959	28,xxix	
I.S.71–1959	2,i	5	I.S.111–1959	28,xxx	
I.S.72–1959	2,ii	4	I.S.112–1959	28,xxxi	
I.S.73–1959	2,iii		I.S.113–1959	28,xxxii	
I.S.74–1959	2,iv		I.S.114–1959	28,xxxiii	
I.S.75–1959	6,i	11	I.S.115–1959	28,xxxiv	
I.S.76–1959	6,ii	14	I.S.116–1959	28,xxxv	
I.S.77–1959	6,iii		I.S.117–1969	28,xxxvi	
I.S.78–1959	6,iv	13	I.S.118–1959	28,xxxvii	
I.S.79–1959	6,v		I.S.119–1959	28,xxxviii	
I.S.80–1959	6,vi	12	I.S.120–1959	28,xxxix	
I.S.82–1959	28,i	56	I.S.121–1959	28,xl	
I.S.83–1959	28,ii	57	I.S.122–1959	28,xli	
I.S.84–1959	28,iii	58	I.S.123–1959	28,xlii	
I.S.85–1959	28,iv	59	I.S.124–1959	28,xliii	
I.S.86–1959	28,v		I.S.125–1959	28,xliv	
I.S.87–1959	28,vi		I.S.126–1959	28,xlv	
I.S.88–1959	28,vii		I.S.127–1959	28,xlvi	
I.S.89–1959	28,viii		I.S.128–1959	28,xlvii	
I.S.90–1959	28,ix		I.S.129–1959	28,xlviii	
I.S.91–1959	28,x		I.S.130–1959	28,xlix	
I.S.92–1959	28,xi		I.S.131–1959	28,l	
I.S.93–1959	28,xii		I.S.132–1959	28,li	
I.S.94–1959	28,xiii		I.S.133–1959	28,lii	

Museum number	Catalogue number	Figure number	Museum number	Catalogue number	Figure number
I.S.134–1959	28,liii		I.S.173–1959	28,xcii	
I.S.135–1959	28,liv		I.S.174–1959	28,xciii	
I.S.136–1959	28,lv		I.S.175–1959	28,xciv	
I.S.137–1959	28,lvi		I.S.176–1959	28,xcv	
I.S.138–1959	28,lvii		I.S.177–1959	28,xcvi	
I.S.139–1959	28,lviii		I.S.178–1959	28,xcvii	
I.S.140–1959	28,lix		I.S.179–1959	28,xcviii	
I.S.141–1959	28,lx		I.S.180–1959	28,xcix	
I.S.142–1959	28,lxi		I.S.181–1959	28,c	
I.S.143–1959	28,lxii		I.S.182–1959	28,ci	
I.S.144–1959	28,lxiii		I.S.183–1959	28,cii	
I.S.145–1959	28,lxiv		I.S.184–1959	28,ciii	
I.S.146–1959	28,lxv		I.S.185–1959	28,civ	
I.S.147–1959	28,lxvi		I.S.186–1959	28,cv	
I.S.148–1959	28,lxvii		I.S.187–1959	28,cvi	
I.S.149–1959	28,lxviii		I.S.188–1959	28,cvii	
I.S.150–1959	28,lxix		I.S.189–1959	28,cviii	
I.S.151–1959	28,lxx		I.S.190–1959	28,cix	
I.S.152–1959	28,lxxi		I.S.191–1959	28,cx	
I.S.153–1959	28,lxxii		I.S.192–1959	28,cxi	
I.S.154–1959	28,lxxiii		I.S.46–1959	29,i	
I.S.155–1959	28,lxxiv		I.S.47–1959	29,ii	
I.S.156–1959	28,lxxv		I.S.48–1959	29,iii	
I.S.157–1959	28,lxxvi		I.S.49–1959	29,iv	
I.S.158–1959	28,lxxvii		I.S.50–1961	29,v	60
I.S.159–1959	28,lxxviii		I.S.51–1961	29,vi	61
I.S.160–1959	28,lxxix		I.S.52–1961	29,vii	62
I.S.161–1959	28,lxxx		I.S.53–1961	29,viii	63
I.S.162–1959	28,lxxxi		I.S.54–1961	29,ix	
I.S.163–1959	28,lxxxii		I.S.55–1961	29,x	
I.S.164–1959	28,lxxxiii		I.S.56–1961	29,xi	
I.S.165–1959	28,lxxxiv		I.S.57–1961	29,xii	
I.S.166–1959	28,lxxxv		I.S.240–1961	15,iii	37
I.S.167–1959	28,lxxxvi		I.S.264–1961	30,i	
I.S.168–1959	28,lxxxvii		I.S.265–1961	30,ii	
I.S.169–1959	28,lxxxviii		I.S.266–1961	30,iii	
I.S.170–1959	28,lxxxix		I.S.267–1961	30,iv	
I.S.171–1959	28,xc		I.S.268–1961	30,v	
I.S.172–1959	28,xci		I.S.269–1961	30,vi	

Museum number	Catalogue number	Figure number	Museum number	Catalogue number	Figure number
I.S.270–1961	30,vii		I.S.309–1961	30,xlvi	
I.S.271–1961	30,viii		I.S.310–1961	30,xlvii	
I.S.272–1961	30,ix		I.S.311–1961	30,xlviii	
I.S.273–1961	30,x		I.S.312–1961	30,xlix	
I.S.274–1961	30,xi		I.S.313–1961	30,l	
I S.275–1961	30,xii		I.S.314–1961	30,li	
I S.276–1961	30,xiii		I.S.315–1961	30,lii	
I.S.277–1961	30,xiv		I.S.316–1961	30,liii	
I.S.278–1961	30,xv		I.S.317–1961	30,liv	
I.S.279–1961	30,xvi		I.S.318–1961	30,lv	
I.S.280–1961	30,xvii	64	I.S.319–1961	30,lvi	
I.S.281–1961	30,xviii	65	I.S.320–1961	30,lvii	
I.S.282–1961	30,xix	66	I.S.321–1961	30,lviii	
I.S.283–1961	30,xx	67	I.S.322–1961	30,lix	
I.S.284–1961	30,xxi		I.S.323–1961	30,lx	
I.S.285–1961	30,xxii		I.S.324–1961	30,lxi	
I.S.286–1961	30,xxiii		I.S.325–1961	30,lxii	
I.S.287–1961	30,xxiv		I.S.326–1961	30,lxiii	
I.S.288–1961	30,xxv	68	I.S.327–1961	30,lxiv	
I.S.289–1961	30,xxvi	69	I.S.328–1961	30,lxv	
I.S.290–1961	30,xxvii	70	I.S.329–1961	30,lxvi	
I.S.291–1961	30,xxviii	71	I.S.330–1961	30,lxvii	
I.S.292–1961	30,xxix		I.S.331–1961	30,lxviii	
I.S.293–1961	30,xxx		I.S.332–1961	30,lxix	
I.S.294–1961	30,xxxi		I.S.333–1961	30,lxx	
I.S.295–1961	30,xxxii		I.S.334–1961	30,lxxi	
I.S.296–1961	30,xxxiii		I.S.335–1961	30,lxxii	
I.S.297–1961	30,xxxiv		I.S.336–1961	30,lxxiii	
I.S.298–1961	30,xxxv		I.S.337–1961	30,lxxiv	
I.S.299–1961	30,xxxvi		I.S.338–1961	30,lxxv	
I.S.300–1961	30,xxxvii		I.S.339–1961	30,lxxvi	
I.S.301–1961	30,xxxviii		I.S.340–1961	30,lxxvii	
I.S.302–1961	30,xxxix		I.S.341–1961	30,lxxviii	
I.S.303–1961	30,xl		I.S.342–1961	30,lxxix	
I.S.304–1961	30,lxi		I.S.343–1961	30,lxxx	
I.S.305–1961	30,xlii		I.S.344–1961	30,lxxxi	
I.S.306–1961	30,xliii		I.S.345–1961	30,lxxxii	
I.S.307–1961	30,xliv		I.S.346–1961	30,lxxxiii	
I.S.308–1961	30,xlv		I.S.347–1961	30,lxxxiv	

Museum number	Catalogue number	Figure number	Museum number	Catalogue number	Figure number
I.S.348–1961	30,lxxxv		I.S.108–1965	17,viii	
I.S.349–1961	30,lxxxvi		I.S.109–1965	17,ix	26
I.S.350–1961	30,lxxxvii		I.S.110–1965	17,x	29
I.S.351–1961	30,lxxxviii		I.S.111–1965	17,xi	30
I.S.352–1961	30,lxxxix		I.S.112–1965	17,xii	39
I.S.353–1961	30,xc		I.S.113–1965	17,xiii	40
I.S.354–1961	30,xci		I.S.50–1968	41,iii	81
I.S.355–1961	30,xcii		I.P.N.2574	34	76
I.S.356–1961	30,xciii		I.P.N.2575	38,iv	
I.S.357–1961	30,xciv		I.P.N.2576	38,vi	
I.S.358–1961	30,xcv		I.P.N.2577	38,i	
I.S.359–1961	30,xcvi		I.P.N.2578	38,ii	
I.S.360–1961	30,xcvii		N.M.W.1	13,i	
I.S.361–1961	30,xcviii		N.M.W.2	13,iii	
I.S.362–1961	30,xcix		N.M.W.3	13,iv	23
I.S.363–1961	30,c		N.M.W.4	13,viii	25
I.S.103–1965	17,i		N.M.W.5	13,ix	24
I.S.103A–1965	17,ii		N.M.W.6	13,v	22
I.S.104–1965	17,iii		N.M.W.7	13,vii	
I.S.104A–1965	17,iv		N.M.W.8	13,x	33
I.S.105–1965	17,v		N.M.W.9	13,vi	
I.S.106–1965	17,vi		N.M.W.10	13,ii	
I.S.107–1965	17,vii	42			

Index

Plates

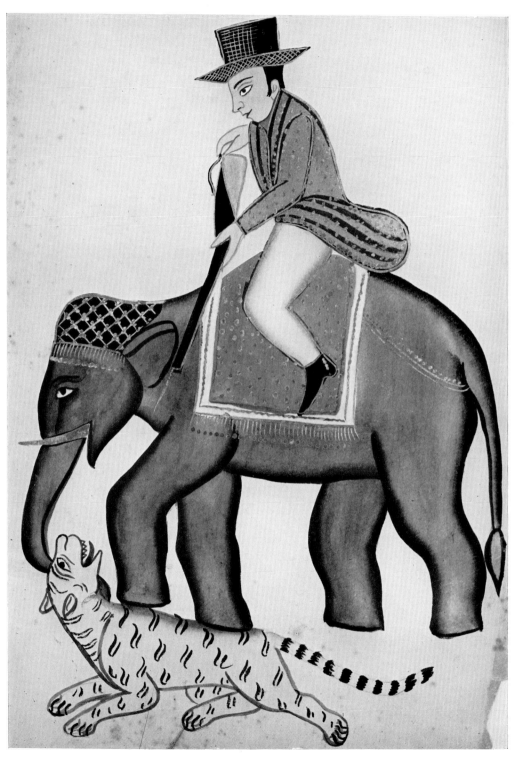

1 Englishman on an elephant, shooting at a tiger. Kalighat, *c.*1830.
I.S.209–1950. Cat.no.1,xxxi: *p.45*

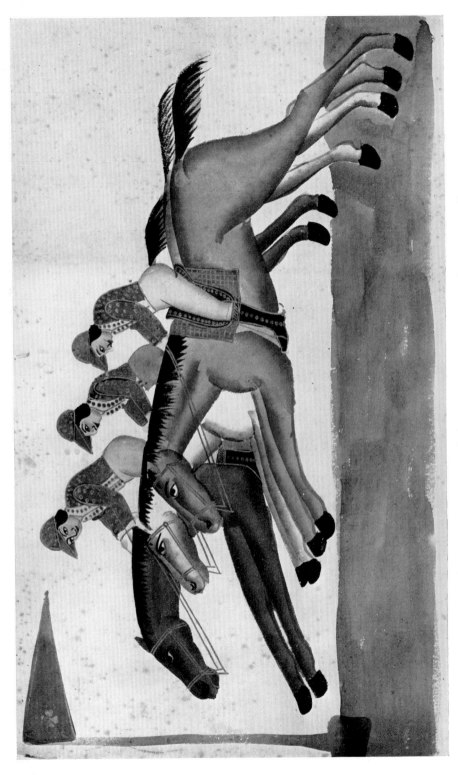

2 Jockeys horse-racing. Kalighat, c.1830. I.S.210–1950. Cat.no.I,xxxii: *p.45*

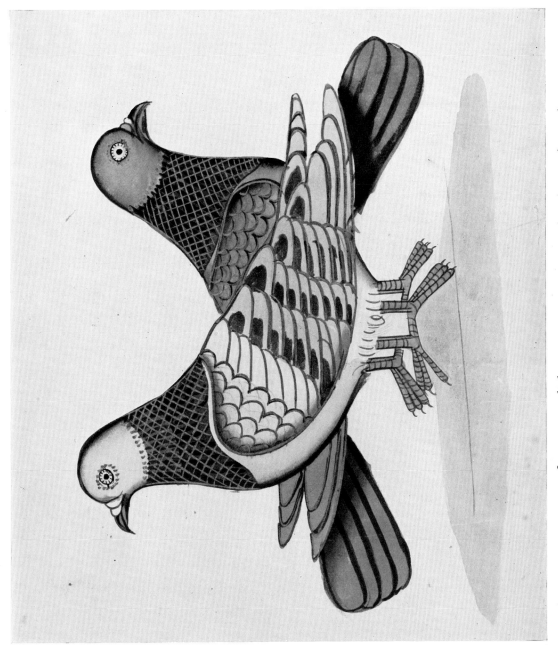

3 A pair of pigeons. Kalighat, c.1830. I.s.213–1950. Cat.no.I,xxxiv: *p.46*

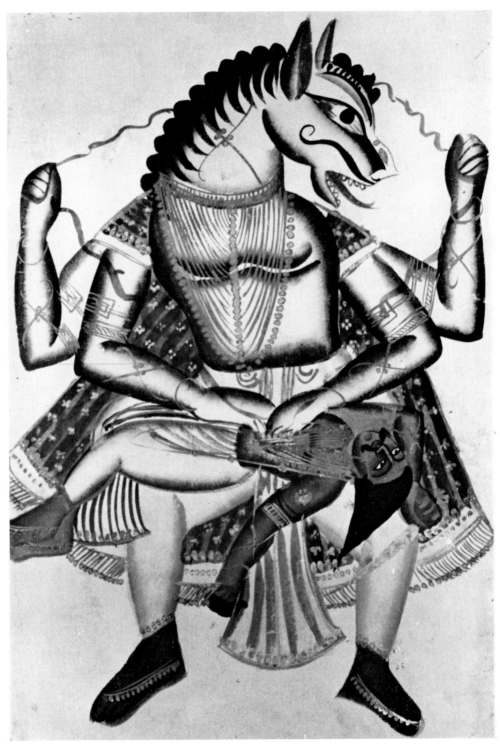

4 Narasimha rending the demon Hiranyakasipu. Kalighat, *c*.1835–1840.
I.S.72–1959. Cat.no.2,ii: *p.47*

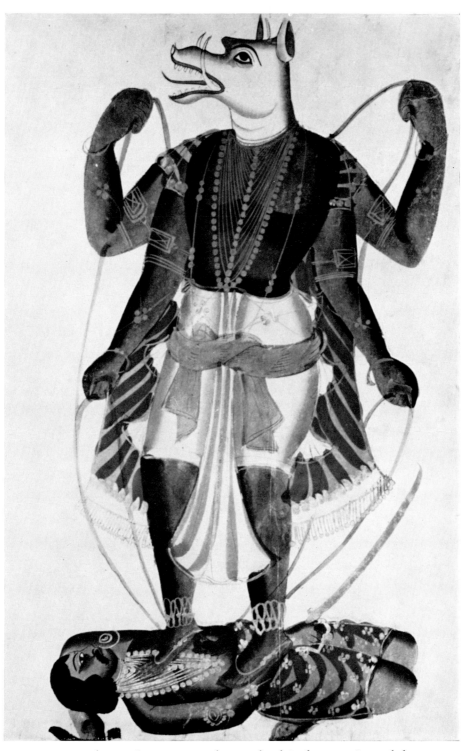

5 Varaha standing in triumph over the slain demon Hiranyaksha.
Kalighat, *c.*1835–1840.I.S.71–1959. Cat.no.2,i: *p.47*

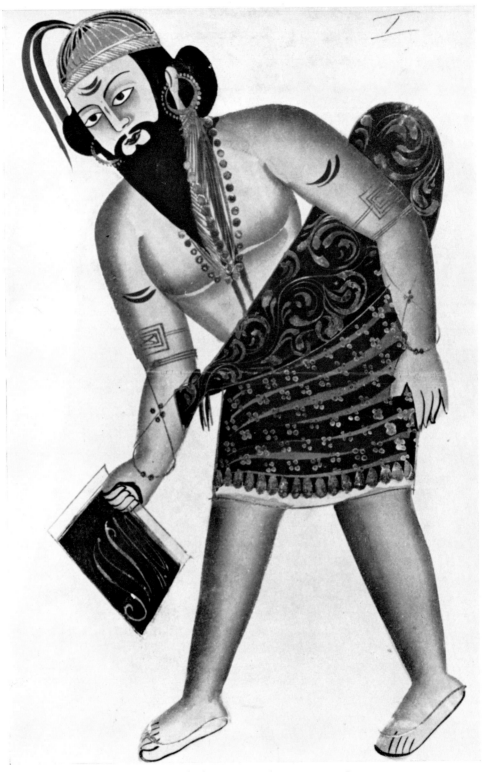

6 Water-carrier. Kalighat, *c.*1830. I.S.90–1955. Cat.no.3: *p.47*

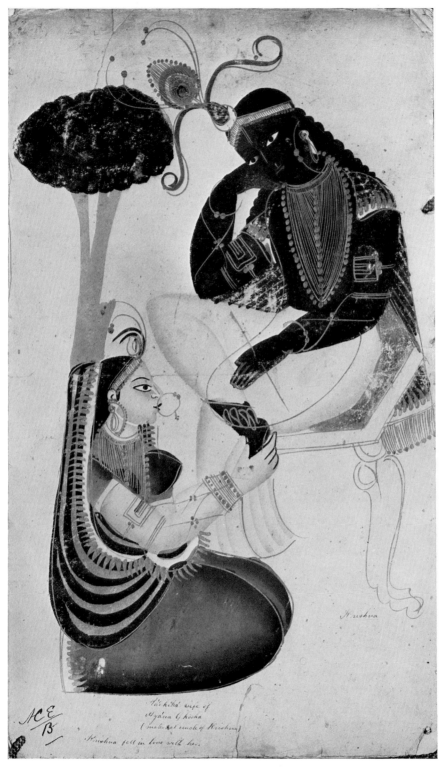

7 Radha at Krishna's feet. Kalighat, *c.*1850. D.661–1889. Cat.no.4,x: *p.48*

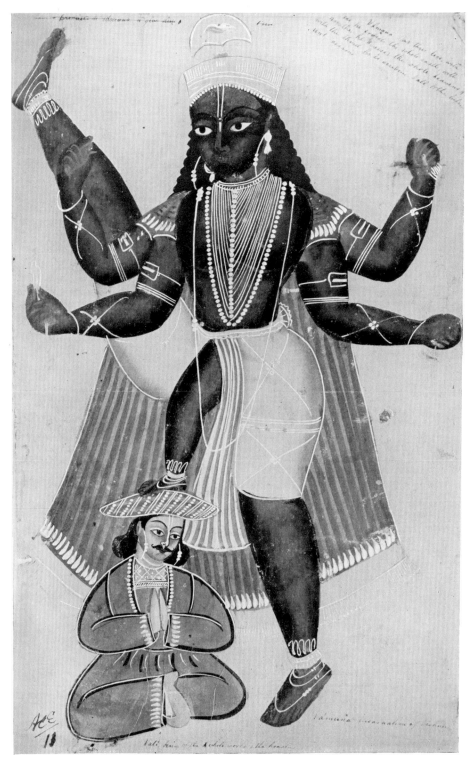

8 Vamana quelling Bali. Kalighat, *c*.1850.
D.657–1889. Cat.no.4,vi: *p.48*

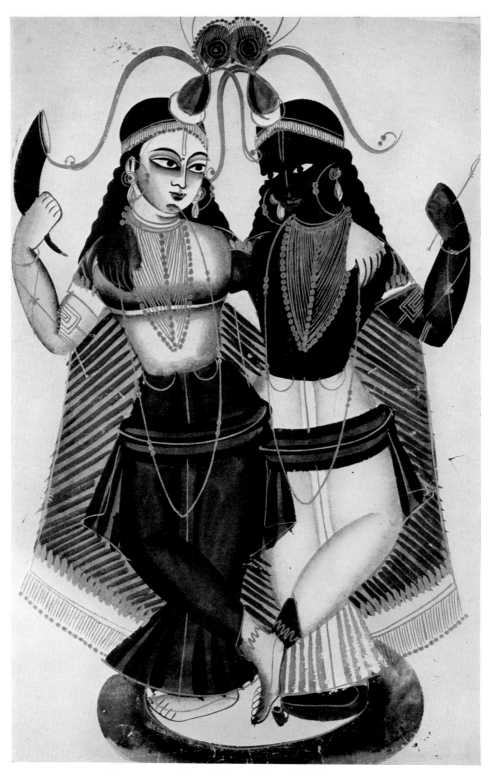

9 Balarama standing with Krishna. Kalighat, *c.*1855–1860.
I.M.2(62)–1917. Cat.no.5,ii: *p.51*

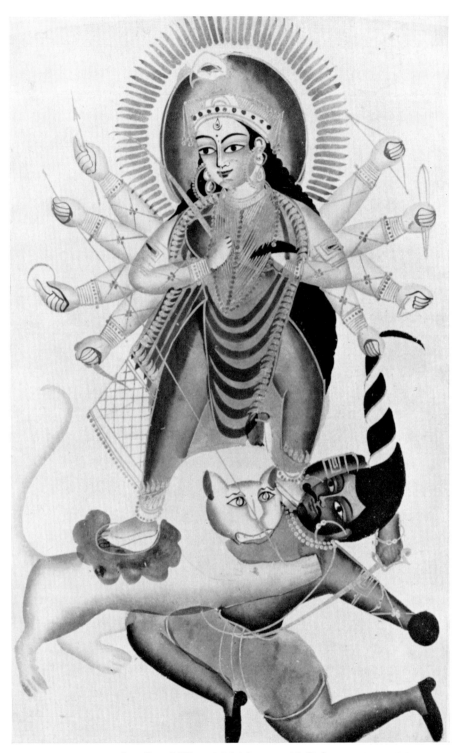

10 Durga on her lion killing Mahishasura. Kalighat, *c.*1855–1860.
I.M.2(79)–1917. Cat.no.5,ix: *p.51*

11 The Jagannatha trio: Balbhadra, Subhadra and Jagannatha. Kalighat, c.1860. I.S.75–1959. Cat.no.6,i: *p.52*

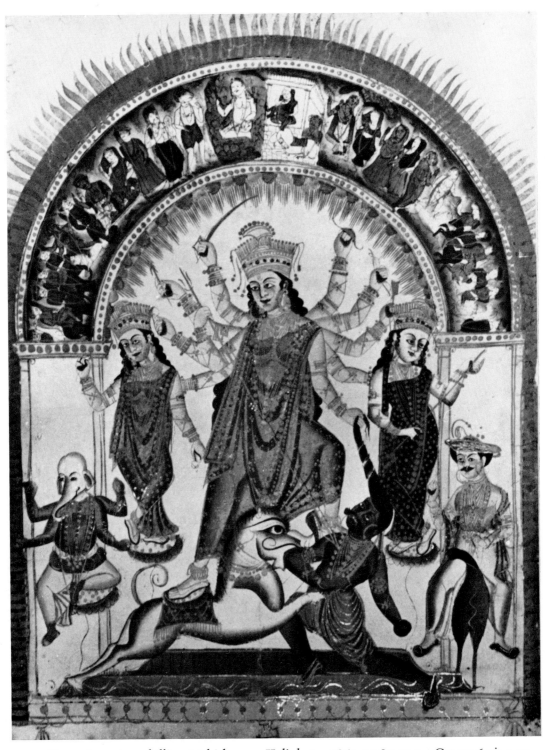

12 Durga in majesty killing Mahishasura. Kalighat, *c.*1860. I.S.80–1959. Cat.no.6,vi: *p.52*

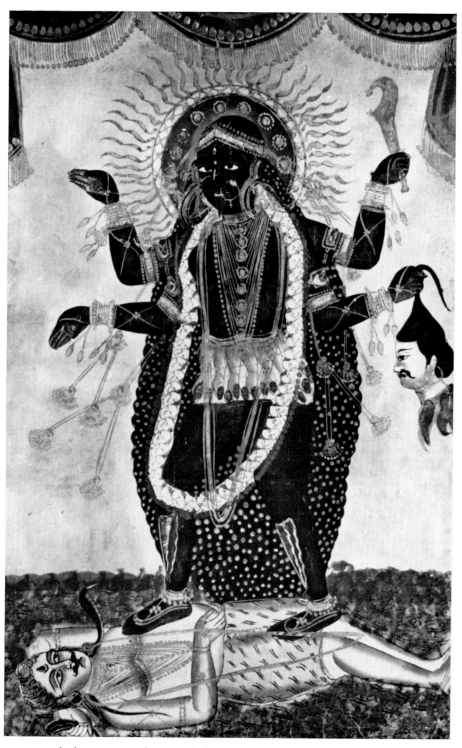

13 Kali dancing on Shiva. Kalighat, *c.*1860. I.S.78–1959. Cat.no.6,iv: *p.52*

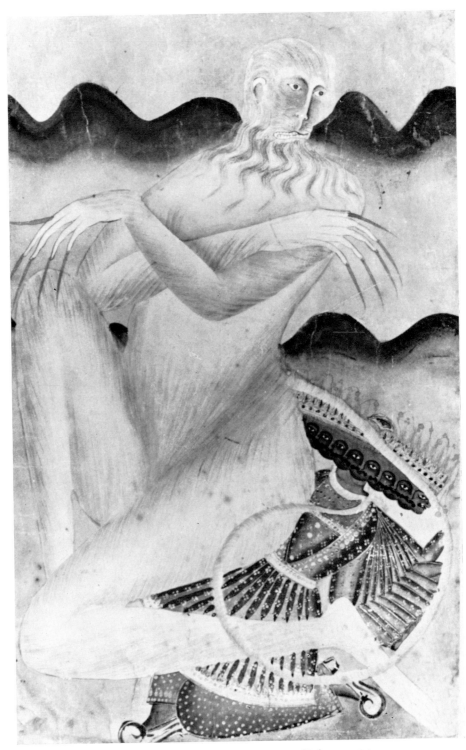

14 Hanuman fighting Ravana. Kalighat, *c.*1860.
1.s.76–1959. Cat.no.6,ii: *p.52*

15 Rama and Sita enthroned; Lakshmana and Hanuman attending.
Kalighat, *c.*1860. 1.s.465–1950. Cat.no.7, iv: *p.52*

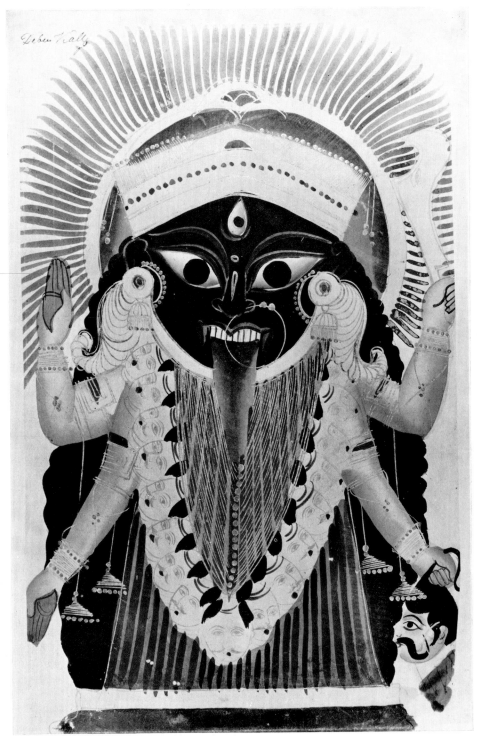

16 Kali. Kalighat, *c.* 1865. I.S.3–1955. Cat.no.,9,ii: *p.53*

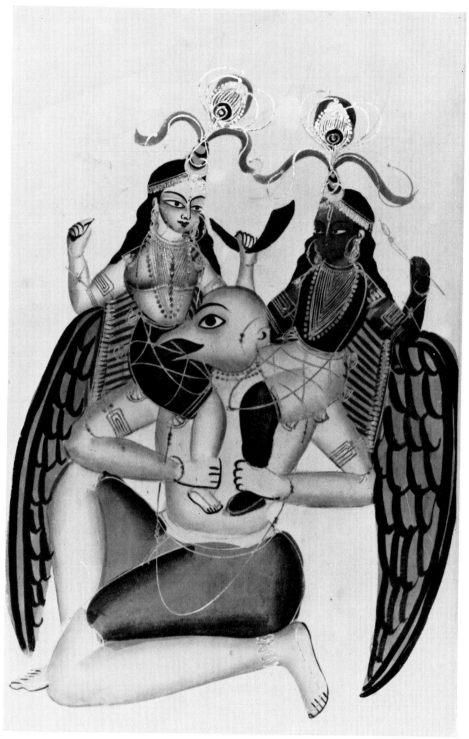

17 Garuda carrying Balarama and Krishna. Kalighat, *c.*1865–1870.
I.S.236–1953. Cat.no.10,vi: *p.54*

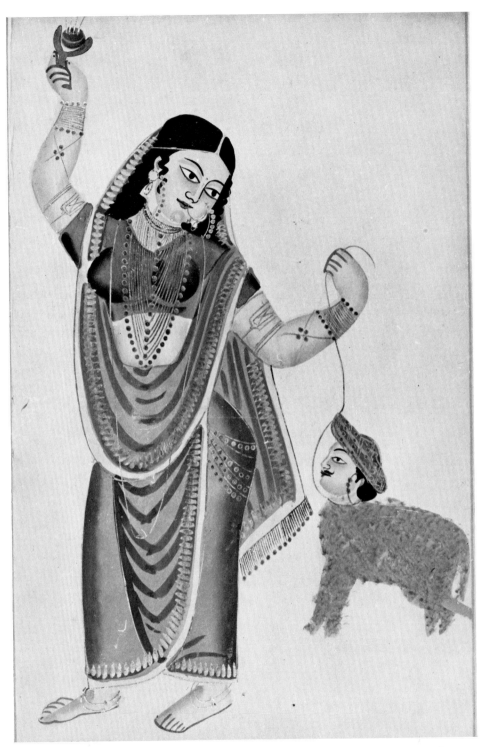

18 The sheepish lover. Kalighat, *c.*1865–1870. I.S.239–1953. Cat.no.10,xvi: *p.54*

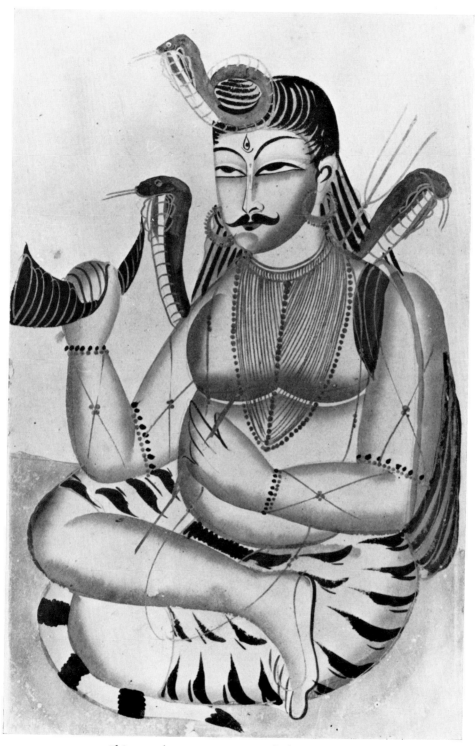

19 Shiva as the great ascetic. Kalighat, *c.*1865–1870.
I.S.240–1953. Cat.no.10,ix: *p.54*

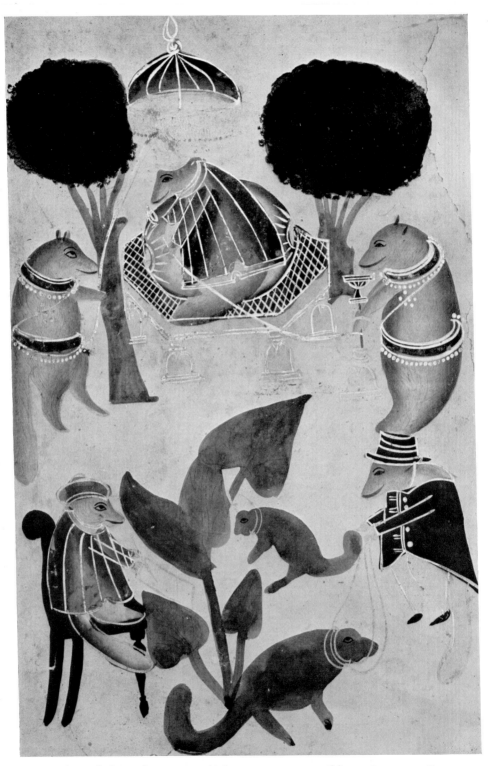

20 The Jackal Raja's court. Kalighat. *c.*1870. 08144(b) i.s. Cat.no.11,ii: *p.55*

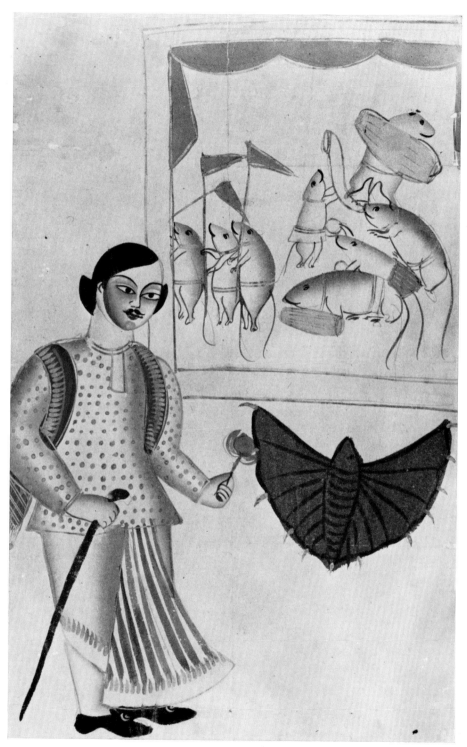

21 The musk-rats' music-party. Kalighat, *c.*1870.
1.S.117–1958. Cat.no.12: *p.55*

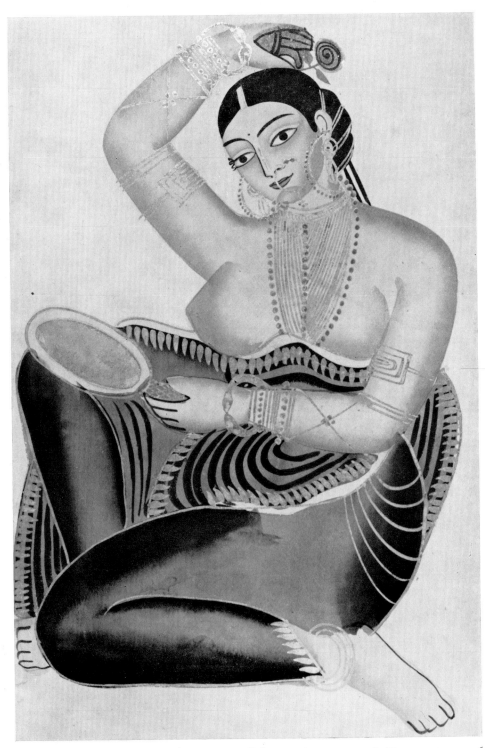

22 Courtesan with rose and mirror. Kalighat, *c.*1875. N.M.W.6. Cat.no.13,v: *p.56*

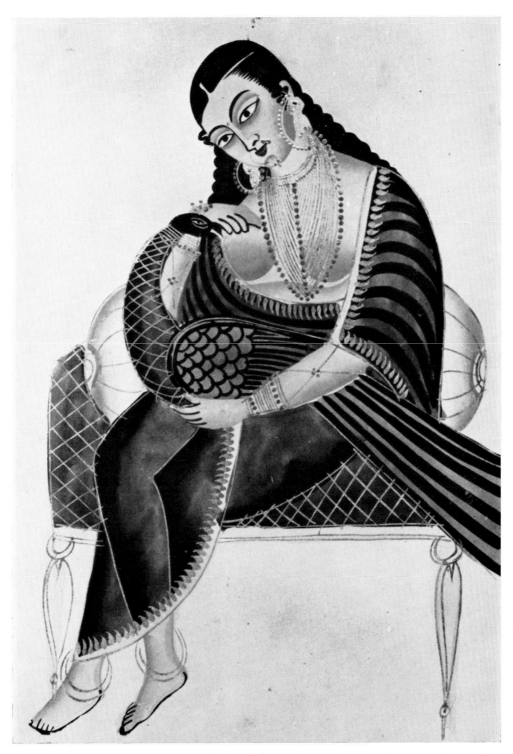

23 Courtesan nursing a peacock. Kalighat, *c.*1875. N.M.W.3. Cat.no.13,iv: *p.56*

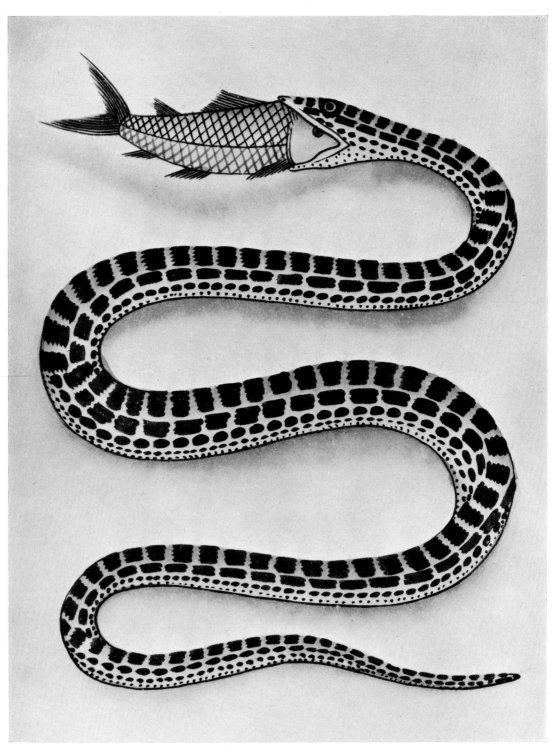

24　Water-snake swallowing a fish. Kalighat, *c*.1875. N.M.W.5. Cat.no.13,ix: *p.57*

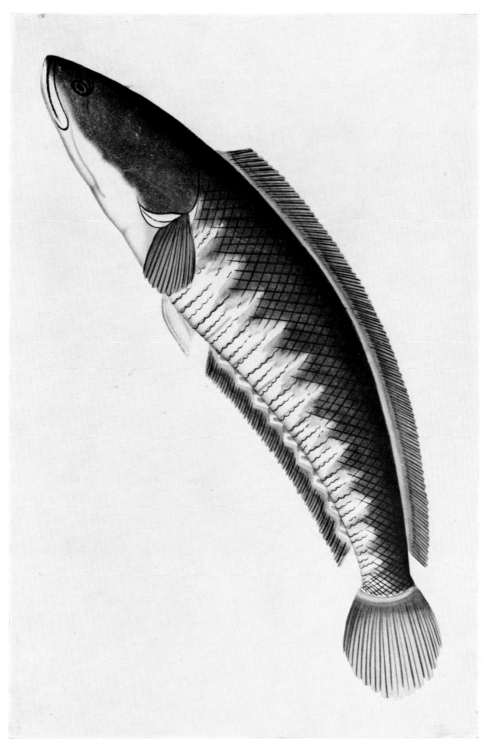

25 Fish. Kalighat, *c.*1875. N.M.W.4. Cat.no.13,viii: *p.57*

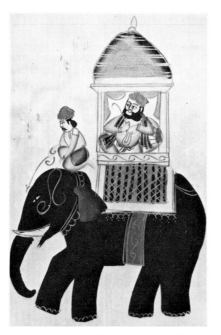

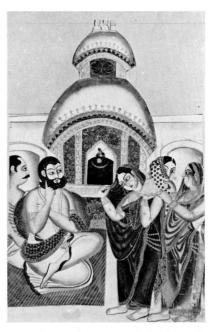

26 The Tarakeshwar murder:
the Mahant of Tarakeshwar rides
out. Kalighat, *c*.1880.
I.S.109–1965. Cat.no.17,ix: *p.61*

27 The Mahant sees Elokeshi at the
Tarakeshwar shrine. Kalighat, *c*.1875.
I.M.2(86)–1917. Cat.no.14: *p.58*

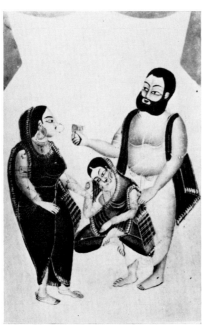

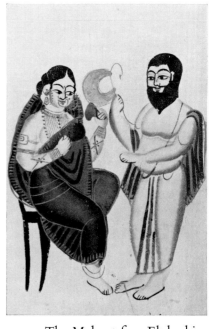

28 Telebo leaves Elokeshi with
the Mahant. Kalighat, *c*.1880.
State Museum, Prague. *P.24*

29 The Mahant fans Elokeshi.
Kalighat, *c*.1880.
I.S.110–1965. Cat.no.17,x: *p.61*

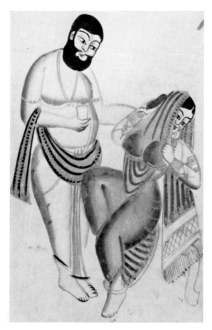

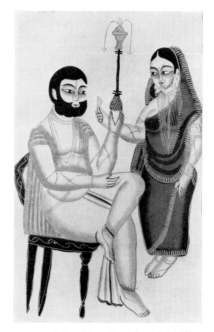

30 The Tarakeshwar murder:
the Mahant plies the reluctant
Elokeshi with Liquor.
Kalighat, *c.*1880. I.S.111–1965.
Cat.no.17, xi: *p.61*

31 Elokeshi offers betel-leaf to
the Mahant. Kalighat, *c.*1890.
I.M.137–1914. Cat.no.31,xxxii:
p.91

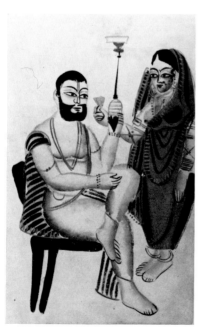

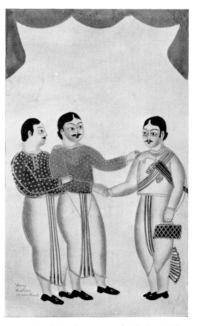

32 Elokeshi offers betel-leaf to
the Mahant. Kalighat. *c.*1880.
Collection Edwin Binney
3rd Brookline, Mass. *P.25*

33 Nabin learns of Elokeshi's
adultery. Kalighat, *c.*1875.
N.M.W.8. Cat.no.13,x: *p.58*

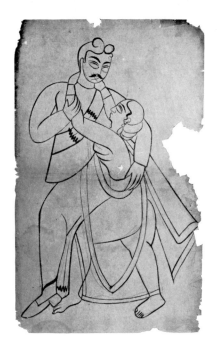

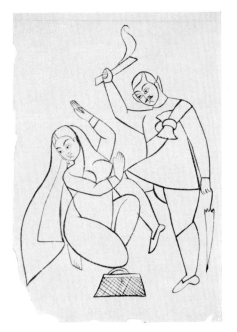

34 The Tarakeshwar murder:
Nabin and Elokeshi reconciled.
By Nibaran Chandra Ghosh,
Kalighat, *c.*1880. I.S.24–1952.
Cat.no.18,iii: *p.62*

35 The fatal blow.
By Nibaran Chandra Ghosh,
Kalighat, *c.*1875.
I.S.25–1952. Cat.no.16: *p.59*

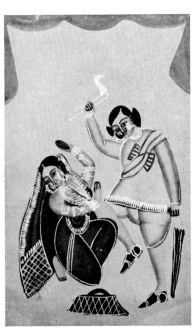

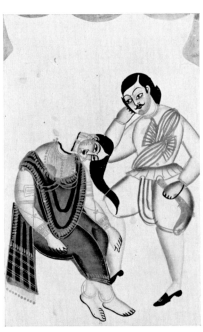

36 The fatal blow.
Kalighat, *c.*1890. I.M.140–1914.
Cat.no.31,xxxiv: *p.91*

37 After the murder.
Kalighat, *c.*1875. I.S.240–1961.
Cat.no.15,iii: *p.59*

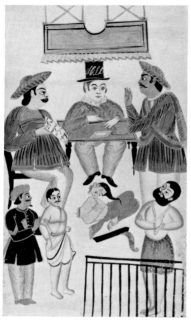

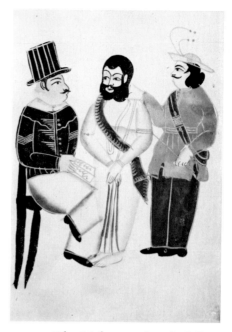

38 The Tarakeshwar murder:
the Mahant's trial. Kalighat,
*c.*1875. Collection Dr O.W.
Samson, London. *P.25*

39 The Mahant arrives in jail.
Kalighat, *c.*1880.
I.S.112–1965. Cat.no.17,xii: *p.61*

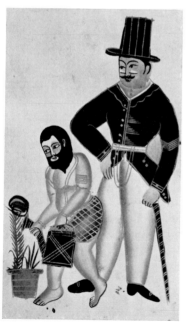

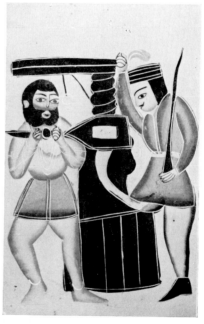

40 The Mahant works as
prison-gardener. Kalighat, *c.*1880.
I.S.113–1965. Cat.no.17,xiii: *p.61*

41 The Mahant turns an oil-press.
Kalighat, *c.*1890. I.M.138–1914.
Cat.no.31,xxxiii: *p.91*

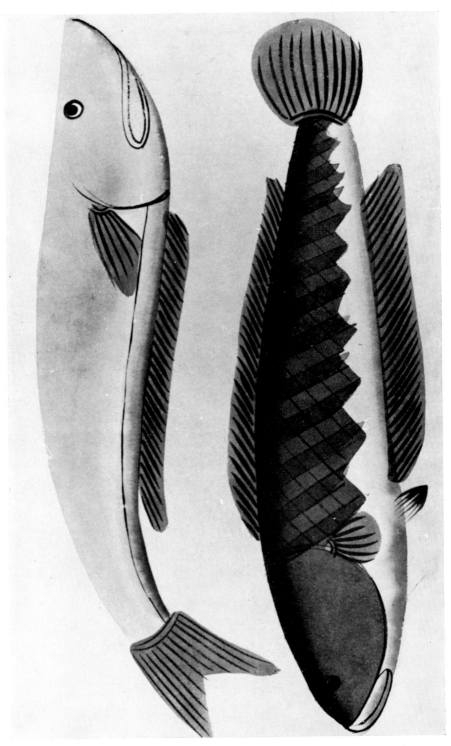

42 Two fish. Kalighat, *c.*1880. I.S.107–1965. Cat.no.17,vii: *p.60*

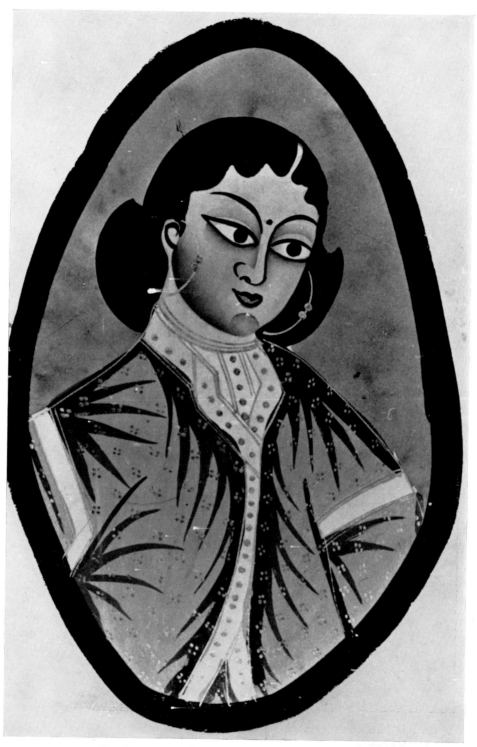

43 Oval portrait of a Calcutta dandy. Kalighat, *c.*1880.
I.S.257–1953. Cat.no.20,iv: *p.63*

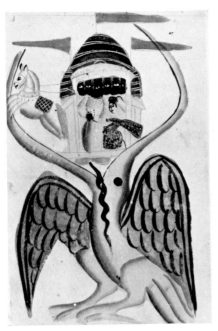

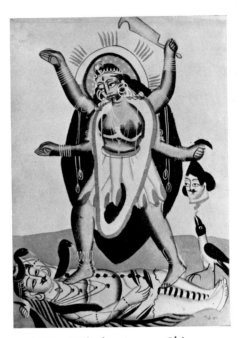

44 Ravana and Sita in the beak of
Jatayu. Kalighat, *c.*1880.
I.S.75–1949. Cat.no.21,ii: *p.64*

45 Kali dancing on Shiva.
Kalighat, *c.*1890.
I.M.2 (185)–1917. Cat.no.32,ii: *p.91*

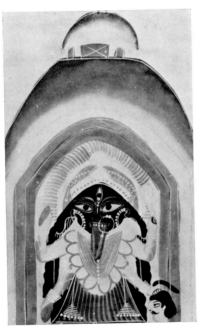

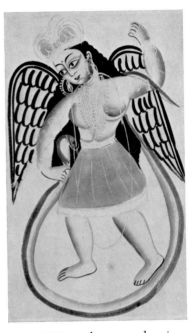

46 Kali enshrined.
Kalighat, *c.*1885.
I.S.658–1950. Cat.no.23,i: *p.65*

47 Winged *apsaras* dancing
with a snake. Kalighat, *c.*1885.
I.S.683–1950. Cat.no.23,lvii: *p.67*

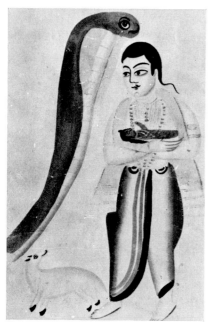

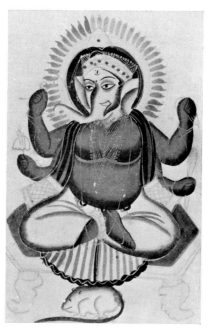

48　Vasudeva, with the infant
Krishna, encounters a cobra
and jackal. Kalighat, *c.*1885.
I.S.672–1950. Cat.no.23,xvi: *p.65*

49　Ganesha enthroned; his vehicle,
the rat, beneath. Kalighat, *c.*1885.
I.S.76–1949. Cat.no.24,iii: *p.68*

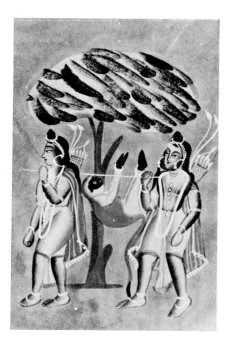

50　Kusha and Lava carrying the
bound Hanuman. Kalighat, *c.*1885.
I.S.555–1950. Cat.no.25,xxii: *p.69*

51　Vishnu resting on Ananta.
Kalighat, *c.*1885.
I.S.567–1950. Cat.no.25,xxxiv: *p.70*

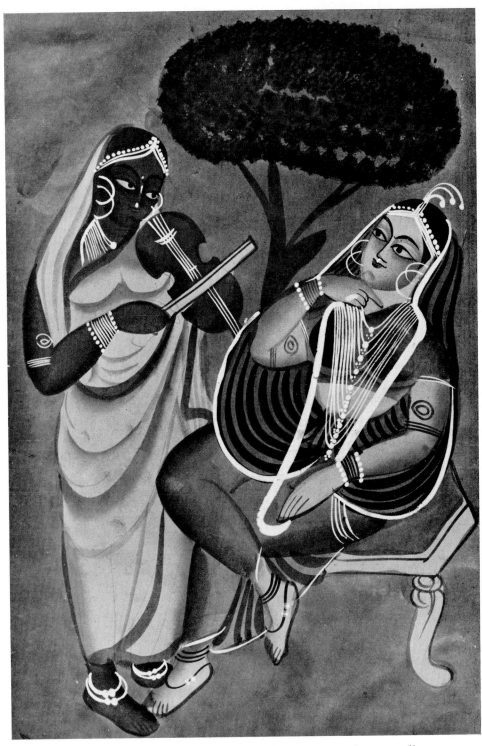

52 Krishna, disguised as a woman, playing a violin to Radha.
Kalighat, *c*.1885. I.S.534–1950. Cat.no.25,i: *p.68*

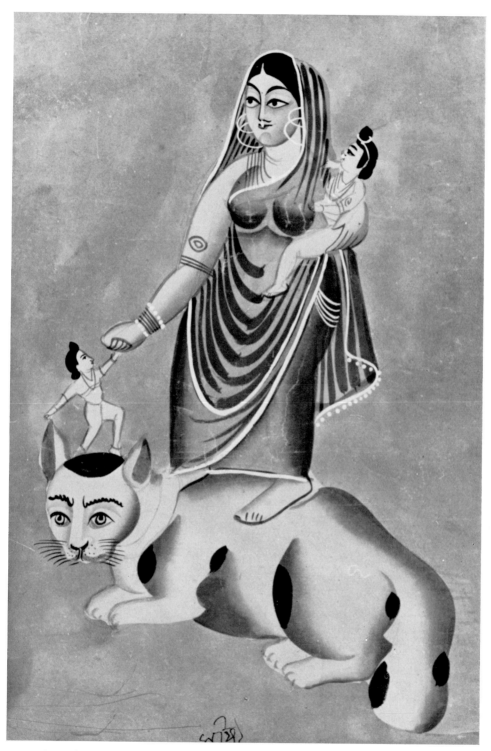

53 Shashthi standing on a cat. Kalighat, *c.*1885. I.S.574–1950. Cat.no.25,xli: *p.70*

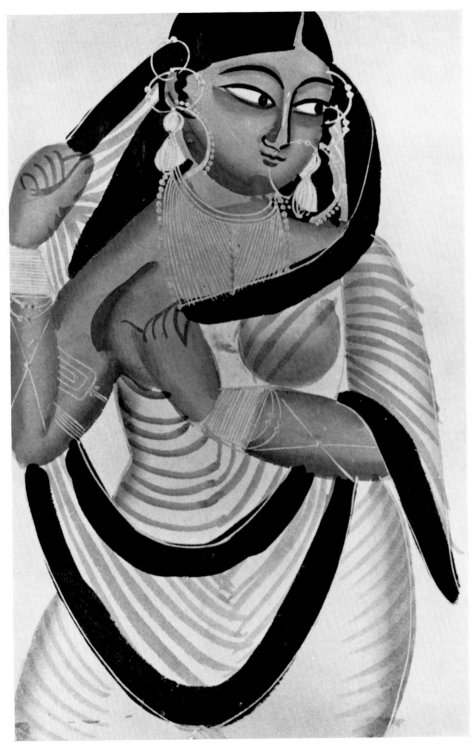

54 Courtesan. Kalighat, *c*.1890. I.S.262–1955. Cat.no.26,xx: *p.73*

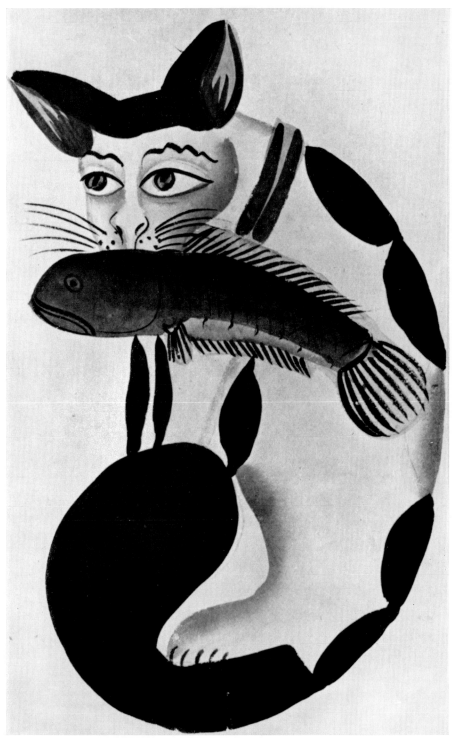

55 Cat with a fish in its mouth. Kalighat, *c.*1890.
I.S.261–1955. Cat.no.26,xxi: *p.73*

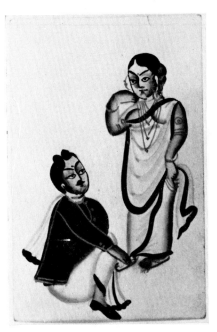

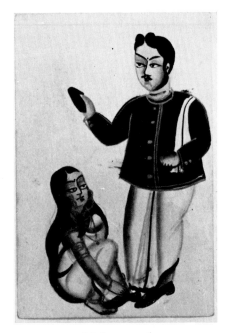

56 Female ascendancy.
Kalighat, c. 1890.
I.S.82–1959. Cat.no.28,i: *p.77*

57 Male ascendancy.
Kalighat, c.1890.
I.S.83–1959. Cat.no.28,ii: *p.77*

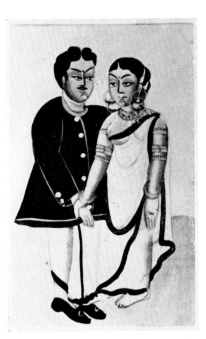

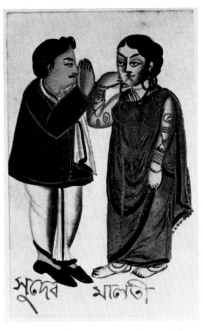

58 Bengali husband and wife.
Kalighat, c.1890.
I.S.84–1959. Cat.no.28,iii: *p.78*

59 Sudeva conversing with
Malati. Kalighat, c.1890.
I.S.85–1959. Cat.no.28,iv: *p.78*

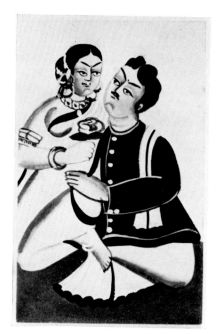

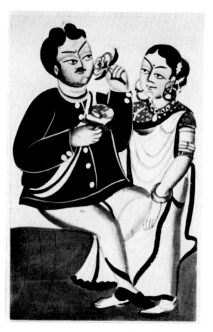

60 Courtesan and client
embracing. Kalighat, *c.*1890.
I.S.50-1961. Cat.no.29,v: *p.84*

61 Client approached by a
courtesan. Kalighat, *c.*1890.
I.S.51–1961. Cat.no.29,vi: *p.84*

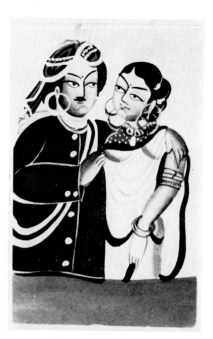

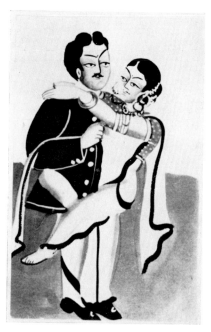

62 Turbaned lover and mistress.
Kalighat, *c.*1890.
I.S.52–1961. Cat.no.29.vii: *p.84*

63 Courtesan embracing a lover.
Kalighat, *c.*1890.
I.S.53–1961. Cat.no.29,viii: *p.84*

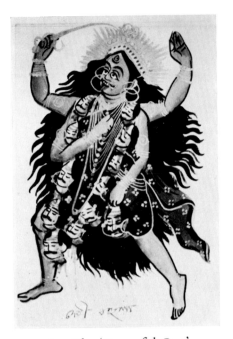

64　Aspects of Devi: the 'Ever-rising
One'. Kalighat, *c*.1890.
I.S.280–1961. Cat.no.30,xvii: *p.85*

65　The 'Powerful One'.
Kalighat, *c*.1890.
I.S.281–1961. Cat.no.30,xviii: *p.85*

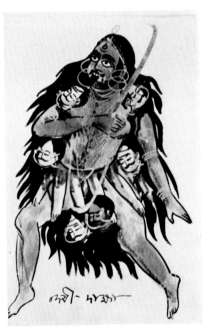

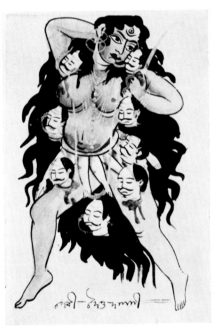

66　The 'Daughter of Daksha'.
Kalighat, *c*.1890.
I.S.282–1961. Cat.no.30,xix: *p.85*

67　The 'Subduer of Demons'.
Kalighat, *c*.1890.
I.S.283–1961. Cat.no.30,xx: *p.85*

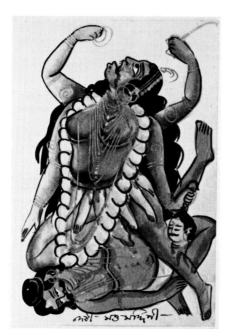

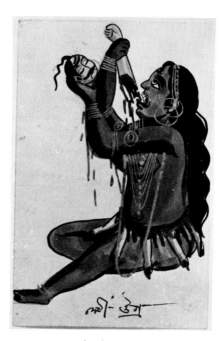

68 Aspects of Devi: the 'Destroyer
 of Passions'. Kalighat, *c.*1890.
 I.S.288–1961. Cat.no. 30,xxv: *p.85*

69 The 'Angry One'.
 Kalighat, *c.*1890.
 I.S.289–1961. Cat.no.30,xxvi: *p.85*

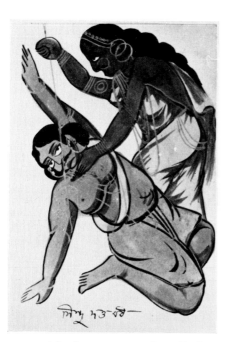

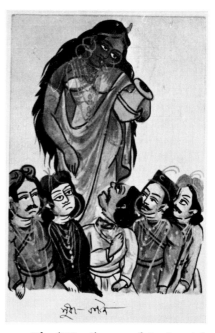

70 The 'Destroyer of Sindhu'.
 Kalighat, *c.*1890.
 I.S.290–1961. Cat.no.30,xxvii: *p.86*

71 The 'Distributor of Ambrosia'.
 Kalighat, *c.*1890.
 I.S.291–1961. Cat.no.30,xxviii: *p.86*

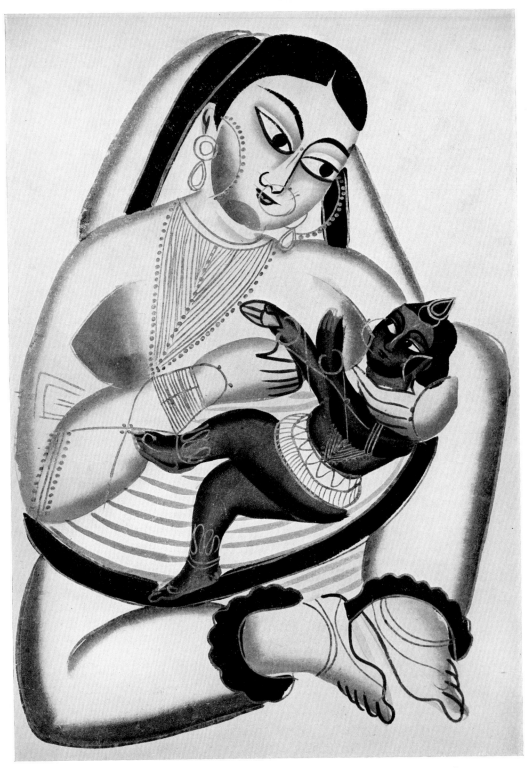

72 Jasoda nursing Krishna. Kalighat, *c.*1890. I.M.119–1914. Cat.no.31,xiv: *p.90*

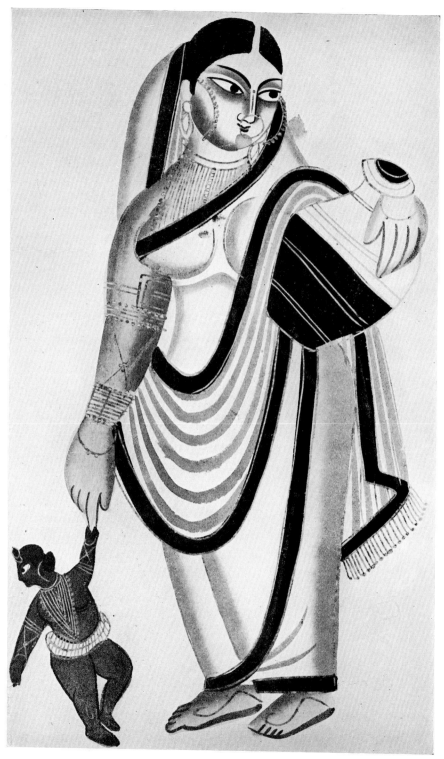

73 Jasoda taking the infant Krishna for a walk. Kalighat, *c.*1890.
I.M.120–1914. Cat.no.31,XV: *p.90*

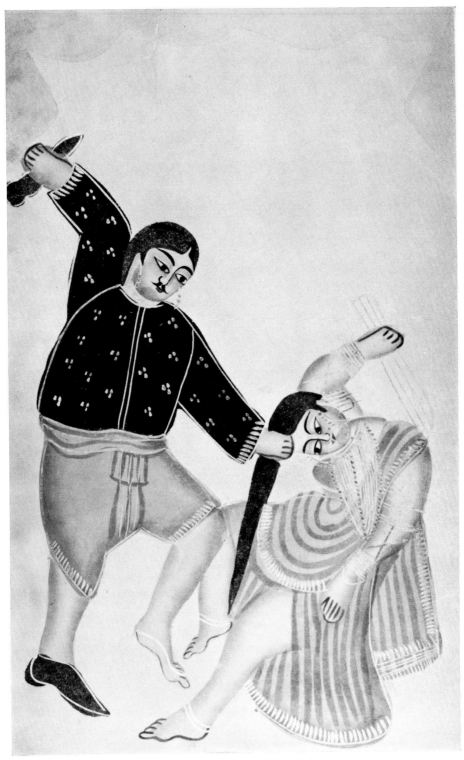

74 A husband beating his wife with a shoe. Kalighat, *c.*1890.
I.M.141–1914. Cat.no.31, xxxv: *p.91*

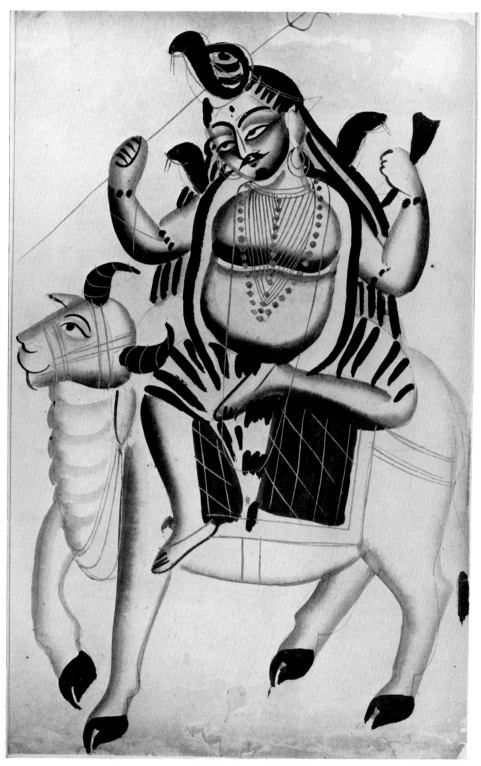

75 Shiva on the bull Nandi. Kalighat, *c.*1890.
I.M.2(190)–1917. Cat.no.32,iii: *p.92*

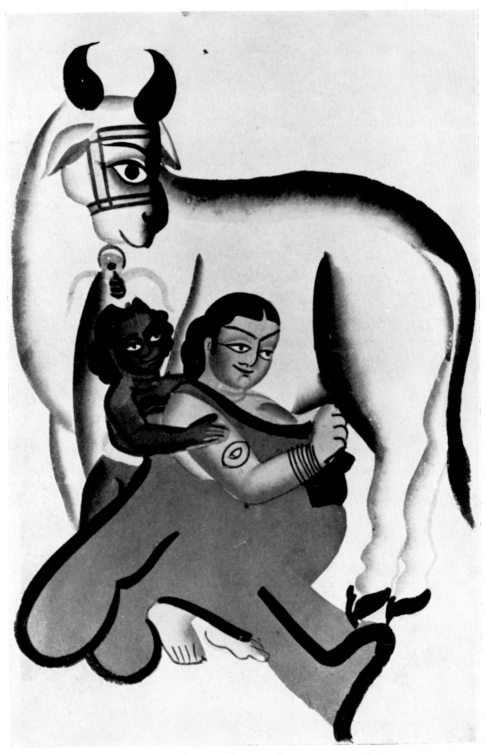

76 Jasoda, with the infant Krishna, milking a cow. Kalighat, *c.*1900.
I.P.N.2574. Cat.no.34: *p.92*

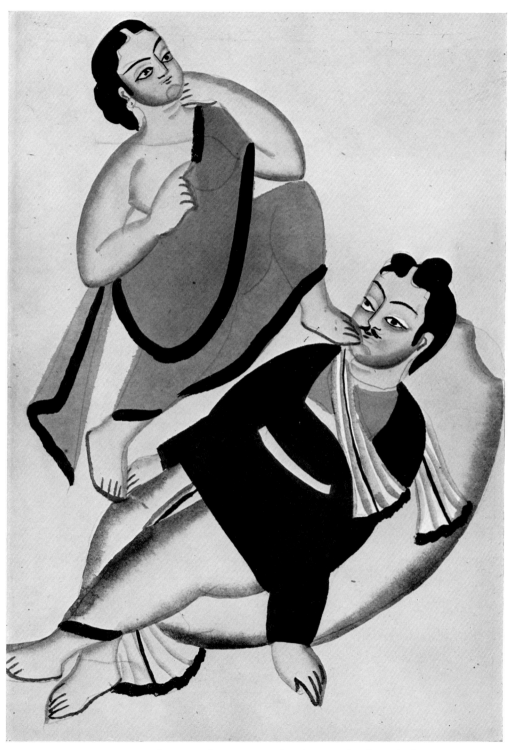

77 Courtesan trampling on a lover. By Kali Charan Ghosh, Kalighat, *c.*1900.
I.S.39–1952. Cat.no.36,v: *p.93*

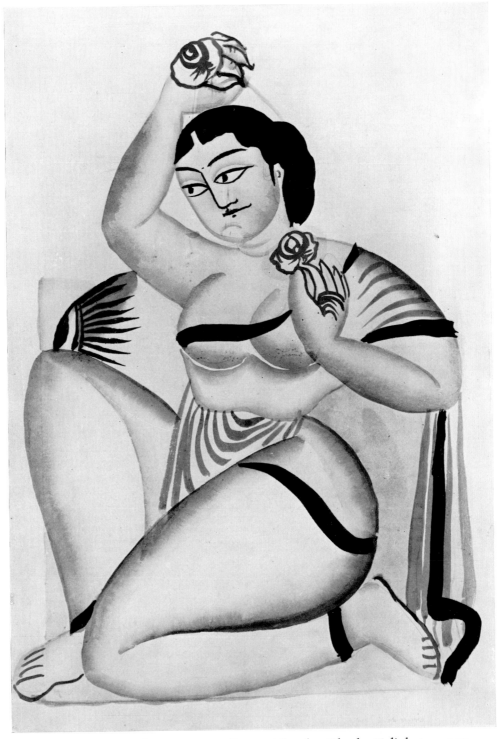

78 Courtesan with roses. By Nibaran Chandra Ghosh, Kalighat, *c.*1900.
I.S.31–1952. Cat.no.37,iii: *p.93*

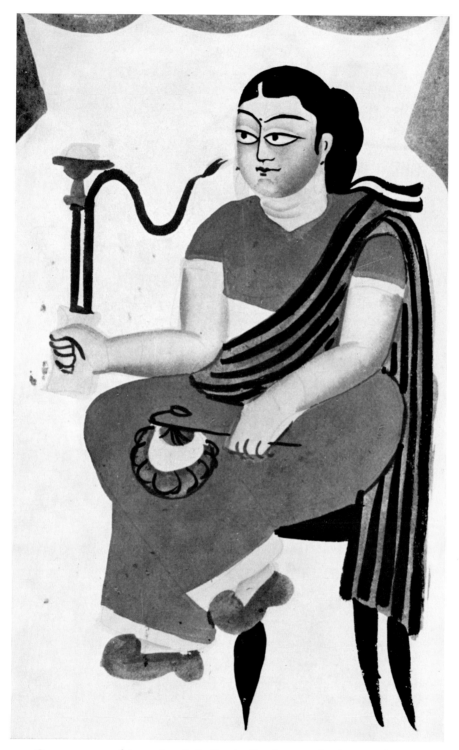

79 Courtesan smoking a hookah. By Kali Charan Ghosh, Kalighat, *c.*1900.
I.S.38–1952. Cat.no.36,iv: *p.93*

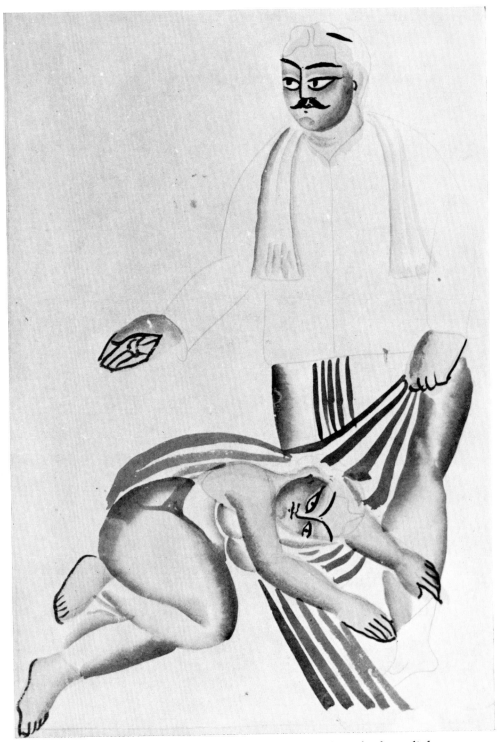

80 A husband striking his wife. By Nibaran Chandra Ghosh, Kalighat, *c*.1900. I.S.36–1952. Cat.no.37,viii: *p.94*

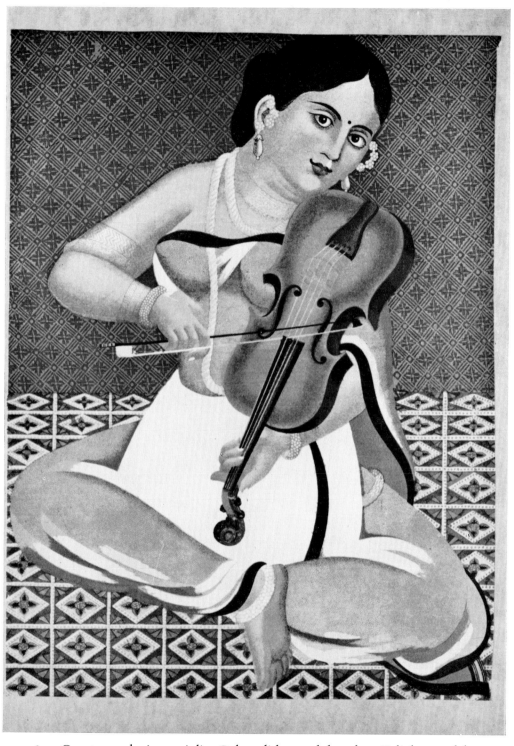

81 Courtesan playing a violin. Colour-lithograph based on Kalighat models.
I.S.50–1968. Cat.no.41,iii: *p.96*

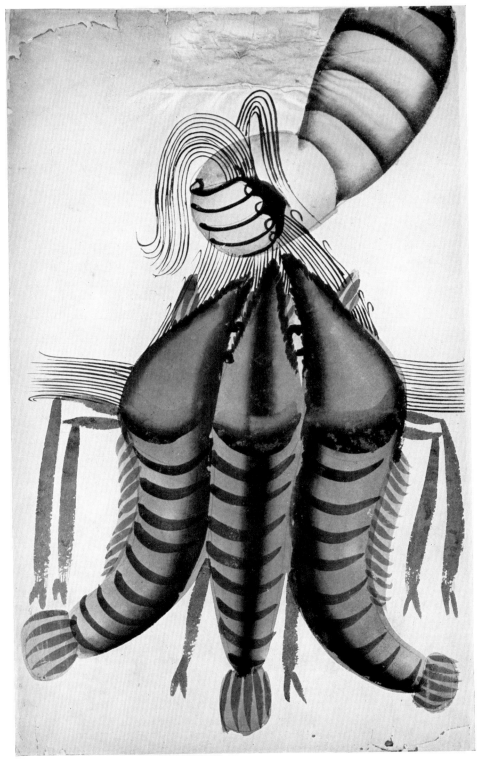

82 Hand with fresh-water prawns. Kalighat, *c.*1880. Monier-Williams Collection, Indian Institute, Bodleian Library, Oxford. *P.50*

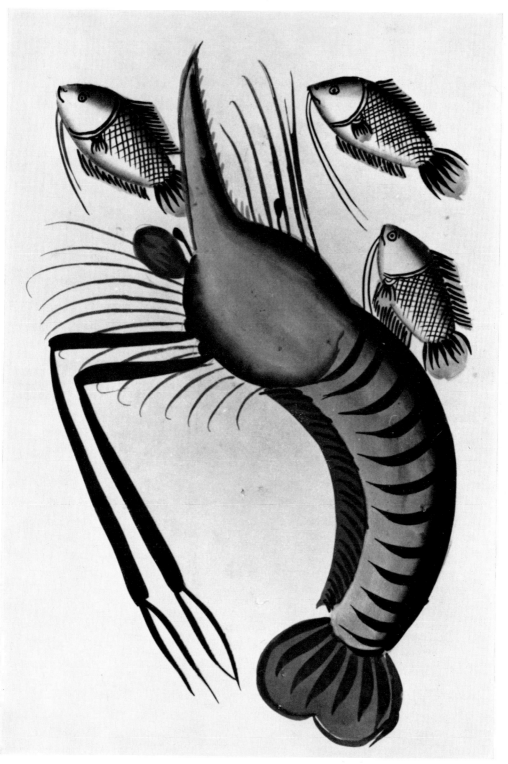

83　Fresh-water prawn with cat-fishes. Copy by a modern Calcutta painter.
Calcutta, *c*.1940. I.S.2–1954. Cat.no.42. *P.96*

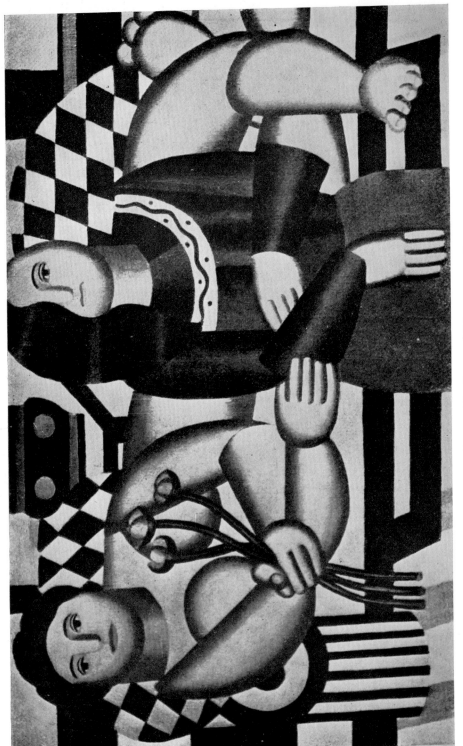

84 Two figures. By Fernand Léger, 1923. *P.1*

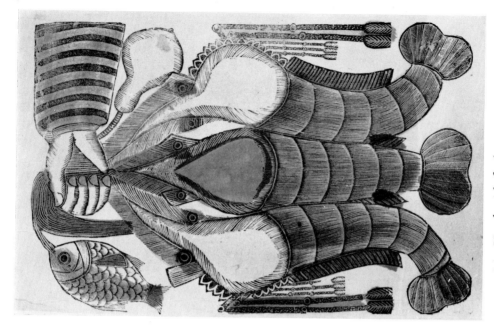

86 Hand with fresh-water prawns.
Tinted woodcut. Calcutta, *c.*1890.
I.S.469–1950. Cat.no.40,ii: *p.95*

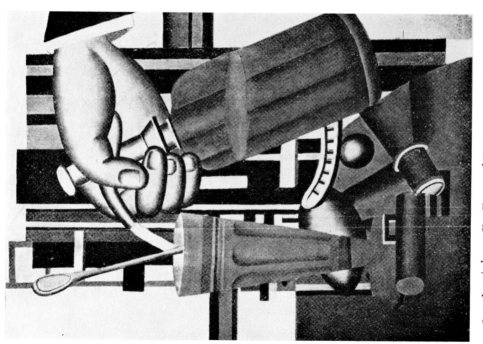

85 Le siphon. By Fernand Léger, 1924. *Pp.17–18*

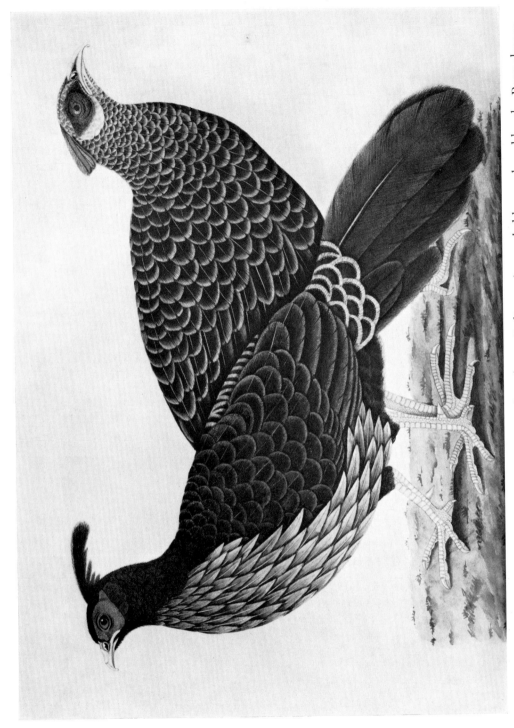

87 A pair of Nepal Kaleege pheasants. Water-colour by an Indian artist, probably employed by the Barrackpore Menagerie, near Calcutta, *c.*1804–1805. India Office Library, London. *P.46*

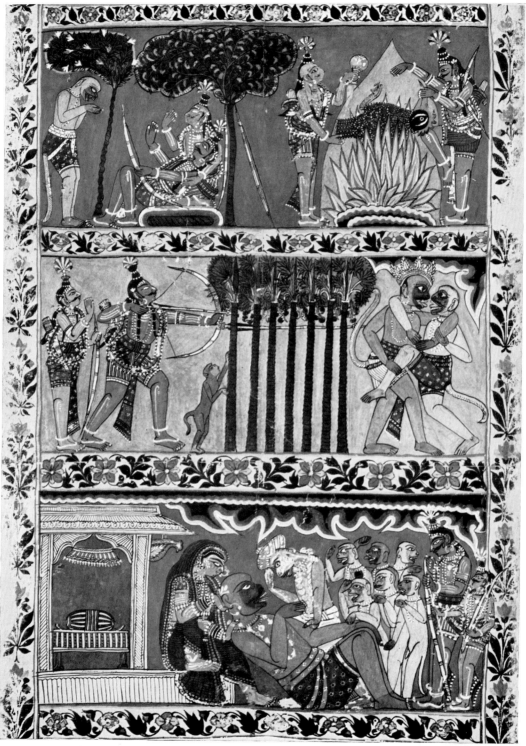

88 Scenes from the *Ramayana*. Scroll-painting by a rural *patua* artist, Murshidabad
District, West Bengal, *c.*1800. I.S.105–1955. *P.8*

89 Metamorphosis. Caricature of the westernized Bengali. By Gogonendranath Tagore.
Dated 9 August 1917. Collection G.K. Kanoria, Patna. *P.26*

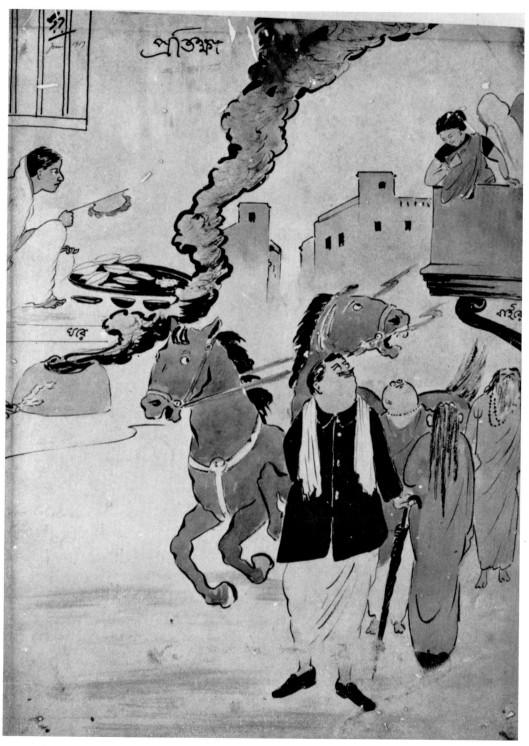

90 The rival attraction. Caricature of the Calcutta man-about-town and the up-to-date
courtesan. By Gogonendranath Tagore. Dated June 1917.
Collection G.K. Kanoria, Patna. *P.26*

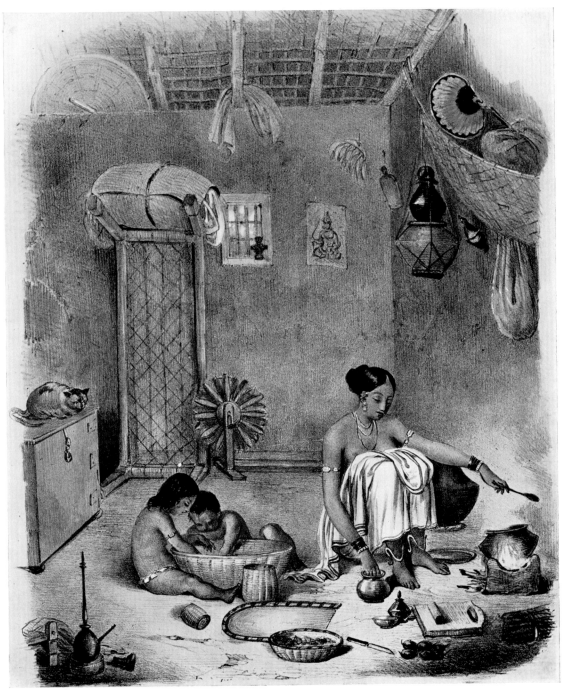

91 Interior of a native hut. Plate 14 from Mrs S.C. Belnos, *Twenty-four plates illustrative of Hindoo and European manners in Bengal* (London, 1832). *Pp.2,18*

Dd. 147328 K24